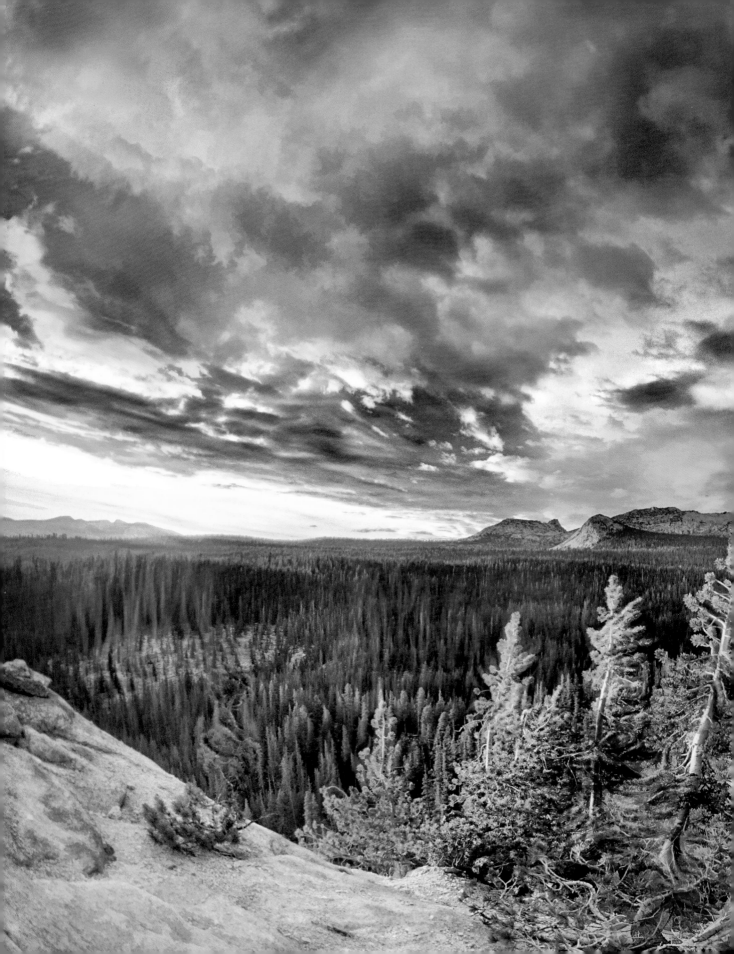

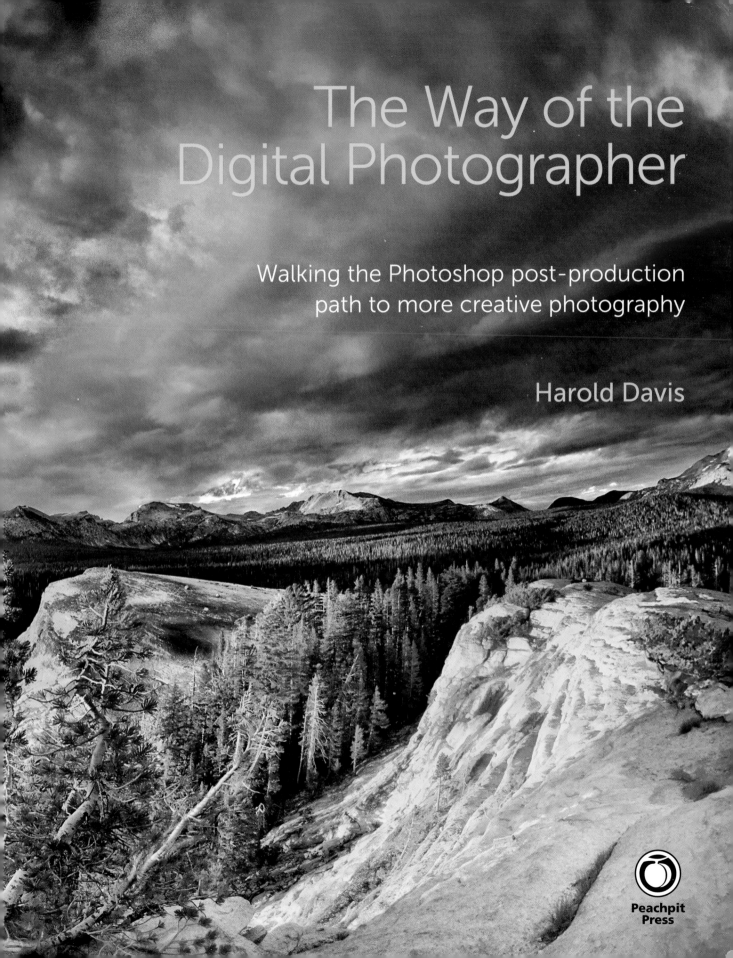

The Way of the Digital Photographer

Walking the Photoshop post-production
path to more creative photography

Harold Davis

Peachpit
Press

Acknowledgments

Special thanks to Nancy Aldrich-Ruenzel, Nancy Bell, Mark Brokering, Gary Cornell, Tracey Croom, Martin Davis, Virginia Davis, Rebecca Gulick, Barbara Hopper, Ronna Lichtenberg, Marc Schotland, Jeffery Stein, and Matt Wagner.

Dedication

For all those who seek to tread a path less traveled.

The Way of the Digital Photographer: Walking the Photoshop post-production path to more creative photography
Harold Davis

Peachpit Press
www.peachpit.com

To report errors, please send a note to: errata@peachpit.com
Peachpit Press is a division of Pearson Education.

Acquisitions Editor: Rebecca Gulick
Production Editor: Tracey Croom
Book design, production, and indexing: Phyllis Davis
Copyeditor: Nancy Bell
Proofreader: Patricia Pane

ISBN-13: 978-0-321-94307-1
ISBN-10: 0-321-94307-4

9 8 7 6 5 4 3 2 1

Printed and bound in the United States of America

The beginner's mind is the mind of compassion.

—Shunryu Suzuki

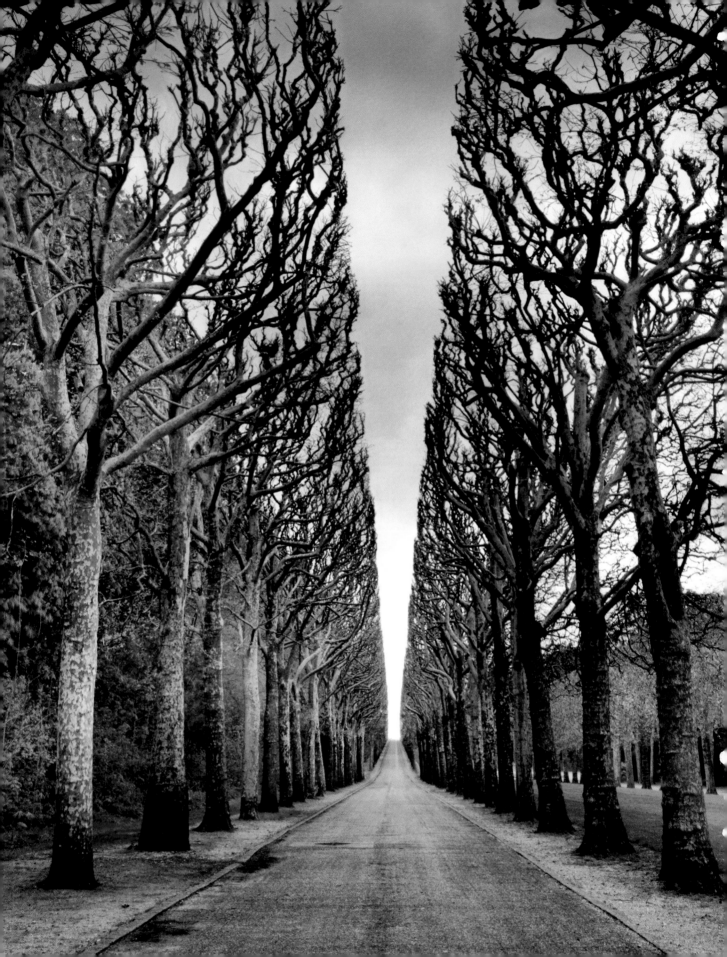

Contents

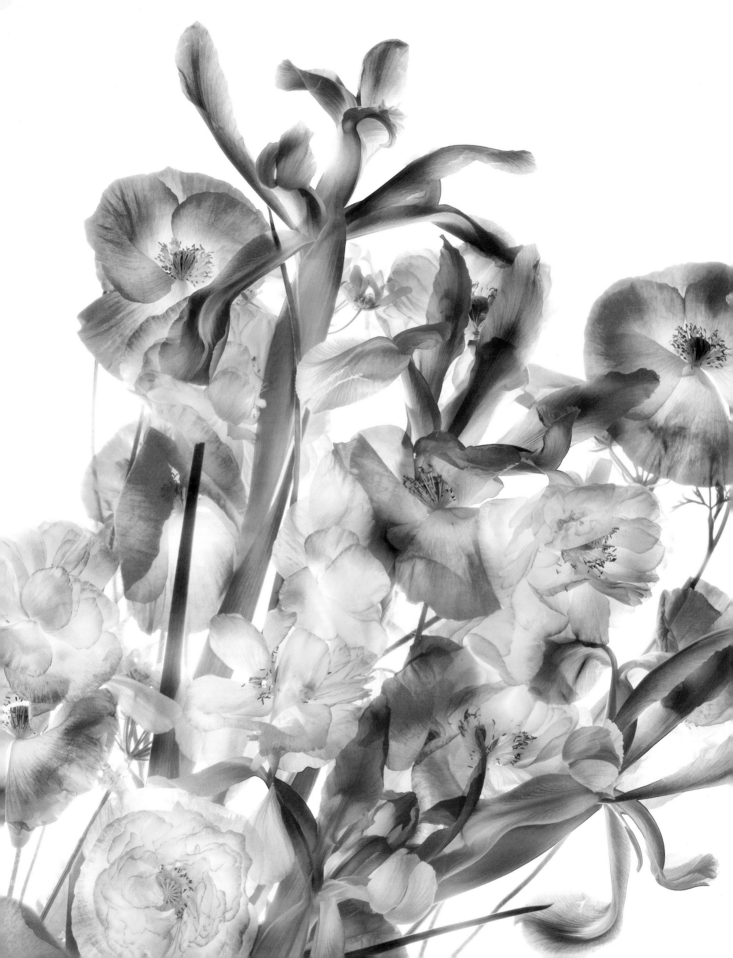

Introduction

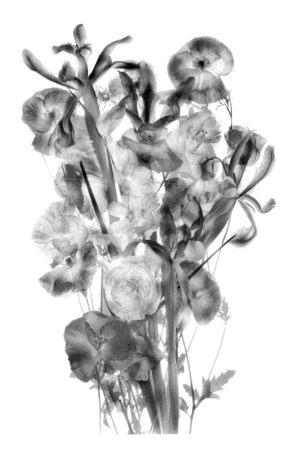

Looking at the bright red poppies from my garden, I envisioned an image that best showed off their bright color and translucency. To accomplish the first goal, I knew I needed to combine the red flowers with another color that would complement them. So I purchased some blue irises from a supermarket. To accomplish the second goal, I shot the flowers straight down on a light box, combining the different exposures as layers in Photoshop. The finished image is much along the lines of what I saw in my mind's eye when I pre-visualized it. In this case, the road from pre-visualization to final image took planning, work, and time—and I feel the results warrant the effort.

50mm macro lens, eight exposures at shutter speeds ranging from 1/30 of a second to 4 seconds; each exposure at f/11 and ISO 100, tripod mounted; exposures combined in Photoshop.

Your digital camera probably resembles a film camera in both appearance and basic functionality. Like a film camera, your digital camera has a lens with aperture and shutter controls that can be used to decide how much light penetrates into the body of the camera for each shot.

But that's where the similarities between film and digital cameras end. Despite the similarity in appearance of the hardware device used to make the exposures, digital photography is an entirely new medium compared to film photography.

Historically, chemical properties of film and developing were used to record light that entered the camera. Today with a digital camera, the light is captured as a digital signal by a sensor. Digital signal data recorded by the sensor can be processed by the computer in your camera. More powerfully, and here's where the fun really begins, image data saved by your camera can be processed on a standalone computer after you upload your files.

People don't fully understand this new digital medium that consists of the camera-computer partnership. They're still hooked on the fact that their handheld computer with a lens (a.k.a. a digital single-lens-reflex, or DSLR) looks like a good old-fashioned film camera—and if it looks like one, it must work like one. Not so. For those who get over this misunderstanding, the door is wide open for experimentation and new approaches.

Digital *is* different. Very different.

One of the main goals of *The Way of the Digital Photographer* is to show you how to take advantage of this difference to enrich your own work.

With digital photography, it is my contention that your computer, and the image-processing software that runs on it, is an integral part of the image-creation process. It may be even more important as a creative tool than the camera itself.

You can easily see this difference when you use your iPhone camera, where more than half the fun is processing camera-phone images through a variety of image-manipulation apps.

To make the most of the creative potential of digital photography, you need to understand what can be done in post-processing and how post-production techniques should inform both your photographic choices and your overall workflow.

▶ *On my way to teach a workshop session on the eastern slope of the Sierra Nevada Mountains in California, the world seemed veiled in clouds. At one vista point, I decided to stop and just wait awhile so that I could get a sense of the weather and its movements. In the hopes that the vista might clear, I took out my gear and set it up.*

As I watched the scene, the distant basins and peaks of the Panamint Range were invisible, hidden in a dense swirl of fog and cloud.

But then, for a brief instant, the clouds lifted, and I was able to peer through my lens at range after range of valleys filled with low-hanging clouds, lit by the light of the sun. Thankfully, I was ready to go. A few seconds after I clicked the shutter, the view was gone.

In post-production, I worked to enhance the sense that sunlight was streaming through a clouded landscape that a moment before had been completely overcast.

300mm, 1/160 of a second at f/6.3 and ISO 320, handheld.

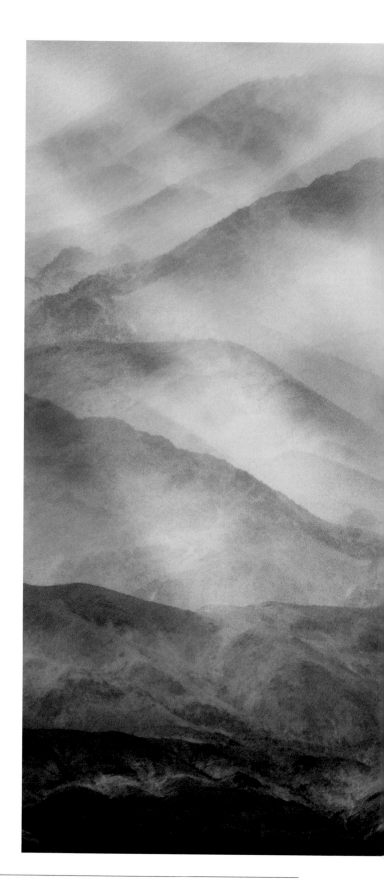

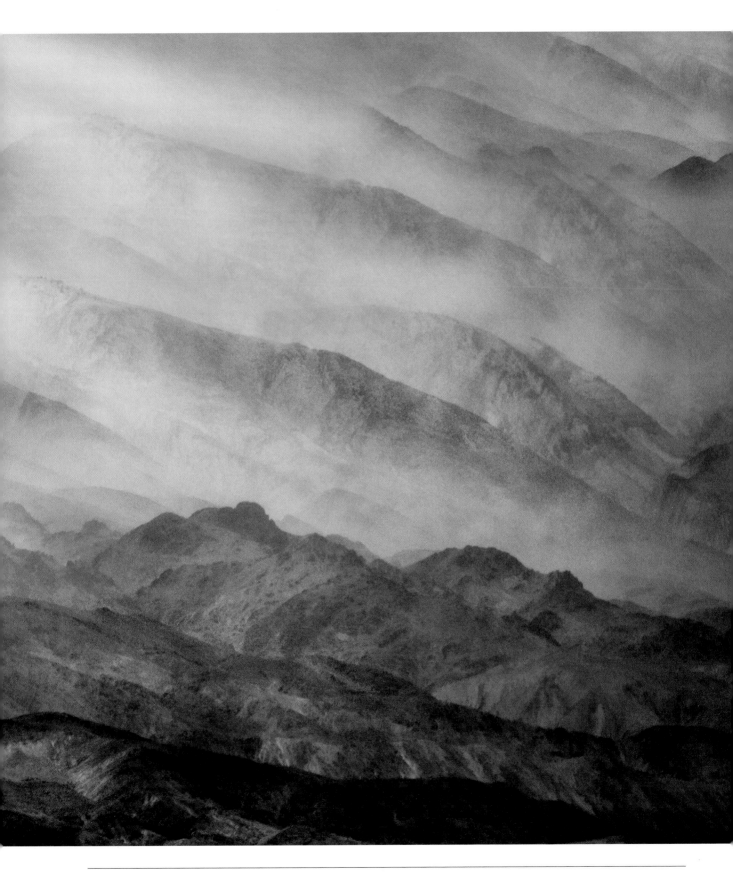

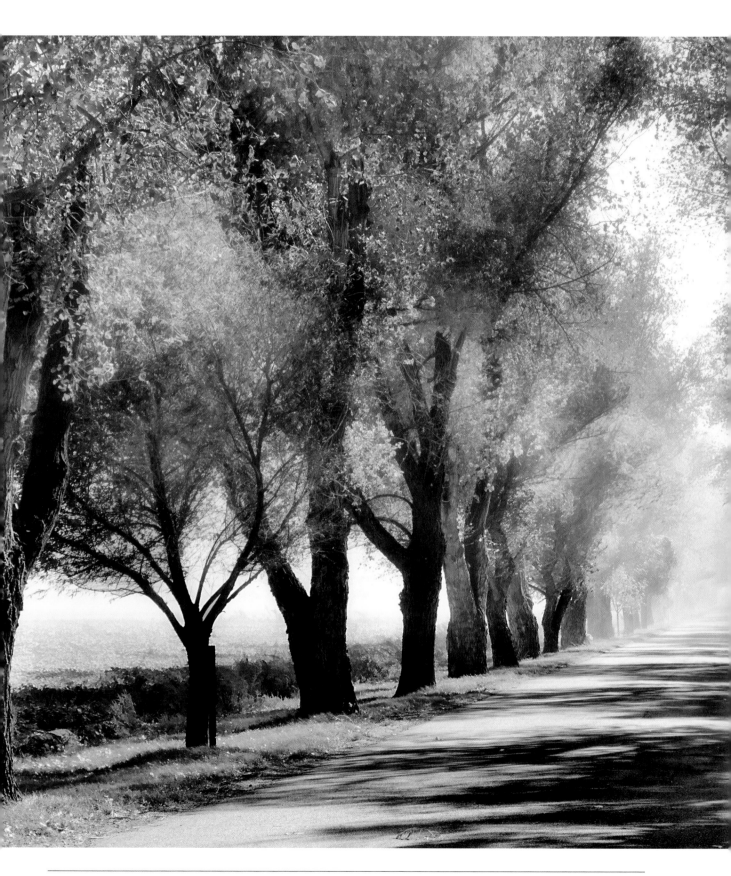

The Way of the Digital Photographer

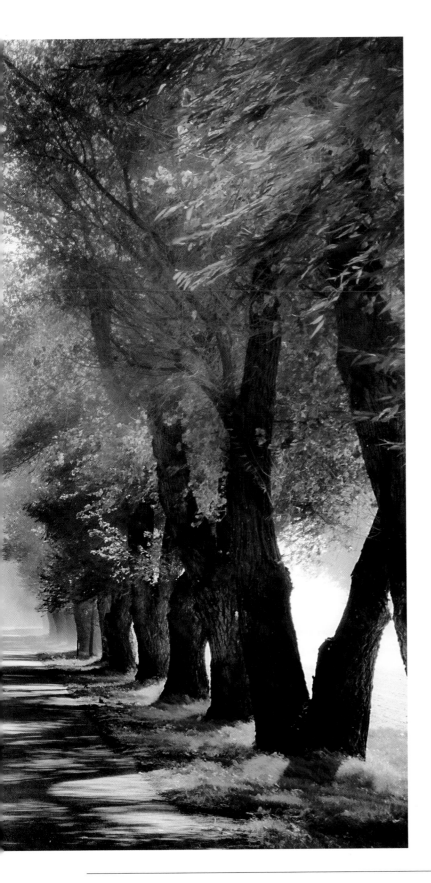

In *The Way of the Digital Photographer*, you'll discover how to effectively use several of the post-processing techniques that I use to create the final versions of my own imagery.

These techniques are presented as case studies in the context of actual examples, so you can understand what each step does. More important, I want you to gain insight into how the techniques and steps involved can inform your choices when you make a photo and in your post-production workflow. (For a discussion of workflow and to understand how best to adapt your workflow to the digital world, turn to page 107.)

With great power comes great responsibility. Today's digital photographers can control every pixel, every color, every shape, and every form in their processed imagery.

This means that it is no longer enough—if it ever was—to justify a creative photo because the scene in front of the camera was "like that." This excuse harks back to the idea that a film camera captures "reality"—and, indeed, that capturing reality should be a primary goal of photography.

◄ *Driving across the great Central Valley of California on my way to Yosemite, a fierce wind kicked up dust and limited visibility. As I drove farther, I noticed that the hazy light was selectively clearing, and sunshine was starting to shine through. I stopped my car at a long row of trees, pulled out my camera, and snapped this photo. Right after the shutter clicked, the wind started up and the dust closed in again.*

62mm, 1/160 of a second at f/11 and ISO 200, handheld.

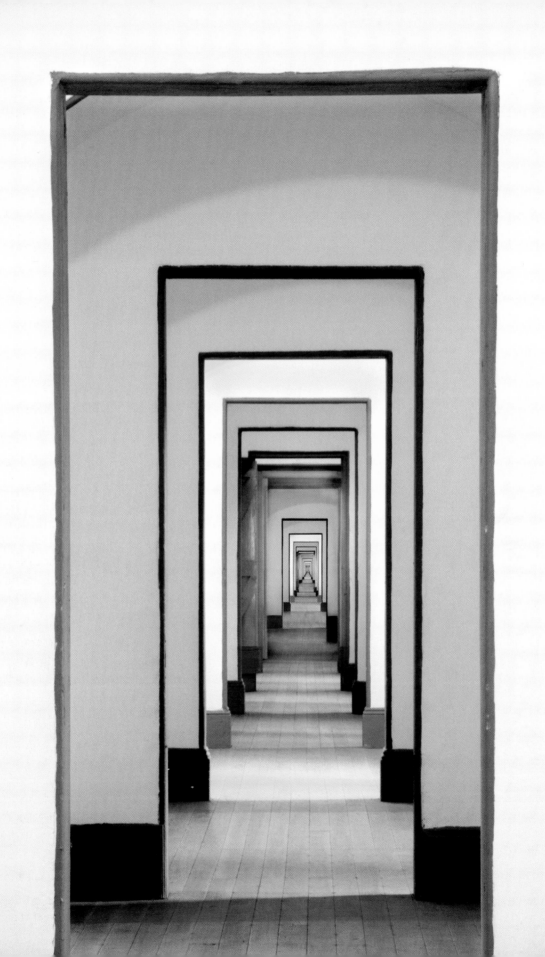

Whether the scene is "like that" or not, the digital photographer is an omniscient ruler of each and every image and pixel—completely responsible for final appearances. By the way, this doesn't absolve the journalistic or documentary photographer from the responsibilities of honest presentation that journalism should imply.

Don't be fooled by the apparent resemblance of a digital photo to an old-fashioned photo, or to the verisimilitude of a digital photo to "real life."

Both resemblances can be used to good effect—for instance, to create a willing suspension of disbelief in the viewer.

The underlying structure of a digital photograph is different from that of an analog photo in many ways—and, as I've noted, completely susceptible to manipulation both at the pixel level and using the tools of a digital painter.

Digital photography and post-production techniques that are used to inform one another—how you take a photograph with an idea or pre-visualization in mind, knowing what you can do to it later in post-production—are the basis of this new digital medium. If you can see a photograph in your mind's eye *before* you take it and know *how* you can process it later to achieve

Image captions, sensor size, and focal lengths

I want you to know the backstory behind every image in this book. This information is an important part of *The Way of the Digital Photographer*, and is included in each image caption. Along with the stories about the photos, I've also noted the complete exposure data.

Where I used a prime lens—one with a fixed focal length—it is written as, for example, *105mm macro lens*. Otherwise, the designation in millimeters (mm) refers to the focal length I used in shooting the image with a zoom lens, for example, *18mm*.

Not all sensors are created equal, and in particular they vary in size. The smaller the sensor, the closer a given focal length lens brings you to your subject. For example, if a sensor has half the area of another sensor, then a given focal length lens will bring you twice as close when placed on a camera with the smaller sensor.

Since different cameras have different sized sensors, it is not possible to have a uniform vocabulary of lens focal lengths. So people compare focal lengths to their 35mm film equivalent by adjusting for the sensor size.

To make the comparison with 35mm film focal lengths, you need to know the ratio of your sensor to a frame of 35mm film, which is called the *focal-length equivalency*. Unless otherwise noted, the photos in this book were created using Nikon DSLRs with a 1.5 times 35mm focal-length equivalency. To find out how the focal lengths I used compare with 35mm focal lengths, simply multiply my focal lengths by 1.5.

If your sensor has a different size than mine, to compare lens focal lengths with the shots in this book, you need to know the focal-length equivalency factor of your sensor. Check your camera manual for this information.

◄ *I composed this photo to show a framed sequence of diminishing doorways, each door smaller than the previous one. Maximum depth-of-field, achieved by stopping down the lens to its smallest possible aperture (f/22), ensured that all the doors were in focus. I wanted the image to show an apparently infinite progression, so I composited larger and smaller versions of the original photo to create an extension of the line of the doors.*

95mm, 10 seconds at f/22 and ISO 100, tripod mounted; photo composited two times with itself in Photoshop.

your vision, then *nothing* can hold your imagery back. Truly, the sky's the limit!

Technique without heart is banal and useless. I've found in the workshops I give that many people come to digital photography precisely because they enjoy—and are good at—working with technology. Indeed, perhaps these folks work in technology-related industries.

But even if you are a technocrat it is important not to lose the creative aspects of digital photography. Often the people who start with digital photography because they are comfortable with the gear find some resistance to fully engaging their creative powers. They may be more comfortable with measuring pixels and navigating software than with conveying emotion.

If this describes you, be of good cheer. Provided that you approach image making in the spirit that anything is possible, you may be amazed by what you can achieve.

Along with the post-production case studies in *The Way of the Digital Photographer*, you will find thoughts and exercises, presented as *Meditations*. These Meditations will help you with the conceptual and emotional side of digital photography and also guide you in pre-visualizing your photographs with the idea of post-production in mind.

As you walk down the path of the digital photographer, you will find that photography is about your creative vision and your notions about art. Digital photography is also a way to show others your very personal view of the world. By combining your pre-visualization with your photography and appropriate post-production techniques, you can fully render *anything* you can imagine.

Harold Davis

Berkeley, California

Meditations

An important aspect of *The Way of the Digital of Photographer* is the Meditations. These are sporadic exercises intended to help you understand the concepts I am explaining. The idea is for you to frame the tools and techniques in your own terms so you can draw your own road map for becoming a more powerful and creative digital photographer.

▶ *While I enjoy photographing nature a great deal, I also have fun in the studio shooting models. In fact, nothing makes a session of model photography work better than when everyone is having fun—both model and photographer. That's why Kelly, the model shown in this photograph, is one of my favorites. She's got a wonderful sense of mischief and always has a great time in front of the camera.*

I shot a series of photos of Kelly on the satin covered chaise longue using very controlled studio lighting. I wanted to be very careful about shadows and how her face was lit.

Back in my studio, I looked over the photo shoot and decided I wanted to do something in post-processing that would create a photo reminiscent of 19th-century model painting. Looking through my photo files, I found a sunset that I added to the background. Then, I gently brushed in a subtle canvas-like texture.

The addition of these overlays helps transform the image of Kelly away from a standard studio pose of a glamour model and closer to an image that seems more artistic and painterly.

Model: 36mm, 1/160 of a second at f/5.6 and ISO 200, handheld; Sunset: 200mm, 1/2500 of a second at f/20 and ISO 200, handheld; photos combined in Photoshop; overlay texture applied in Photoshop (to find out more about textures, turn to page 175).

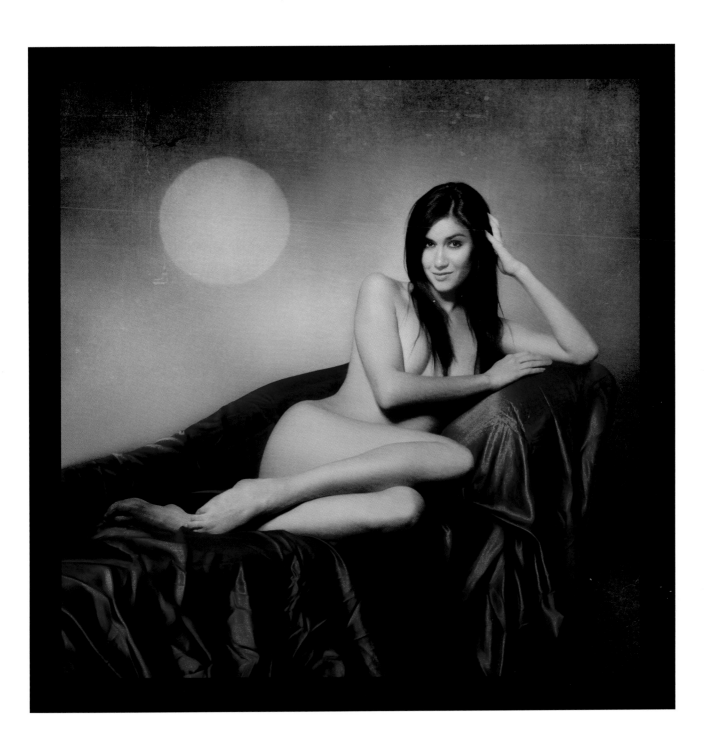

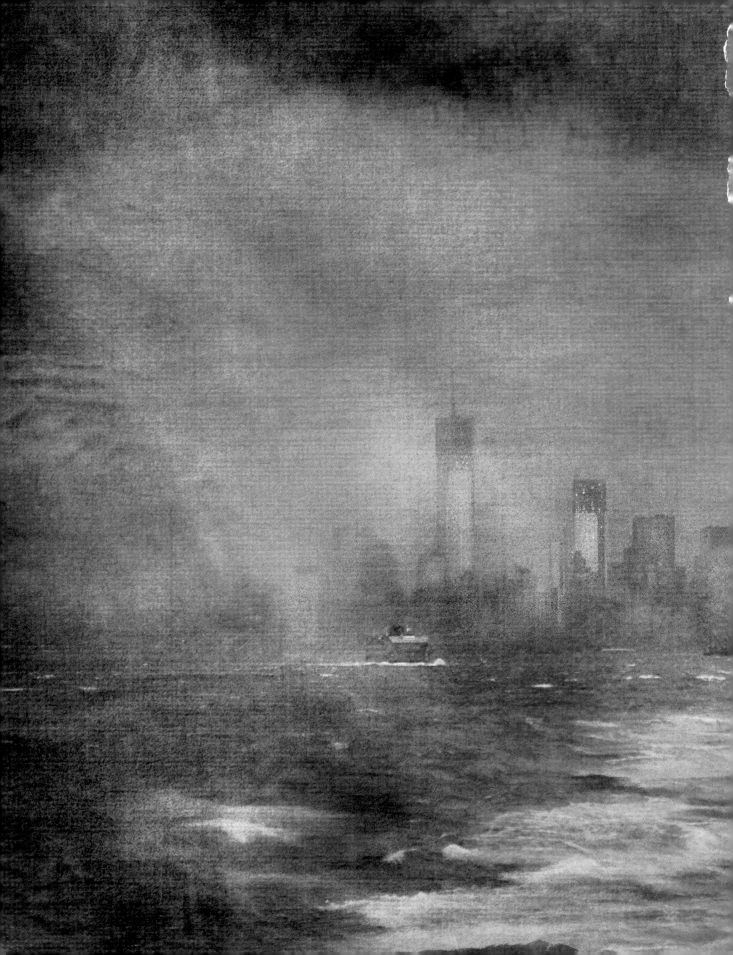

Digital Photography
Is Painting

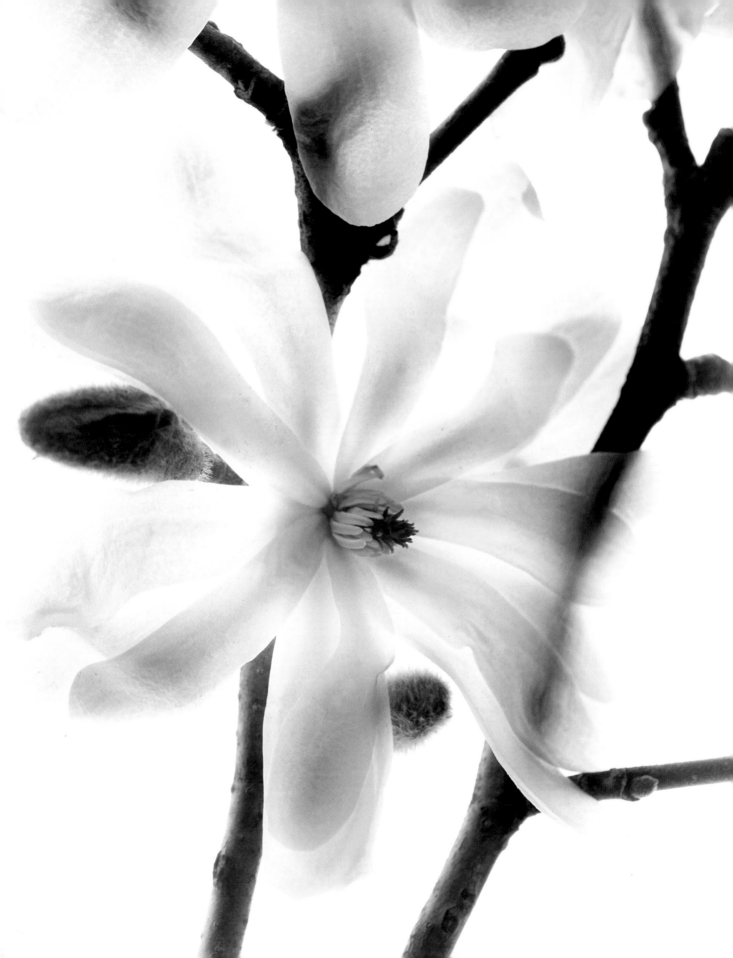

First things first

*A camera is an extension of ourselves. An appendage to
bring us closer to the universe.* —Robert Leverant

Before you dive into *The Way of the Digital
Photographer*, I think it is important that you
understand some assumptions I am making
about your level of knowledge and experience
with photography and digital post-processing,
and how these assumptions relate to the con-
tent of this book. You should also know my
approach—and biases—regarding a number
of key issues. So let's get a few preliminaries
out of the way.

The camera to use

It's well said that cameras don't take pictures,
people do—and, as photographer Jay Meisel puts
it, the best camera to use is the one you have with
you. True learning about photography is learning
about how to see, and the best photography has
to do with vision and showing us things in a new
way. So you won't find me peddling a fancy new
camera as a necessity for making creative images.

In fact, I am so convinced that digital photogra-
phy has everything to do with ideas, concepts,
and clarity of vision—and so little to do with
the particular camera model you use to imple-
ment your visual ideas—that I've come to enjoy
working with my iPhone camera. This is indeed
the camera that is always with one, and a very
good demonstration of "the way of the digital
photographer" because an IPhone camera itself is
programmatic. You can choose from a number of
different camera apps, or just stick with the one
that came with your camera.

Creative iPhone images can be processed on
the iPhone, and understanding the iPhone's
post-processing options can influence the entire
process of taking photos and making iPhone
imagery. Sure, the small screen is a drawback—
but the creative possibilities are endless and have
spawned a whole new art medium, sometimes
called "iPhoneography."

◄ *I knew when I made this photo of a backlit magnolia blossom that I wanted the flower to look extremely
translucent. To achieve this effect, I literally painted in the petal details where the petals overlapped the
magnolia branches to create what I sometimes call an "illusion of transparency"—the petals, of course,
are not literally transparent, but the contrast between petal and stem created via digital painting creates
the illusion that the petals are transparent.*

200mm macro lens, 3/10 of a second at f/7.1 and ISO 100, tripod mounted.

▲ PAGES 18–19: *In stormy weather I handheld this shot in New York's upper harbor from the open deck of a
rocking boat. The weather was dramatic and the skyline of lower Manhattan made a great backdrop, with
the Staten Island Ferry charging toward my vantage point. But when I looked at the image, it seemed flat
without the contrasts and sense of the elements that had been present when I made the exposure. So I used
Photoshop to add painterly effects—including a texture overlay as explained on pages 174–183—to create
my final image, which can be viewed as a cross between digital painting and photography.*

65mm, 1/200 of a second at f/7.1 and ISO 400, handheld, texture overlay added in Photoshop.

The iPhone "interludes" in *The Way of the Digital Photographer* show some of these possibilities, and may stimulate you not only to get out there and be more creative with your mobile phone camera, but also to become a more creative photographer generally.

Any creative image can benefit from intelligent and disciplined post-processing techniques—although of course these can be overdone. Regarding the camera you use, the vision should inform the craft, and not the other way around. So it's important to learn the capabilities of your camera, but not as an end in and of itself, but rather as part of mastering the craft of *digital* photography. In other words, craft supports vision.

My recommendation is to work with a camera that has manual exposure controls. This should be almost any decent digital camera, although ease of access to manual exposure settings can vary. If you use manual exposure to make your images, you will learn how exposure works, and master creative control at the moment of initial exposure. But using manual exposure is not necessary to follow the ideas in *The Way of the Digital Photographer*.

JPEG versus RAW

A digital RAW file saves the data captured by your camera's sensor. The precise encoding of a RAW file varies from camera manufacturer to manufacturer, but the idea is the same for all camera brands: as much data as possible is saved as a potential image rather than as one that can actually be rendered. To do *anything* with a RAW file, you first have to use software to render it into a format that can be manipulated, printed, or displayed.

JPEGs are a file format often used for display on computer monitors or on the Web. The JPEG file format can easily be derived from a RAW file, but when you convert an image from RAW to JPEG, a great deal of the image information in

the RAW file is discarded and lost. A JPEG file that has been derived in this way can be thought of as one interpretation of a RAW file.

Most digital cameras can be set to save photos as RAW files, JPEG files, or both (other file formats for saving photos besides JPEG and RAW are also sometimes available, but JPEG and RAW are the most universally available options).

My suggestion is to save your photos as RAW files. If you save your captures in RAW format, then you have access to most of the data that was created when your exposure was made. This leads to creative opportunities that are simply not available if this information has been discarded. Of course, if you want to save your captures in both the RAW *and* JPEG formats, this does no harm other than taking up a bit of extra space on your memory card and your computer.

Some photographers—even professionals—prefer to capture in JPEG and not worry about the additional step of RAW file processing. There are many creative techniques that can be used in post-processing that I show you in *The Way of the Digital Photographer*, even without the full digital information that is available in a RAW file. So don't worry if you are only accustomed to saving your photos as JPEGs.

But do bear in mind that some of the examples in *The Way of the Digital Photographer* relate to RAW and multi-RAW processing. Obviously, the techniques shown are only feasible if you start with a RAW capture in the first place.

▶ *Photographing beneath the Golden Gate Bridge on a foggy day, I knew that I would need to use a RAW capture to be able to show all the detail in the complex structure under the bridge. Since I had all the image data in RAW format, back at my computer I was able to effectively work to tease the variations in tonal information out of the photo file and use it to render the final version of the image.*

12mm, 1/320 of a second at f/8 and ISO 200, handheld.

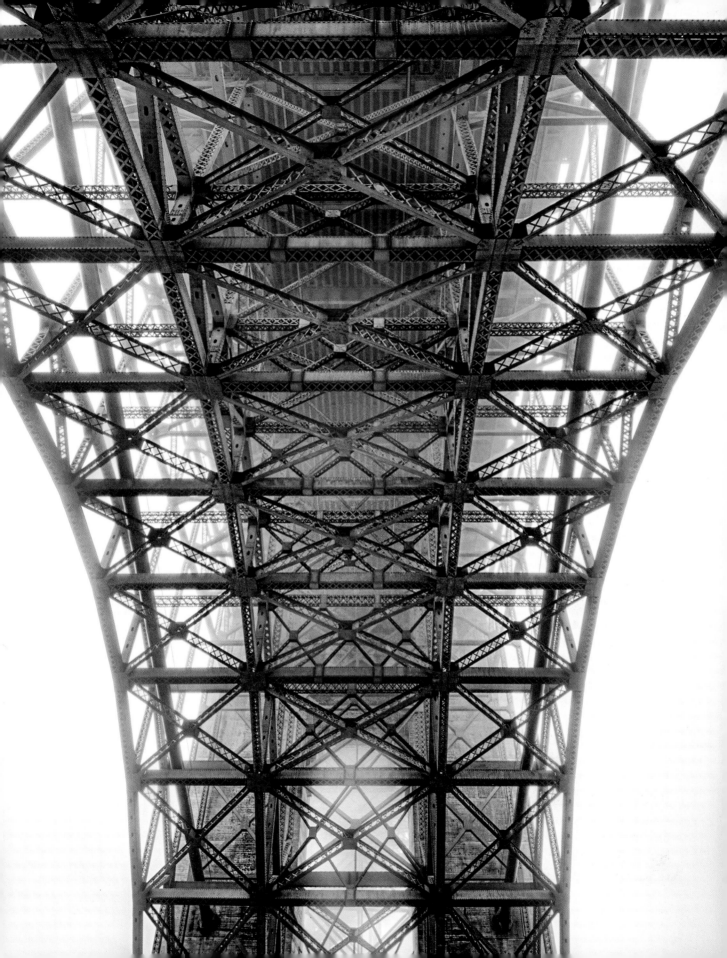

Photoshop prejudices

Adobe Photoshop is a monster. Okay, from my viewpoint it is a friendly monster that has been very good to me. I don't want you to be scared of the monster—you can think of Photoshop maybe as a kind of artistic "cookie monster"—and I want you to understand some things about the Photoshop techniques that are shown in this book. So here's what you need to know about Photoshop and the way I teach before getting started with *The Way of the Digital Photographer*:

1. I am not interested in the latest and greatest features of Photoshop. There are plenty of other writers out there who can tell you about Photoshop's bells and whistles—you won't find that here.

2. Every post-processing example in this book is based upon the single concept that underlies Photoshop. That concept is *layers*, explained starting on page 33. If you are not going to use layers, then you may not need Photoshop at all. A program such as Adobe Lightroom is probably sufficient for your needs because the underlying capability that Photoshop possesses and Lightroom lacks is the ability to handle layers. On the other hand, if you don't learn to work with layers, you are missing much of the point of the digital post-processing revolution.

3. Besides layers, *The Way of the Digital Photographer* will show you how to work with two other Photoshop primitives: layer masks and blending modes—and that's about it for Photoshop techniques. This book isn't about giving encyclopedic coverage of the Photoshop working environment, menus, panels, or even the Photoshop adjustments related to photography. There are plenty of books out there that already do that, so why reinvent the wheel? I'd rather show you something that you *won't* find anywhere else, and that *will* revolutionize your image making.

4. I can't emphasize strongly enough that you don't need the latest and greatest version of Photoshop to accomplish the techniques shown in this book. It all comes down to the ability to work with layers, and layers have been a feature since Photoshop 3.0. The appearance and location of controls will vary slightly between versions of Photoshop, but the functionality is essentially the same. Note also that most of the ideas shown in this book can be implemented in a number of layer-capable image manipulation programs that are much less expensive than Photoshop (or even free). These options include Photoshop Elements (which is much less costly than Photoshop itself, and will do everything shown in this book except LAB color manipulation), Corel Photo-Paint, and GIMP (Gnu Image Manipulation Program), which is free to download.

5. Speaking of ideas, I want you to use *The Way of the Digital Photographer* as primarily an idea book. While I do show you the specific steps I used to accomplish particular results in post-processing, this is not a cookbook, and there are often a number of alternative ways to accomplish the same results. The key thing is to understand the concepts and what you can do after you've taken the photo—so that these concepts can influence your photography and how you go about making creative images in the first place.

Photoshop CC

Photoshop's most recent version incorporates the ideas of cloud computing, hence the new name "Photoshop CC" (Creative Cloud).

Photoshop CC has many new and interesting features that can help the digital photographer on their creative path. However, as I stated in point one above, I'm not interested in the latest and greatest bells and whistles. My goal is to help

you create great images no matter what version of Photoshop you are using.

You *don't* need Photoshop CC in order to work with the ideas and creative techniques found in *The Way of the Digital Photographer.*

The default Photoshop CC interface looks very much like Lightroom, with its dark gray and black features as shown below.

This is the dark default color scheme for Photoshop CC.

I prefer to work with a lighter color scheme that looks very much like previous versions of Photoshop.

When I work in Photoshop, I prefer to work with a lighter color scheme, such as the light gray one shown above.

First off, I think it is easier to see and I find it less distracting. Also, previous versions of Photoshop use essentially these colors. So the lighter scheme shown throughout this book will probably look pretty familiar.

If you would like to change your color scheme to something lighter, choose Photoshop ► Preferences ► Interface (Mac) or File ► Preferences ► Interface (Windows).

On the Interface panel of the Preferences dialog in the Appearance area, use the drop-down list boxes to change the program's colors (below). Once you find a color scheme that works for you, click OK to save your preferences.

Make sure to open images as windows, not tabs

Recent releases of Photoshop have a default setting that makes the creative techniques found here—such as multi-RAW processing and hand-HDR—extremely and unnecessarily difficult. This feature opens images in Photoshop as tabs, not as separate floating windows. Make sure you set your images to open as windows not tabs.

Choose Photoshop ► Preferences ► Interface (Mac) or File ► Preferences ► Interface (Windows) to open the Interface panel of the Preferences dialog. In the Options area, uncheck Open Documents as Tabs. Click OK to save your setting.

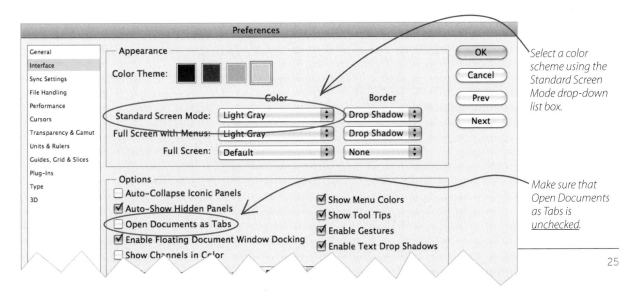

Select a color scheme using the Standard Screen Mode drop-down list box.

Make sure that Open Documents as Tabs is *unchecked*.

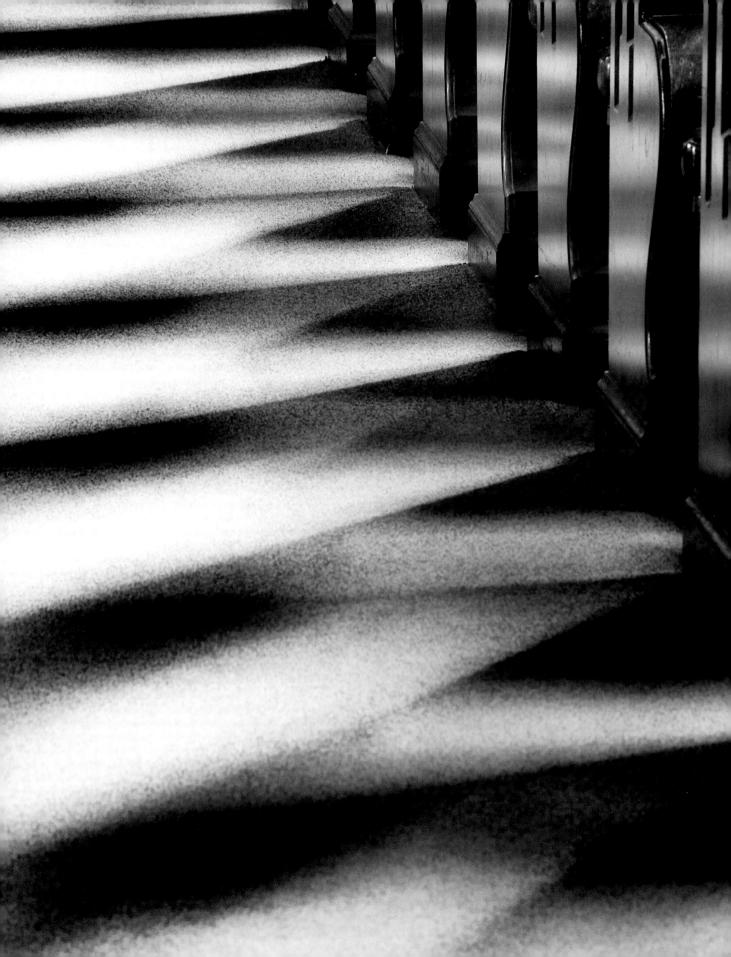

Seeing is about light

One needs light to see, and one needs light to photograph. However obvious the thought, it is one with profound implications for every photographer.

Nothing can be seen—or photographed—in a lightless void. Objects emit light, or reflect light that is emitted elsewhere, and can then be observed and rendered photographically. Light shapes, caresses, and discloses the forms and contours of that which is being observed and photographed.

This can be put very simply: a digital photo captures light that is reflected or emitted by the subject, rather than the subject itself.

So we photograph light rather than the thing being lit.

Once you switch gears away from thinking about "things" and toward thinking about the light that is doing the actual rendering of the "thing" you begin to anticipate the possibilities in digital post-production. Let me explain.

When I observe light I see endless variations, but actually light can be broken down into a number of characteristics. The first and foremost characteristic is how bright a light source is.

Besides brightness, light has a number of other important qualities, including *directionality* (the direction from which it comes) and whether the light is hard—because it is direct—or soft—because it has been diffused and reflected. Light also has a warmth or coolness (technically, this is expressed as a *white balance*, or a *color temperature* on something known as the Kelvin temperature scale).

One of the most important properties of light is that it makes shadows.

So the next time you are looking at something, forget the actual objects you are seeing. Instead, observe the direction, warmth, and quality of light. Pay particular attention to the shadows that the light creates and to the edges between light and dark areas. Are there shapes or interesting

◄ *Mission Dolores is one of the original Spanish missions in California, and the oldest church in San Francisco, although the Basilica was rebuilt following the 1906 earthquake.*

As I explored Mission Dolores Basilica in San Francisco, I saw that inside the church light was coming from two sides. Beams of light were shining through the rows of pews to the right and were interacting with the shadows cast by the pews and the stronger light from the windows on the left. The shapes and lines intrigued me, so I got down on the ground to find the best angle to photograph this interesting lighting effect. As I framed the photograph, I decided to leave only enough of the pews in the upper-right corner so that the scene could be identified.

Of course, the photo was taken in color, so I carefully processed it that way at my computer. But the strong contrasts of the lights and darks were what made this composition work, so I converted the image to black and white to emphasize the image of the striking cross-lighting (see pages 167–173 for more about monochromatic processing of color photos).

170mm, five exposures with shutter speeds ranging from 1 second to 60 seconds at f/16 and ISO 200, tripod mounted; converted to monochrome using Photoshop and Nik Silver Efex 2.

lines created by light or shadows? And if you "frame" a photo with your fingers, how does your perception of the shapes change?

Now, shift your position. It could be just a step to the right or left. You don't have to go far. How does this change your perception of light in the scene?

From the viewpoint of the digital photographer, as light creates subjects that can be photographed by illuminating them, and the shadows of these subjects, pixel-based shapes that can be manipulated are created in your digital files.

If you have observed light closely the way a painter does, you'll begin to have some ideas about how light can be rendered in post-production to appear natural.

Shooting in low light

There's no doubt that light is all-important to photography. But there doesn't have to be much of it. With light, it is quality and not quantity that counts. A digital camera can adjust for almost any level of light. When you are looking at the output of a digital camera, it can be hard to know how bright the light actually was once the exposure has been adjusted. I've taken many shots that appear to be shot in daylight but in fact were made at night.

▶ *Within the Mission Dolores Basilica in San Francisco, the chiaroscuro illumination with its moody contrasts between light and dark got my full attention. I angled my camera to take the best advantage of the contrast between lights and darks and the contrast between the lines of light and the rest of the church interior.*

42mm, six exposures with shutter speeds ranging from 1 second to 60 seconds, each exposure at f/18 and ISO 200, tripod mounted; exposures combined in Photoshop and then converted to monochrome using Photoshop and Nik Silver Efex Pro 2.

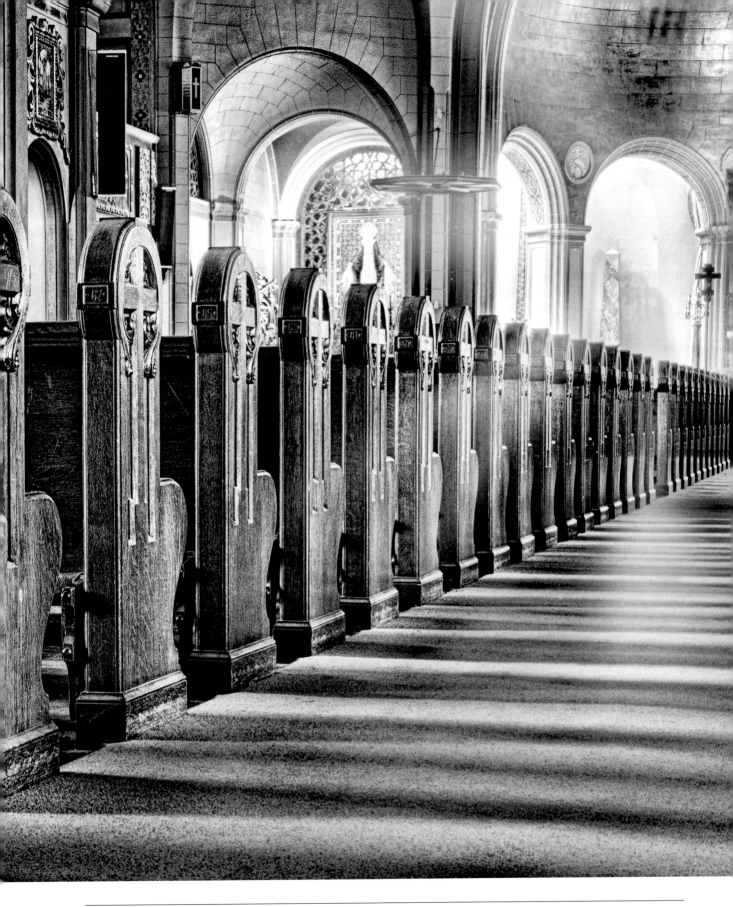

Here are some simple examples of effects that are easily possible in post-production:

- Fill lighting can be added to brighten the foreground of a composition.

- Flower petals can be lightened to emulate translucency.

- Lights can be lightened and darks darkened to enhance a chiaroscuro lighting effect.

The goal of this first section of *The Way of the Digital Photographer* is to show you some simple Photoshop ways to improve the quality of the lighting in your digital photo by combining the vision of a digital painter with the skills of a photographer.

Meditation

Take time looking at something, and observe how light and shadow interact. Then, make a photo that is mainly about the light you observe, and not primarily about the objects that are reflecting or emitting light in the scene. For example, the photo on page 26 primarily shows the shadows created by cross-lighting within a church, and this abstract play of light and shadow is the subject of the image, with only a small portion of the photo devoted to the literal subject matter, the church pews.

▶ *High above New York City's East River, I had to brace my camera and tripod against a strong wind. The vantage point was fantastic and I almost felt like I was in an eagle's eyrie. However, the mass of the East River seemed overly dark and visually uninteresting. Processing this photo I enhanced the dark areas of the river by selectively overexposing the reflective lights, creating a festive and painterly effect.*

24mm, 25 seconds at f/7.1 and ISO 200, tripod mounted.

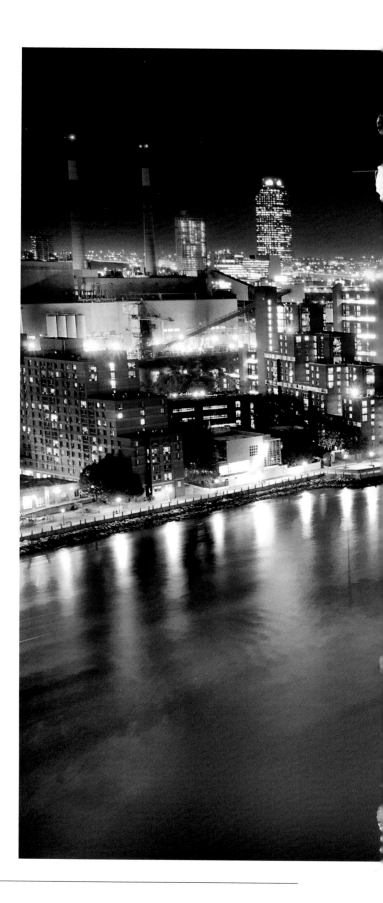

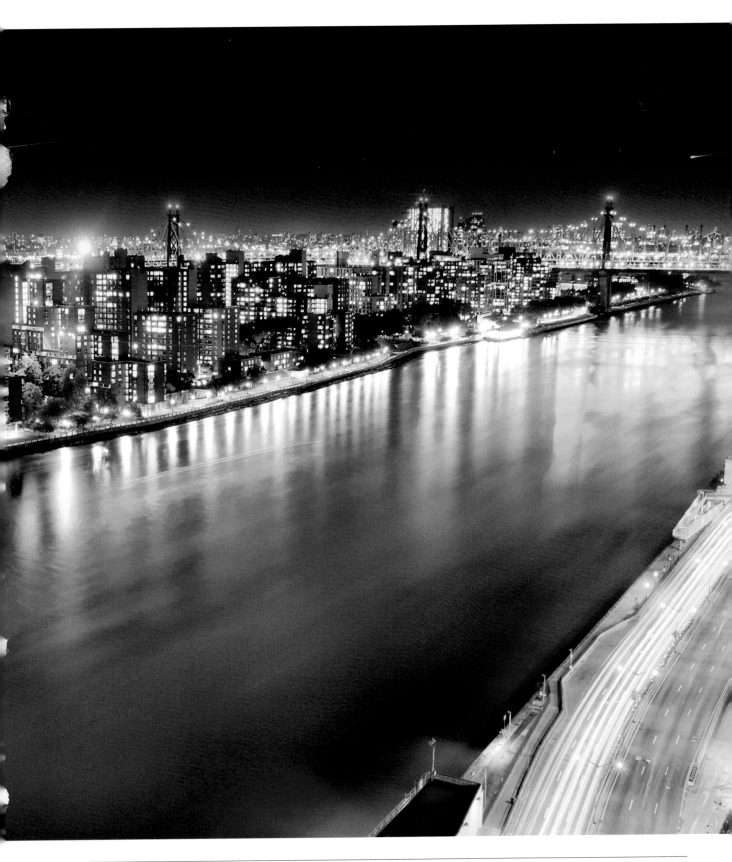

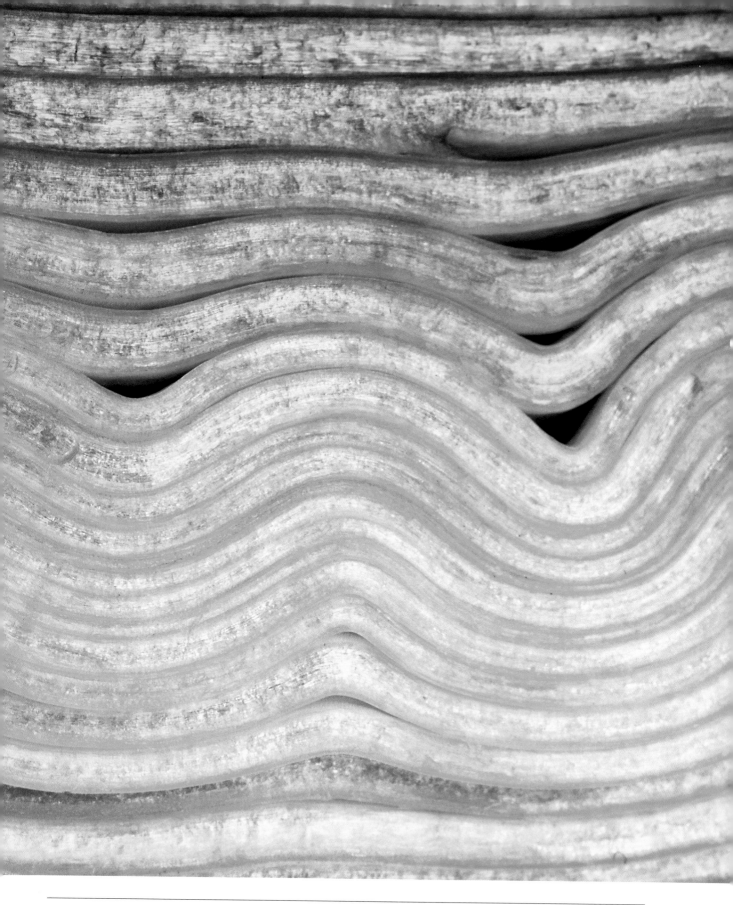

It all starts with a layer

Okay. Let's recap a bit. I started by observing that photographs cannot be taken in darkness, or of a subject that is unlit because exposures actually capture light that is emitted or reflected by objects (see page 27) rather than the objects themselves.

Once you understand that in a significant sense the subject of any photo is light itself, then you'll understand the necessity of starting to make sense of the patterns of light—and the absence of light—that make up any photo.

Good observation of these patterns makes for compelling compositions at the time of exposure. Beyond the initial exposure, enhancing a digital

◄ *This leek, like many things in nature such as plants and geologic formations, is composed of layers. The view you see in this photo is a cross-section, clearly showing the layers. However, if you looked at the leek from the top down, you would see only the topmost layer. Pursuing this analogy a little further, leeks are a member of the onion family and often have some degree of transparency. If the topmost layer of the leek were partly transparent—or removed—you would begin to see the layers farther down the leek's layer stack. This is pretty much the way layers work in Photoshop.*

By the way, my wife was cooking soup when I saw this cross-section of leek on the cutting board. I quickly removed (i.e., stole) it to my studio. When my wife regained possession of the leek in question, it turned out to be quite tasty when added to the soup.

40mm macro lens, 2.5 seconds at f/29 and ISO 100, tripod mounted.

photo in post-production means enhancing these patterns, and bringing out the internal coherence of the patterns of light. If you are skillful—or lucky—that coherence was there in the first place; but, it may not be apparent except to an adept in the way of the digital photographer.

Understanding the possibilities of manipulating light in post-processing informs the digital photographer at the point of exposure by making it reasonable to take chances on light patterns that need post-production "teasing" to be made manifest.

This conceptual approach holds true across many kinds of photography, whether you like to shoot landscapes, flowers, or portraits.

But to make the concept a reality, you'll need a post-processing scaffolding. It turns out that this scaffolding is easily available, and starts with the *layer*.

A layer can be thought of as a transparency on which images, portions of an image, or imaging effects are applied and placed over or under an image. Layers have been available in Photoshop since 1994, and are an integral feature of most powerful image-editing software programs.

Every time you open a photo in Photoshop it becomes a layer. Photoshop documents are made up of layers that are stacked on top of each other. At the end of the day, what I end up with in Photoshop after processing an image (and before printing it) is a stack of layers that have been precisely aligned. Technically, these layers have to be flattened—reduced to a single, combined

layer—before an image can be reproduced or printed.

A Photoshop layer has literally hundreds of properties—meaning, characteristics—that can be set. My plan in *The Way of the Digital Photographer* is to keep things simple. To understand the way layers work, you really don't need to know anything about most of these characteristics. But there are a few things you do need to know about Photoshop layers to get started.

When you open an image in Photoshop for the first time, the image automatically becomes a special kind of layer within a Photoshop document. This special kind of layer is called a *Background layer*, and is denoted as such in the Layers panel (if you don't see the Layers panel, press F7).

Background layers can easily be converted to normal layers by choosing Layer ▸ New ▸ Layer From Background.

One important property of Photoshop layers is the layer *Opacity* setting, which controls the translucency of the layer. For example, with 100% Opacity there is no layer translucency, at 0% Opacity the layer is completely transparent, and at 50% Opacity the layer is 50% translucent.

As I've noted, Photoshop documents are made up of a layer stack. When you bring a photo into Photoshop, it becomes the Background (bottom) layer of the stack. The screen shots shown to the right give an idea of how a stack of layers works. You'll also see part of the stack of layers shown in the Photoshop Layers panel that I used to create the image of the Jaguar wheels shown on pages 36–37.

Meditation

If the top layer of a layer stack is translucent because it has less than 100% opacity, what do you see in the image window?

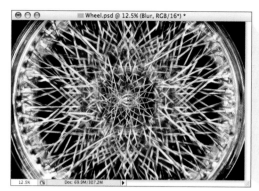

The "Blur" layer is at the top of the layer stack.

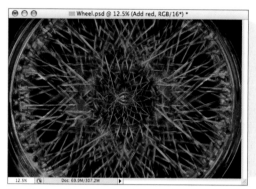

The "Add red" layer, second down in the layer stack.

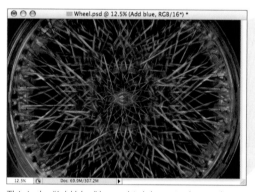

This is the "Add blue" layer, third down in the stack.

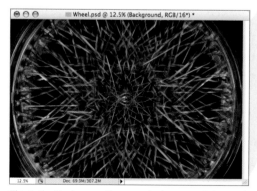

This is the Background layer at the bottom of the stack.

Below is the Layers panel showing four layers: a "Background" layer at the bottom of the layer stack, an "Add blue" layer, an "Add red" layer, and on the top, a "Blur" layer. A thumbnail image gives a quick look at each layer.

The "Background" layer is highlighted in blue because it is selected. When a layer is selected, it is the *active* layer—meaning that any editing, such as painting, will happen on that layer.

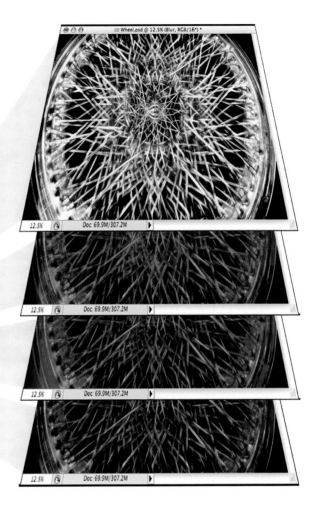

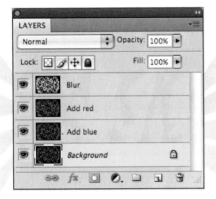

As a general practice, it is always good to name layers meaningfully. That way, if you come back to work on an image at a later date, you have some idea of what each layer does.

At the top left of the Layers panel is the Blending Mode drop-down list. By default this is set to Normal. (For more about the power of blending modes, turn to pages 71–95.)

To the right of the Blending Mode drop-down list is the Opacity slider. The default setting is 100%. You can use this to adjust how transparent or opaque a layer is. Select a layer and drag the slider to the left to reduce the layer's opacity.

The small eyes to the left of each layer show that all the layers are visible. If you click on an eye, that layer will become hidden.

It's easy to confuse hiding a layer using the eye with layer transparency set using the Opacity slider. These two are very *different*. When you use the eye to hide a layer, it is no longer

available for editing and becomes *inactive* (even though it is still there in the layer stack). You can't paint on it, or copy or select it, and it isn't included in the rendered image. When you make a layer transparent using the Opacity slider, the layer is still active. You can paint on it and manipulate it in any way that you like—and, provided it has at least some opacity, it will be included in the image as it is displayed.

Meditation

Yoda says, "Do or do not. There is no try." Plunge in. Don't hesitate to play around with the settings in the Layers panel. One only learns by doing, and experimentation is the best teacher.

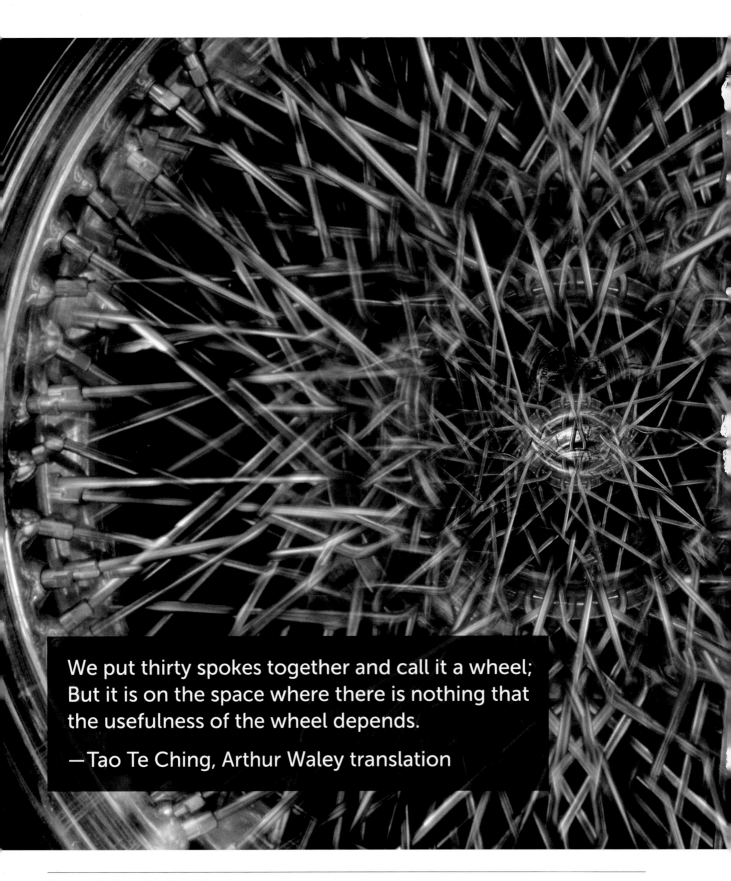

We put thirty spokes together and call it a wheel;
But it is on the space where there is nothing that
the usefulness of the wheel depends.

—Tao Te Ching, Arthur Waley translation

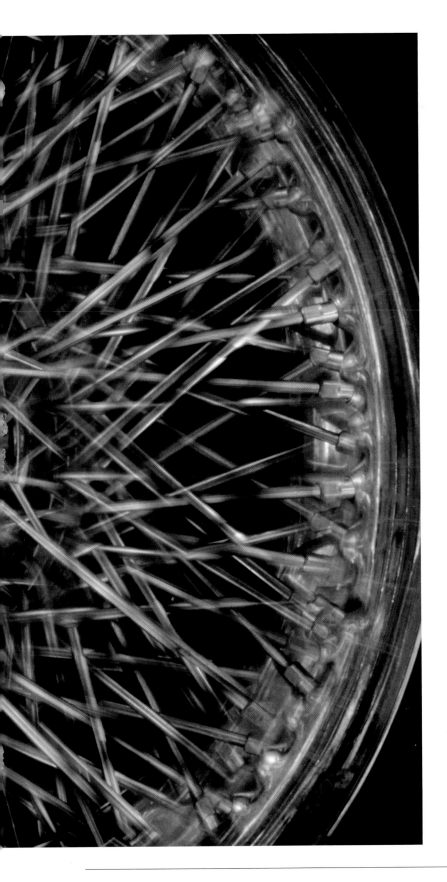

You may think that the purpose of a stack of layers is to control which parts of different layers are used in a final image; for example, I created a composite image including the sun as part of a landscape, where previously there was no sun. Certainly, layers are used in this way as part of compositing technique—but as the single core feature of Photoshop, layers are also used in many other ways. Compositing to create "impossible" imagery is a major subject by itself and will not be covered in *The Way of the Digital Photographer,* as there are other books on this topic (see the Notes section on page 188 for a suggestion).

The best way to think of a layer stack is from the top down. If the layer on the top of a stack has 100% opacity overall (and is blended normally), then the image is entirely made up of the top layer on the stack. In this situation, you could delete all the layers underneath the top layer on the stack without changing the appearance of the image.

◀ *I shot this image of the wheel of an antique Jaguar in the driveway of a classic car collector. Looking at the photo on my computer, I decided that the spokes in the complex wheel needed more color as well as a motion blur. I used many different layers to add the color and blur effects; some of the layers are shown in the Layers panel on pages 34–35.*

85mm, 4/5 of a second at f/45 and ISO 100, tripod mounted.

Each layer can be associated with a *layer mask*. Another term for a layer mask is an *alpha channel*—if you really want to impress your non-Photoshop-savvy friends, just start dropping "alpha channel" into your casual conversation!

The purpose of a layer mask is to control how much of the associated layer is visible. Layer masks are monochromatic in nature. They only care about whites and blacks, and values on the grayscale.

A white layer mask means the associated layer is entirely visible, and a black layer mask means the associated layer is entirely hidden. I like to use the mnemonic "White reveals, and black conceals" in connection with the layer that is connected to the mask.

A layer mask that is 50% gray is 50% revealed.

The blacks, whites, and grayscale pattern you apply—by digital painting or some other mechanism—to a layer mask controls which areas of the associated layer are visible, which are partially visible, and which are invisible.

I'll be walking you through the mechanisms of how I work with layers, layer masks, and layer stacks in a few pages. Don't worry! This part of the journey is really quite straightforward. But in the meantime, I think a simple layer example would be helpful to lock in the crucial concepts that I just explained.

If you've ever photographed San Francisco's magnificent Golden Gate Bridge, you'll know that some of the best vantage points are from the old fortifications along the Marin Headlands, across the Golden Gate from the city of San Francisco. These old forts are great for exploration, and also provide plenty of foreground contrast to the Golden Gate Bridge in the background.

Photographing as the sun goes down, or even well after sunset, this contrast can be problematic. Usually, the detail in the foreground is lost in deep shadow, while the Golden Gate Bridge in the background picks up the last light of twilight, and is illuminated in any case.

For example, when I was scrambling around Battery Spencer with camera and tripod I saw a composition that I thought would work, with the foreground detail juxtaposed with the bridge in the background. But when I exposed for the fortifications (right) the bridge was overexposed. A second exposure for the bridge made the foreground details completely black and under-exposed (far right).

The answer was to combine the two exposures using layers, a simple layer mask, and a gradient (turn to page 59 for information on how to work with gradients). This created the dramatic image shown on pages 40–41 that shows detail in the foreground as well as the Golden Gate Bridge against a dramatic night sky.

Adjustment layers

Adjustment layers are an important and special kind of Photoshop layer that essentially are a gloss on the layer below rather than a layer themselves. Adjustment layers have some very real technical advantages compared to normal layers (for one thing, they take up less space on your computer than a normal layer). Like normal layers, they can be associated with a layer mask. However, to keep the material in *The Way of the Digital Photographer* conceptually simple—and also applicable to other image-editing programs besides Photoshop—unless otherwise noted I'll be showing you how to work with normal layers rather than adjustment layers.

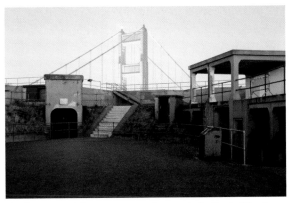

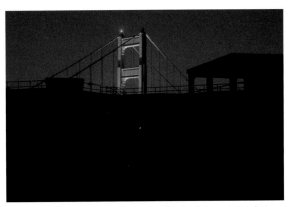

The first image I shot was exposed correctly for the fortifications in the foreground, but overexposed the Golden Gate Bridge in the background. (Who would guess that it was pitch black?)

The second image exposed correctly for the bridge, but left the foreground completely black. The answer to these exposure problems is to seamlessly combine the two images.

First, I put both images in a layer stack in Photoshop with the darker bridge image on the bottom and the fortification image above (right). (Turn to pages 33–38 for a general discussion of layers and layer stacks, and turn to pages 44–45 for instructions about how to combine two different photos in a singe document with two stacked layers.)

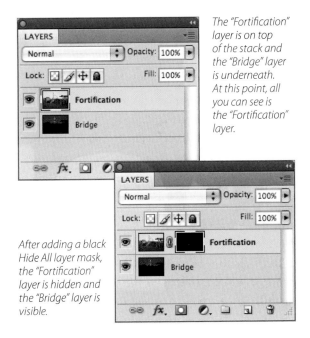

The "Fortification" layer is on top of the stack and the "Bridge" layer is underneath. At this point, all you can see is the "Fortification" layer.

Next, I added a black Hide All layer mask to the "Fortification" layer (center right). (For more about working with layer masks, turn to pages 43–47.)

After adding a black Hide All layer mask, the "Fortification" layer is hidden and the "Bridge" layer is visible.

Finally, I used the Gradient Tool to drag a black to white gradient from top to bottom on the layer mask (pages 59–63). This hid the overexposed bridge on the "Fortifications" layer and revealed the correctly exposed bridge from the "Bridge" layer (bottom right). This created the correctly exposed composite image shown on pages 40–41.

Once a gradient is drawn on the layer mask, the black area of the mask hides the overexposed bridge on the "Fortification" layer, and makes the correctly exposed bridge from the "Bridge" layer visible.

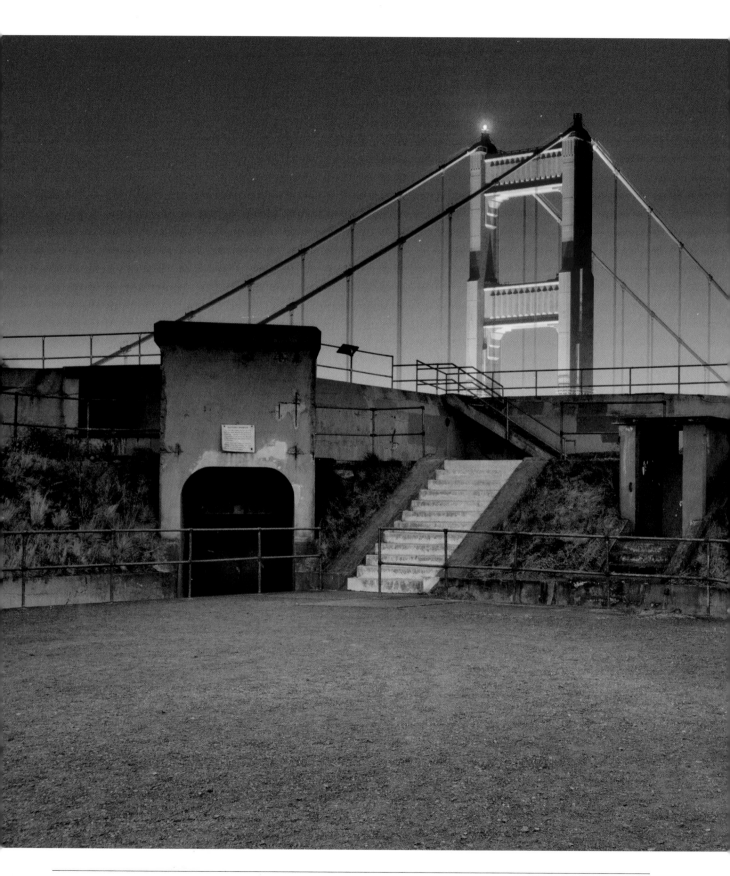

◄ On a dark but clear night, I scrambled around Battery Spencer, an old fortification finished in the late 1800s and abandoned after the end of World War II. The fort is located in the Marin Headlands right next to the Golden Gate Bridge and is across the bay from San Francisco.

As I walked around the fort, climbing stairs and exploring, I kept looking at the Golden Gate Bridge. There are millions of photographs of the bridge, but I was on the lookout for a different angle that would show a different point of view.

Settling in below the area where the second gun emplacement used to be, I pulled out my tripod and set up my camera. Looking around, I could see the bright red-orange tower of the bridge above me, but the area of the fort right in front of me was pitch black. This was a bit of an exposure conundrum.

The only way I was going to be able to create an image that showed both the fort in the foreground and the tower in the background was to shoot two photos—one exposed properly for the bridge and one exposed for the fort. Later, when I returned to my studio, I knew I could combine the two images in Photoshop to create a composite image showing both the foreground and background.

Knowing that I could combine two exposures (as explained on page 39) using layers and a layer mask allowed me to conceptualize an image with my "boots on the ground" that would never have occurred to me without immersion in the way of the digital photographer.

31mm, two exposures, one exposure at 15 seconds and one at 60 seconds, both at f/8 and ISO 200, tripod mounted; exposures combined in Photoshop.

Working with layer masks

The point of using aligned layers in a layer stack becomes apparent when one uses layer masks to control which parts of each layer are shown in the final image.

To add a Hide All layer mask to a layer, with the layer selected, choose Layer ▸ Layer Mask ▸ Hide All. A layer mask that is entirely black appears attached to your layer, as you can see below. This means that the layer will be entirely cloaked or hidden until you begin to reveal it by painting in white or gray on the layer mask.

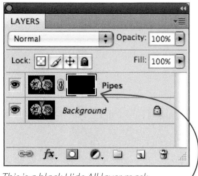

This is a black Hide All layer mask attached to the "Pipes" layer.

◄ *I was walking around an industrial neighborhood in West Oakland, California, when I came across a fenced-in lot filled with giant pipes and an ancient-looking rusty crane.*

I found a large man-sized hole in the fence, so I walked in and started to explore. I liked looking through the pipes to view the graffiti and got to thinking about the image I wanted to create. I realized that I needed to underexpose to capture the vibrant colors of the graffiti, while at the same time I wanted to see the contours of the pipes. How did I solve this exposure challenge?

To add a Reveal All layer mask to a layer, with the layer selected, choose Layer ▸ Layer Mask ▸ Reveal All. A layer mask that is entirely white will be added to your layer. This means that the layer will be entirely revealed until you partially conceal it by painting in black or gray on the layer mask.

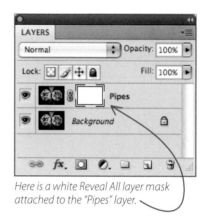

Here is a white Reveal All layer mask attached to the "Pipes" layer.

By the way, you can't attach a layer mask to a Background layer because this layer automatically is locked by Photoshop. In order to attach a layer mask, you need to change the Background layer to a regular layer by selecting Layer ▸ New ▸ Layer From Background.

White or black? That is the layer mask question. Actually, the two can be thought of as logically equivalent: in any layer stack the same visual effect can be achieved using either a Hide All (black) or Reveal All (white) layer mask if you shift the order of the layers. So the question essentially comes down to asking which path is more natural, and involves less effort. Which type of layer mask will require less work?

Creating a layer stack

Let me show you how layer masks work in the context of a real-life example.

I was shooting in a decayed industrial neighborhood in West Oakland, California, when I came across the large pipes and graffiti shown in the final images on pages 42 and 48–49.

It was clear to me that I needed to underexpose to fully capture the vibrant colors and saturation of the graffiti art. At the same time, I knew I would want to see some details in the contour and rim of the pipe. Planning for this digital exposure challenge, I shot twice: once for the art (at 1/15 of a second, top right), and once for the pipe rim (at 1/4 of a second, right).

When I got the images home, the fun started in Photoshop.

1. First, open both images in Photoshop. This means that each image will be in a separate image window. (If your images open in a single, tabbed window in Photoshop, reset this default by selecting Photoshop ▸ Preferences ▸ Interface on Mac or File ▸ Preferences ▸ Interface in Windows and then unchecking Open Documents as Tabs.)

2. Select the Move Tool from the Tool panel.

3. Click the image window that contains the photo you would like on the top of the layer stack. This will be the *source layer*. For this example, the lighter pipe rim photo is the source layer.

4. Choose Select ▸ All to select the entire pipe rim photo.

5. Next, select Edit ▸ Copy to copy the entire image.

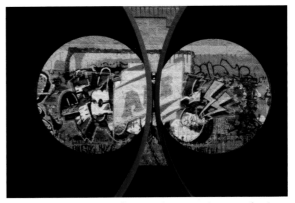

I shot this photo at 1/15 of a second to properly expose for the bright graffiti seen through the pipes.

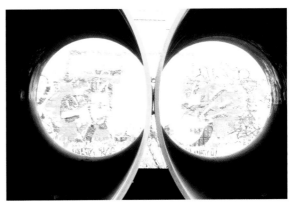

I carefully took this second photo to correctly expose for the pipe rims. The overexposed graffiti doesn't matter, because it will not be visible in the final image.

Choose Select ▸ All to select the entire photo. A moving, dashed line will appear at the edges of the image window, showing that the entire image is selected. This moving, dashed selection is sometime referred to as "marching ants."

When you select Edit ▸ Copy, Photoshop copies the area that you previously selected. In this case it is the entire photo in the image window.

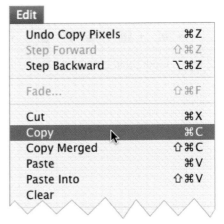

6. Click the image window that contains the photo that will be on the bottom of the layer stack to make it active. This will be the *target* layer. For this example, the graffiti photo is the target layer.

7. Choose Edit ▸ Paste to copy the pipe rim photo into the graffiti photo window. You now have two layers in the Layers panel. For this example, the layers are named "Light Rim" and "Graffiti." At this point, only the "Light Rim" layer is visible in the image window. The "Graffiti" image is hidden underneath.

 In the next set of steps, you will use a black Hide All layer mask attached to the "Light Rim" layer to let you decide which portions of the upper "Light Rim" layer will be visible in the final image.

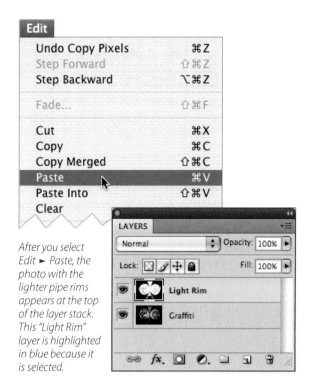

After you select Edit ▸ Paste, the photo with the lighter pipe rims appears at the top of the layer stack. This "Light Rim" layer is highlighted in blue because it is selected.

Combining two exposures with a Hide All layer mask

1. Click on the "Light Rim" layer in the Layers panel to make sure it is selected. (When it is selected, it is highlighted in blue, as shown above right in the Layers panel.)

2. Select Layer ▸ Layer Mask ▸ Hide All. A black Hide All layer mask will appear attached to the "Light Rim" layer. Also, since the Hide All layer mask hides the layer it is attached to, the "Light Rim" layer will no longer be visible in the image window. (It's still there, though!) You will now be able to see the "Graffiti" layer in the image window.

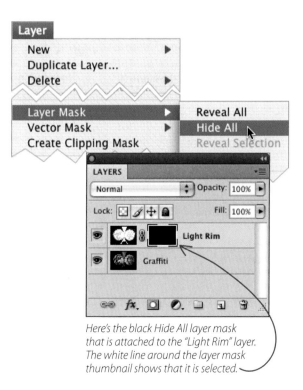

Here's the black Hide All layer mask that is attached to the "Light Rim" layer. The white line around the layer mask thumbnail shows that it is selected.

Meditation

Is there ever a reason to create a layer stack in which the layers are not precisely aligned?

3. Select the Brush Tool from the Tool panel and set the Brush Tool to the width of the pipe rims. Set the Foreground color in the Tool panel to white and the Brush Tool's Hardness setting to 0%. Then, use the Options Bar to set the brush Opacity to 50% and the Flow to 50%. (For more about the Brush Tool and its settings, turn to pages 51–57.)

4. With the black Hide All layer mask selected in the Layers panel, use the Brush Tool to paint in the image window along the pipe rims (don't try to paint on the layer mask thumbnail in the Layers panel).

 Zoom in as close as you need to in order to see the pipes. As you paint with white on the black layer mask, the area on the "Pipe Rim" layer will become visible. If you need to, you can also alter the size and opacity of the brush as you paint.

 When you are finished painting, the layer mask will probably look something like the one shown to the right.

 The finished Oakland Pipes image is shown on pages 48–49.

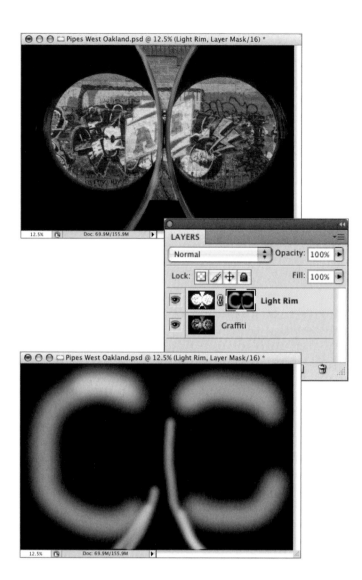

Meditation

Since you can get equivalent results using a black Hide All layer mask as shown above or using a white Reveal All layer mask as shown on page 47 if you reverse the order of the layer stack, which one is best to use?

Hint: It is always important to have a plan that is coherent and makes sense in relationship to a particular image. How much are you going to have to paint if one layer is on the top of the layer stack instead of the other layer?

▼ PAGES 48–49: *Wandering around a deserted industrial area near the West Oakland docks, I came across some large, apparently abandoned pipes in a field covered with weeds and surrounded by walls that had been painted with graffiti. I used a telephoto focal length to compress a composition showing the saturated graffiti, making several exposures to get the details I wanted. In Photoshop, I processed one of the images for the fully saturated paintings, then painted in the outline of the pipes from a lighter exposure (as explained in the text).*

130mm, two exposures, one at 1/4 of a second (lighter) and one at 1/15 of a second (darker), both exposures at f/36 and ISO 200, tripod mounted; exposures combined in Photoshop.

Using a Reveal All layer mask to combine two exposures

As I noted back on page 43, if you reverse the order of your layers in the stack—putting the "Graffiti" layer on top and the "Light Rim" layer underneath—you could use a white Reveal All layer mask and come up with the same results as shown on page 46.

To demonstrate this with the Oakland Pipes image:

1. Put the "Graffiti" image on the top of the layer stack by dragging the layer up in the Layers panel. This leaves the "Light Rim" layer on the bottom.

2. With the "Graffiti" layer selected in the Layers panel, select Layer ► Layer Mask ► Reveal All. A white Reveal All layer mask will appear attached to the layer. The layer mask makes the "Graffiti" layer visible and hides the "Light Rim" layer underneath.

3. Select the Brush Tool from the Tool panel and set the Brush Tool to the width of the pipe rims. Set the Foreground color in the Tool panel to black and the Brush Tool's Hardness setting to 0%. Then, use the Options Bar to set the brush Opacity to 50% and the Flow to 50%.

4. With the white Reveal All layer mask selected in the Layers panel, paint in the image window along the pipe rims. As you paint with black the lighter pipe rims from the "Light Rim" layer will become visible.

It is worth taking a moment or two to compare the two scenarios—using a black Hide All layer mask (page 46) and a white Reveal All layer mask—until you are sure you understand why the two approaches lead to an identical result. The finished image is shown on pages 48–49.

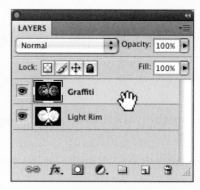

Reverse the layer stack. In the Layers panel, drag the "Graffiti" layer to the top. This puts the "Light Rim" layer on the bottom.

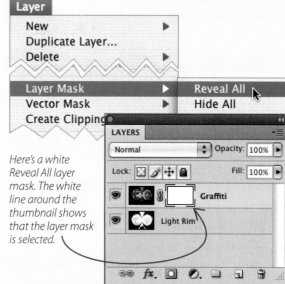

Here's a white Reveal All layer mask. The white line around the thumbnail shows that the layer mask is selected.

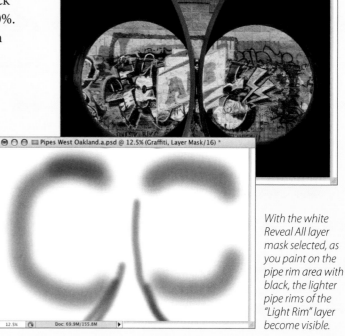

With the white Reveal All layer mask selected, as you paint on the pipe rim area with black, the lighter pipe rims of the "Light Rim" layer become visible.

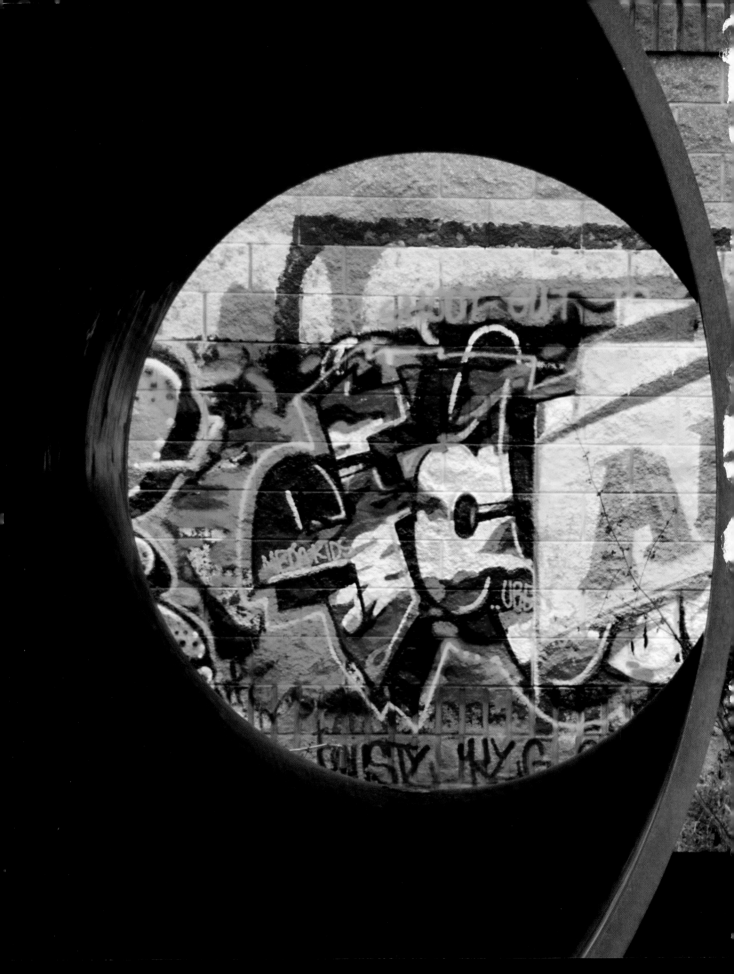

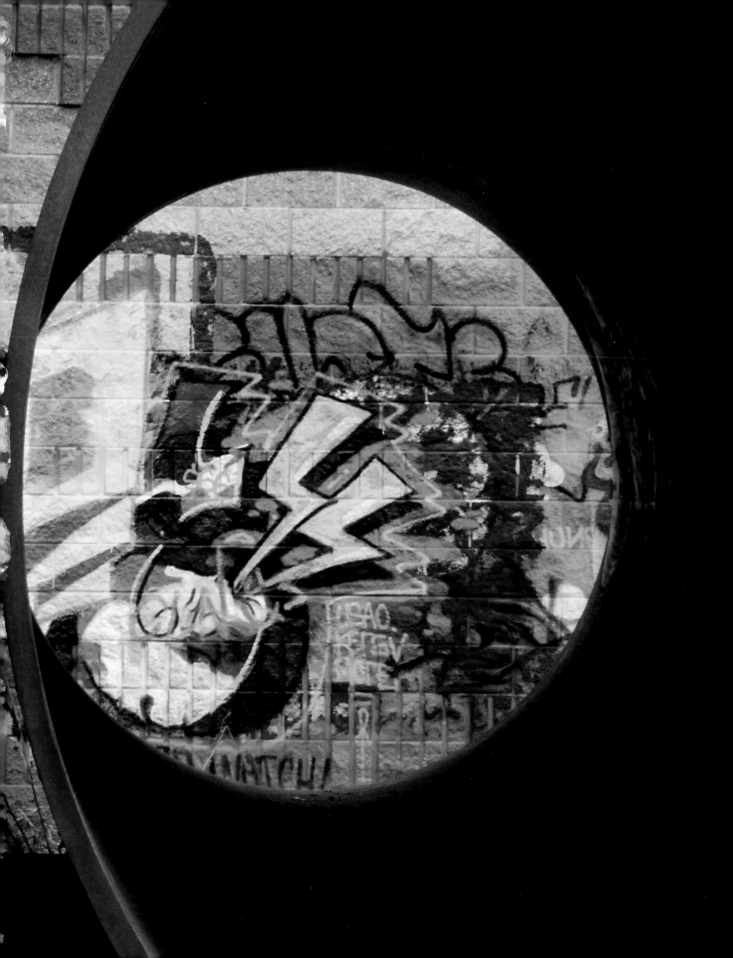

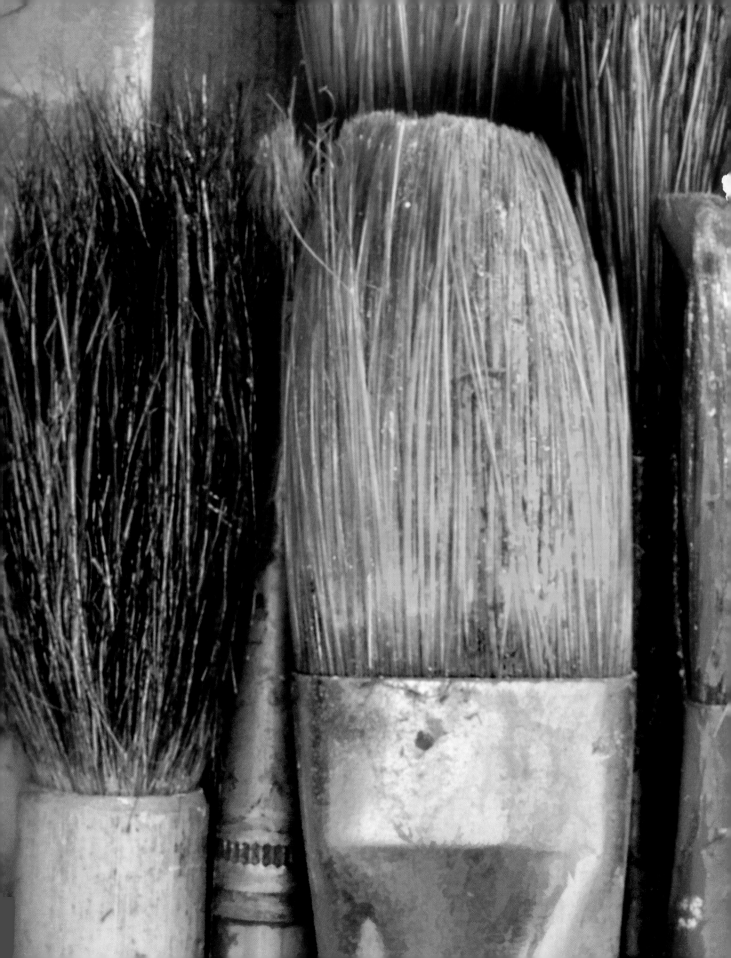

Using the Brush Tool

An artist is a dreamer consenting to dream of the actual world. —George Santayana

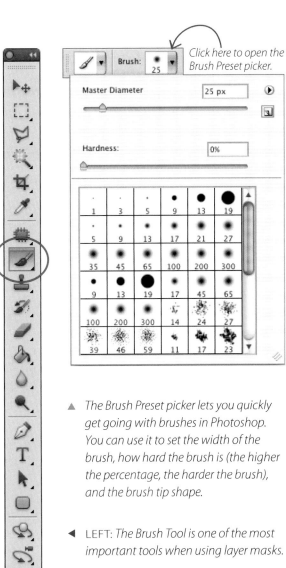

Click here to open the Brush Preset picker.

▲ *The Brush Preset picker lets you quickly get going with brushes in Photoshop. You can use it to set the width of the brush, how hard the brush is (the higher the percentage, the harder the brush), and the brush tip shape.*

◀ LEFT: *The Brush Tool is one of the most important tools when using layer masks.*

◀ FAR LEFT: *In this portrait of my painting brushes, I selectively sharpened the brushes. Also, I slightly blurred the background to make the brushes seem even sharper. With what you know so far about layers and layer masks, how do you think I did this?*

To recapitulate, layer masks determine how much of a layer shows in a final version of an image. A black layer mask conceals the layer it is associated with—and white or gray applied to that layer mask wholly or partially reveals the layer. Conversely, a white layer reveals the associated layer, with black or gray selectively hiding the layer—and revealing the layers beneath. (For more about layer masks, turn to pages 43–47.)

So how do you create the nuance in an otherwise solid layer mask? What tools do you use to reveal or hide parts of a layer?

The first tool I reach for when I create my layer masks is the Brush Tool. It is shown to the left in the Photoshop Tools panel, circled in red.

When you select the Brush Tool in the Tool panel, the Options bar at the top of the Photoshop screen changes, showing Brush Tool options. One of these is the Brush Preset picker, which displays the active brush tip (above left).

To open the Brush Preset picker, click the blue arrow. Using the picker, you can select several options. These include:

- Brush tip—There is a vast selection of possible brush tips and shapes that determine what is drawn by the brush.

- Diameter—The width of the brush tip.

- Hardness—The harder the brush, the more abrupt the edge transition is when you paint. I usually paint on layer masks with a very soft brush, from 0% to 10% hardness.

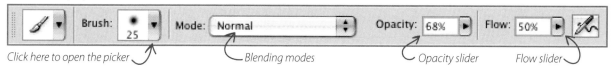

Click here to open the picker · *Blending modes* · *Opacity slider* · *Flow slider*

The Options bar (shown above) also sports several important Brush Tool settings:

- Blending Modes—Generally, I leave the Brush blending mode at Normal, and change blending modes at the layer level using the Layers panel. (Turn to pages 71–95 for an explanation of this very important feature.)

- Opacity—Controls the translucency of the brush (see page 35 for a further discussion about opacity).

- Flow—This sets how fast the virtual "paint" flows out of the Brush Tool. With layer masks, I like to leave Flow at 50% unless I am creating a solid, completely opaque effect.

Several different brush sets come with Photoshop. The one loaded by default into the Brush Preset picker is a basic set containing some round and square brushes, some star tips, and a few dry brushes.

You can load a different set of brushes into the picker by clicking the tiny arrow at the upper right of the picker, and selecting a brush set from the drop-down list (below).

Many of the brush tips in these different sets try to mimic real-world brush strokes that you would see in oil, acrylic, or watercolor painting, as well as textures that you would create if you were working with chalk, charcoal, or pastels.

As a small sample of what you can do with the Brush tool, I created some rectangular color shapes. I then picked several brush tips, each using a different color, to create the brush sampler shown below.

This is just a small sample of brush shapes and textures.

Click this tiny arrow in the Brush Preset picker to open a drop-down list containing many brush sets. Try experimenting with the different brushes that come with Photoshop.

After experimenting, if you want to load the Brush Preset picker with the default set of brushes, click the tiny arrow and choose Reset Brushes from the drop-down list.

Brushes are fun, easy to use, and powerful. Once you start experimenting with them, you'll find uses that go beyond layer masks—but painting on a layer mask is one of the most powerful possibilities in Photoshop for the digital photographer.

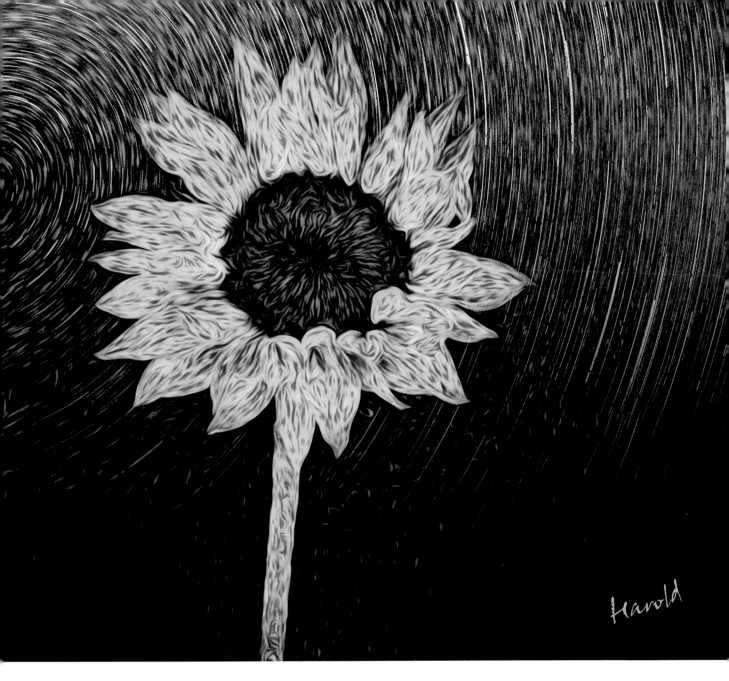

▲ *To create this homage to the great painter Vincent van Gogh, which I call Go van Gogh, I combined an image of a sunflower with an image of star trails at night. Starting with this composite image, I duplicated the Background layer. On the duplicate layer, I applied the Adobe Labs Pixel Bender OilPaint filter (see page 149) to create simulated brush strokes à la Vincent. Next, I used a black Hide All layer mask to hide the OilPaint effects, and then selectively painted in the brush strokes I wanted at a moderate opacity. To add that touch of simulated authenticity, I added a digital signature—in this case, "Harold" rather than "Vincent."*

Flower: 65mm, 4/5 of a second at f/32 and ISO 100, tripod mounted; Star trails: 10.5mm fisheye lens, 2 hours at f/2.8 and ISO 400, tripod mounted; images combined in Photoshop.

Selective sharpening

There are many reasons to sharpen an image, although sharpening probably won't save an image that is unintentionally out of focus. I like to differentiate between *output* sharpening and *aesthetic* sharpening.

Output sharpening is performed at the end of a workflow to meet the demands of a specific printing need. In contrast, aesthetic sharpening is intended simply to create a visual effect.

It turns out that folks viewing a photo look at sharp areas sooner and with more concentration than unsharp areas. So provided you don't overdo it, you can use selective sharpening to emphasize particular areas of your image, often without your viewers consciously realizing you have employed this tactic.

One of the most compelling things about the selective sharpening technique is that it operates subliminally—viewers usually don't even know they are responding to your technique.

For example, to create the image of paint brushes shown on page 57, I wanted to make the bristles and ferules on the brushes seem sharp while leaving the rest of the image was somewhat soft.

Here's how you can easily incorporate selective sharpening in your quiver of post-processing tools and techniques.

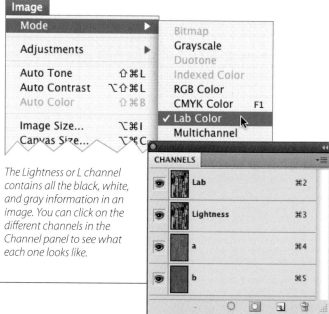

1. To get started, open the image you want to sharpen in Photoshop. For this example, the paintbrush photo on page 57 will be used.

 As you can see in the Layers panel to the right, there is one layer, the Background layer.

 Open the image you want to sharpen in Photoshop.

2. Select Image ▸ Mode ▸ LAB Color to convert the image from the RGB *color space* to the LAB color space. (For a discussion of color spaces, LAB color, and some of LAB's exciting uses, turn to pages 155–163.)

 If you take a look at the Channels panel, you will see that the LAB color space has three channels: Lightness (L), A, and B. (If the Channels panel is not available on your Photoshop desktop, choose Window ▸ Channels to open the panel.)

 The Lightness channel contains all the black and white color information for the photo from the darkest darks to the lightest lights. This is the channel that you will use to sharpen the image.

The Lightness or L channel contains all the black, white, and gray information in an image. You can click on the different channels in the Channel panel to see what each one looks like.

3. Duplicate the "Background" layer by selecting Layer ▸ Duplicate. A Duplicate Layer dialog box will open. Name the new layer something memorable. For this example, the duplicate layer is named "Selective Sharpening." You should now have two layers in the Layers panel, "Background" and "Selective Sharpening."

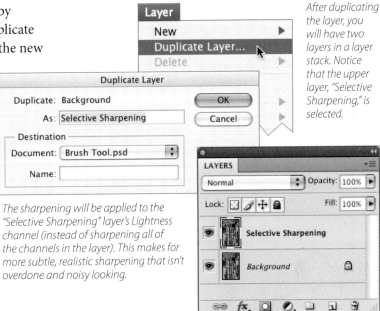

After duplicating the layer, you will have two layers in a layer stack. Notice that the upper layer, "Selective Sharpening," is selected.

The sharpening will be applied to the "Selective Sharpening" layer's Lightness channel (instead of sharpening all of the channels in the layer). This makes for more subtle, realistic sharpening that isn't overdone and noisy looking.

4. Make sure the "Selective Sharpening" layer is selected in the Layers panel. Then, click the Lightness channel in the Channels panel to select it (it will be highlighted in blue).

 Notice that when you select the Lightness channel, the eyeballs next to the other channels disappear, and the photo in the image window appears gray. This is because the other channels that contain the color information, a and b, are inactive—the color is still there, though, waiting for later!

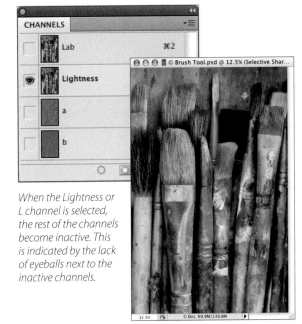

When the Lightness or L channel is selected, the rest of the channels become inactive. This is indicated by the lack of eyeballs next to the inactive channels.

5. Select Filter ▸ Sharpen ▸ Unsharp Mask.

 The Unsharp Mask filter works by increasing the contrast between pixels that are next to one another. This is a simulation of an old photographic technique that was used in the darkroom.

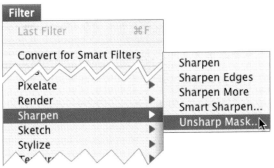

6. After selecting the Unsharp Mask menu item, an Unsharp Mask dialog box opens. There are three settings in this box: Amount, Radius, and Threshold.

When sharpening with the Unsharp Mask filter, start by setting the Threshold to 9 levels and the Radius to 4.0 pixels. Next, use the Amount slider to adjust the sharpening. Usually the Amount should be set between 50% and 100%. For this example, 80% works well.

Once you have the sharpness of the Lightness channel adjusted to your satisfaction, click OK to close the dialog box and apply the sharpening.

7. In the Channels panel, click the Lab channel to reactivate all the channels. The photo will now be in color in the image window.

8. In the Layers panel with the "Selective Sharpening" layer selected, add a black Hide All layer mask to the layer (step 2 on page 45).

9. Select the Brush Tool from the Tools panel and using the Options Bar, set both Opacity and Flow to 100% (page 52), and then press X to change the Foreground color to white.

10. With the layer mask selected in the Layers panel, paint on the areas you want to selectively sharpen in the image window.

If you like the sharpening, but it seems a bit too strong, you can reduce it by lowering the Opacity setting of the "Selective Sharpening" layer (page 35).

11. When you are pleased with the sharpening effect, flatten the layers by selecting Layer ▸ Flatten Image. Then return the photo to the RGB color space by selecting Image ▸ Mode ▸ RGB Color.

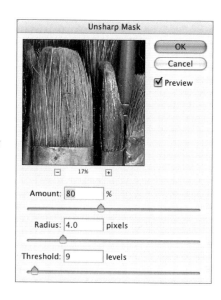

Use the Unsharp Mask dialog box to adjust the sharpening of the Lightness channel.

As you play with the sliders, make sure the sharpening doesn't become pixelated looking, introducing noise.

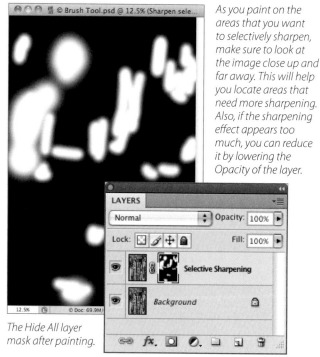

The Hide All layer mask after painting.

As you paint on the areas that you want to selectively sharpen, make sure to look at the image close up and far away. This will help you locate areas that need more sharpening. Also, if the sharpening effect appears too much, you can reduce it by lowering the Opacity of the layer.

▸ *To create this image of my well-used paintbrushes, I wanted to make the bristles and ferules seem sharp while the rest of the image was somewhat soft. To achieve this effect, I duplicated the original image's Background layer and sharpened the duplicate layer. I then added a black Hide All layer mask to the duplicate layer, and used the Brush Tool to selectively paint in the areas that I wanted to seem extra sharp.*

85mm macro lens, 8 seconds at an effective aperture of f/64, ISO 200, tripod mounted.

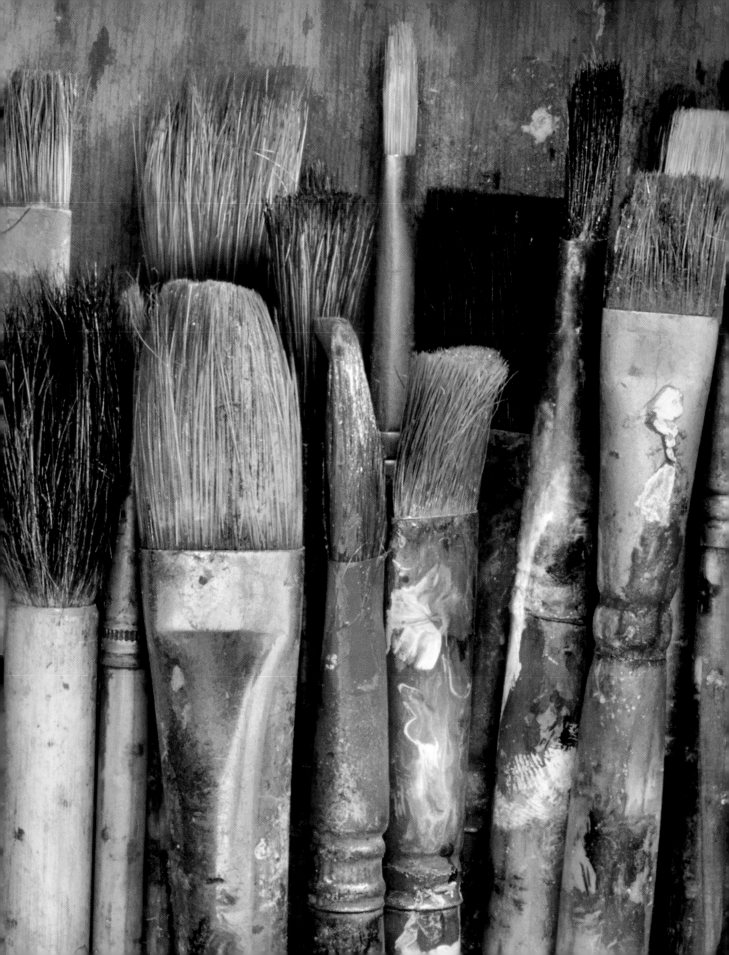

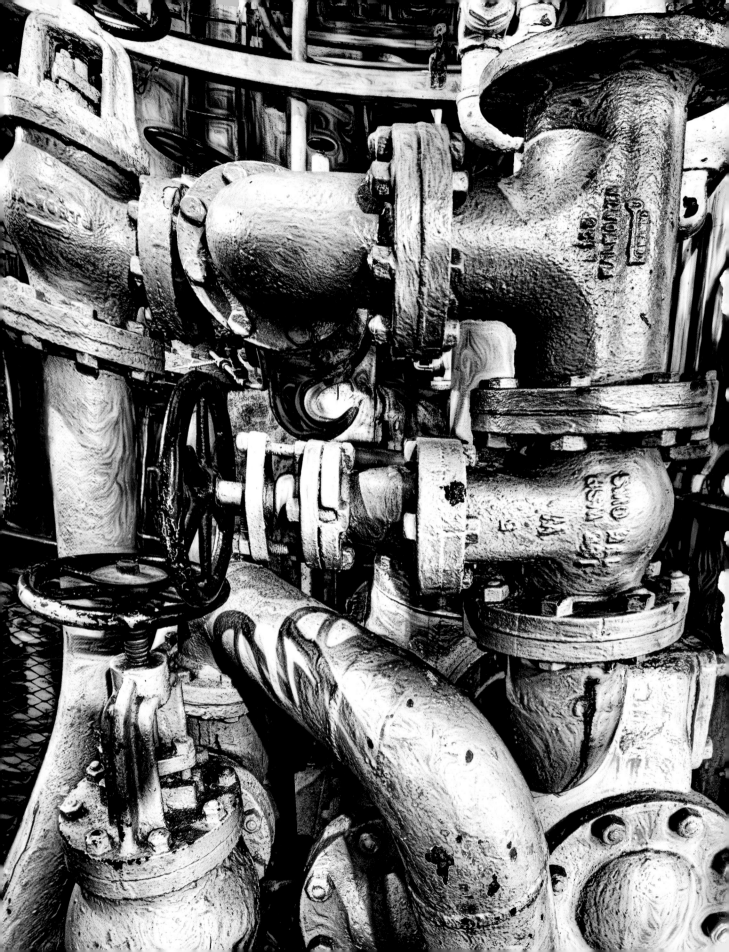

Working with gradients

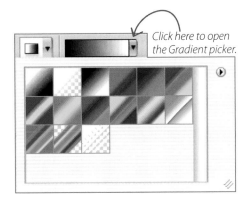

Click here to open the Gradient picker.

▲ *When you select the Gradient Tool from the Tool panel, the Gradient picker appears at the upper left of the Options bar. To open the picker, click the blue arrow. Most times, you'll use a black to white (or white to black) gradient on a layer mask.*

◀ LEFT: *The Gradient Tool can be used to create a smooth transition from white to black on a layer mask. This makes for a smooth transition on a layer of the part that is revealed and the part that is hidden.*

◀ FAR LEFT: *The steam sidewheel paddle ferry Eureka is from the 1890s. Moored in San Francisco's Maritime National Park, it is open to visitors.*

Aboard the Eureka, the only way I could photograph the massive engine room was with a wide-angle lens (12mm), which works to exaggerate the curvilinear shapes of pipes going in every direction.

12mm, 15 seconds at f/18 and ISO 200, tripod mounted.

Photoshop offers many tools that you can use to create layer masks, either by themselves or in combination.

As I said before, my first tool of choice for working on masks is the Brush Tool. But a very close second is the Gradient Tool. For some images, the Gradient Tool even beats the Brush Tool hands down. Landscape photos are particular grist for the Gradient Tool's mill because there can be great variation in exposure values between the earth and the sky, and you can blend them seamlessly using the Gradient Tool.

Gradient Tool setup works in a similar fashion to Brush Tool setup. To start with, choose the Gradient Tool in the Photoshop Tool panel (it is circled in red on the Tool panel to the left). Sometimes the Gradient Tool will be hidden behind the Bucket Tool since they nest under the same tool button. If you don't see it, press Shift+G to toggle between the Bucket and Gradient Tools in the Tool panel.

After selecting the Gradient Tool, the Gradient picker appears at the left of the Options bar at the top of the Photoshop window (in the same place as the Brush Tool picker described on page 52). Using the Gradient picker (above left), you can select a gradient that will suit your masking and blending needs.

Most of the time, for photographic applications on a layer mask, you can keep the choice of gradient simple and choose the first black-to-white (or white-to-black) pattern shown in the upper left of the default Gradient picker.

Using the Gradient Tool to seamlessly blend two layers

A typical situation where I would use the Gradient Tool on a layer mask is when I have two exposures that need to be blended together seamlessly. For instance, in the shot of Horseshoe Bend on the Colorado River taken at sunset (right), the upper photo is exposed correctly for the river, and the other photo is exposed for the sky.

By themselves, each photo doesn't quite work because one appears overexposed and the other underexposed. When combined together, so that the exposures for the sky and water are both correct, the composite image becomes something spectacular (shown on pages 62–63).

1. Open the two photos you would like to combine in Photoshop. For this example, I'll use the Colorado River photographs.

2. Select the Move Tool from the Tool panel.

3. Click the window containing the photo exposed for the sky (and underexposed for the river) and choose Select ► All.

4. Next, select Edit ► Copy to copy the entire image.

5. Click the image window containing the photo exposed for the river, and then choose Edit ► Paste to copy the sky photo into the river image window. (Turn to pages 44–45 to find detailed directions about this copy and paste procedure.)

 You will now have two layers in a stack. For this example, I've named the layers "Sky" and "River." The "Sky" layer is currently visible in the image window and the "River" layer is hidden.

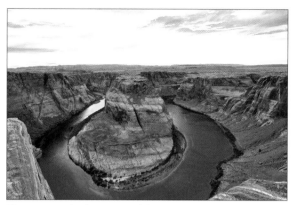

This exposure (with a 1-second duration) works well for the river and rock formations but is overexposed for the sky.

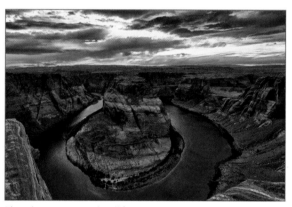

This photo is exposed well for the sunset sky (1/20 of a second duration), but is too dark for the water and rock formations.

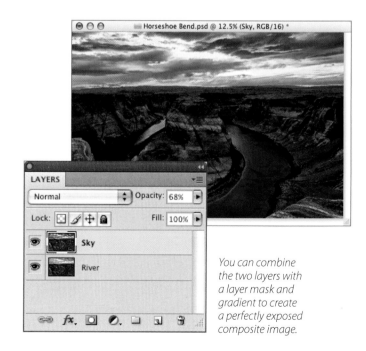

You can combine the two layers with a layer mask and gradient to create a perfectly exposed composite image.

6. Make sure the "Sky" layer in the Layers panel is selected and add a black Hide All layer mask (page 45, step 2).

The Hide All layer mask will hide the "Sky" layer and make the "River" layer visible in the image window.

At the bottom of the Tool panel, the Foreground color will automatically change to white and the Background color will change to black.

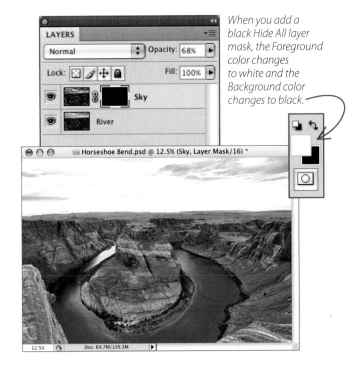

When you add a black Hide All layer mask, the Foreground color changes to white and the Background color changes to black.

7. Click the Gradient Tool in the Tool Panel to select it.

8. Open the Gradient picker (page 59) and select the gradient in the upper-left corner labeled "Foreground to Background."

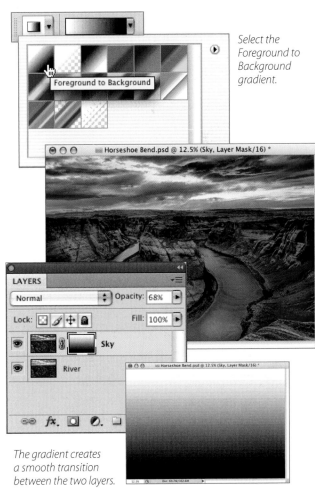

Select the Foreground to Background gradient.

9. With the layer mask selected in the "Sky" layer, position the Gradient Tool at the top of the image window, and click and drag the gradient down to the bottom of the image window.

This draws a white-to-black gradient on the layer mask that reveals the correctly exposed sky area of the "Sky" layer and reveals the correctly exposed rocks and river of the "River" layer.

To see the finished image, turn to pages 62–63.

The gradient creates a smooth transition between the two layers.

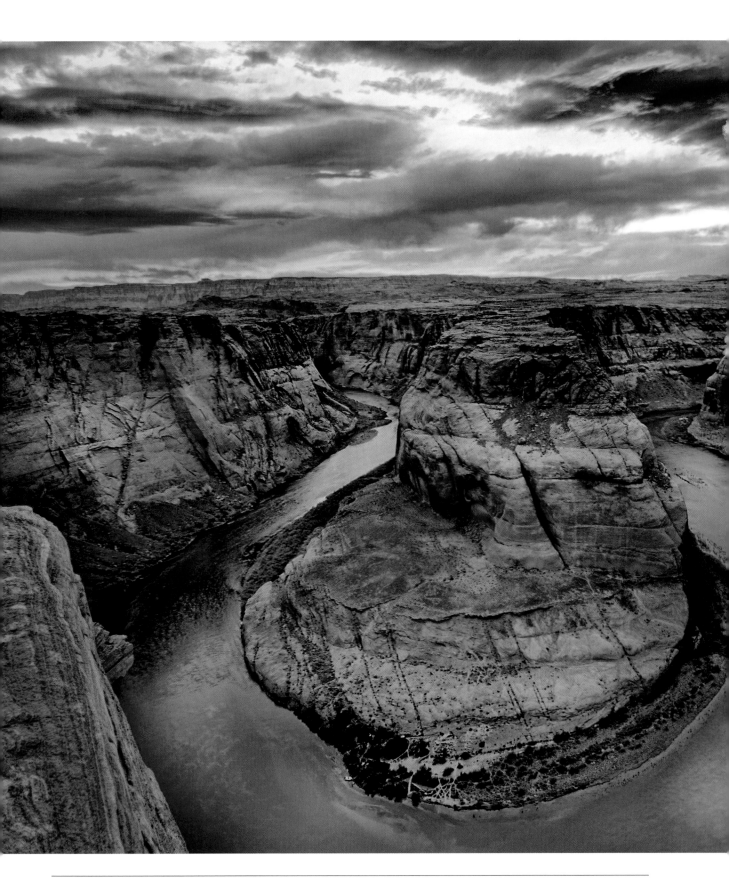

The Way of the Digital Photographer

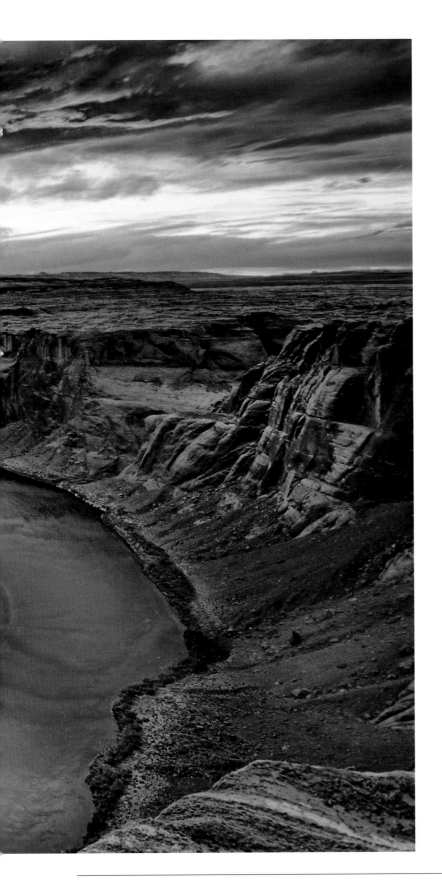

◀ *Thunder was booming along the high mesas of the Colorado River plateau, and rain squalls were flitting across the landscape, driven by a biting wind. My hopes for photographing in the light of the "golden hour" at sunset were fairly slight, but, after all, one never knows! So I wrapped my gear in watertight plastic bags, and trudged out to the edge of the Colorado River, a thousand feet below at Horseshoe Bend.*

By the time I reached the edge of the canyon, the rain had diminished but the light was dull and overcast, and the chill winter wind made waiting uncomfortable. I was ready to call it a day, but then I said "Never surrender"— and just before darkness fell, the clouds lit up with the glorious colors shown here.

12mm, two exposures (1 second for the Colorado River, 1/20 of a second for the sky), both exposures at f/7.1 and ISO 200, tripod mounted; exposures combined using a layer mask and gradient in Photoshop.

▼ PAGES 64–65: *Standing on the edge of the cliff that marks the beginning of the volcanic uplands of Owens Valley, California, I looked out along the Owens River toward the magnificent winter crest of the Sierra Nevada Mountains.*

It was clear that the exposure value for the river valley in shadow was quite different than the bright mountains still reflecting the afternoon sun. Fortunately, I was easily able to solve this exposure problem using a series of layers, layer masks, and the Gradient Tool.

20mm, six exposures at shutter speeds ranging from 1/13 of a second to 1.6 seconds, each exposure at f/22 and ISO 100, tripod mounted; exposures combined in Photoshop.

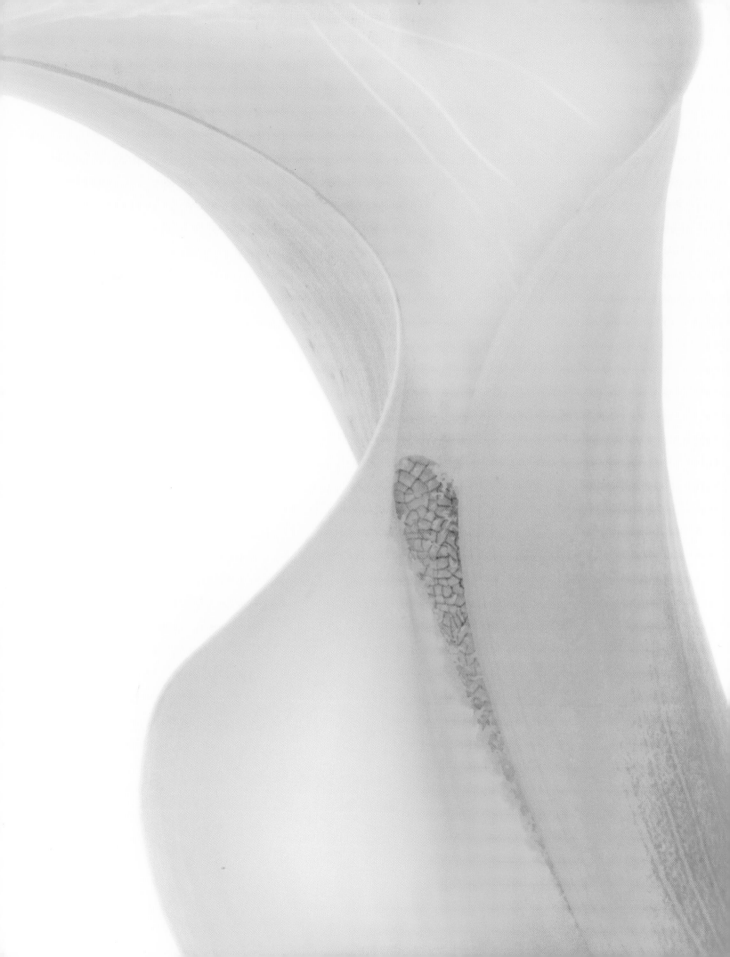

Drawing directly on a layer

Do the best you can, because that's the best you can do. —Rolie Polie Olie

◄ *Walking around my neighborhood one beautiful late spring day, I came across a large clump of calla lilies blooming in a neighbor's yard. Fascinated by the shapes of the flowers, I rang the doorbell and asked whether I could have a few to photograph. The kind neighbor gave me six!*

Back at my studio after shooting a series of close-ups, I looked at the photos on my computer and discovered that the spadix peeking out from the lily petal did not have enough contrast. It just looked like an orange shape with some faint lines.

For this photo to work, the spadix needed to contrast in resolution with the softer parts of the flower. To achieve this result, I hand-painted some of the detailed lines into the spadix on a duplicate layer.

300mm, 68mm combined extension tubes, 1/2 of a second at f/36 and ISO 200, tripod mounted.

There's a special technique that I frequently use that takes advantage of the ability to reduce the opacity of a layer. I use this technique in photos where selected areas just don't seem to have enough resolution or detail. In essence, I paint in the missing details on a layer at full opacity—and then reduce the Opacity setting to the point where my painting seems entirely natural. That way, someone looking at the final image won't be able to detect any alterations.

The idea is to duplicate the layer you want to work on. Next, use a fairly hard brush loaded with black to paint in the enhanced detail. Finally, reduce the opacity of the duplicated layer to the point where the enhanced detail looks natural and attractive.

Variations on the theme

There are a number of variations on the way one approaches hand painting additional details into a photo.

One possibility that works well is to select and sample a color you want to use to "beef up" an area that is not black. Often, it looks more natural to use a color other than black, but you have to be careful that the color you select has enough coverage.

Note that while you can reduce the opacity of the Brush Tool, it's more flexible to use the opacity property of a layer rather than that of the Brush—because you can more easily adjust layer opacity up or down depending on the results even after you've completed the brush work.

One related technique I use is to duplicate the Background layer, and put the duplicate into Multiply blending mode. I then add a layer mask, and paint in what I want on the layer mask. Depending on the results, the opacity of the entire duplicate layer can be adjusted after the layer mask is complete.

Blending modes are explained on pages 71–95, and there's more detail about the Multiply blending mode on pages 83–85.

As an example of when it might make sense to paint directly on a layer and then take down the opacity, have a look at the image of a Calla Lily shown on page 66. For this image to work, the details in the calyx, the flower cluster within the lily, needed to contrast with the soft and luxurious feeling of the spathe—the large white bracht that encloses the spadix.

But when I opened the photo of the flower in Photoshop and looked at the area of the calyx up close, it was clear it did not provide as much detail as I would have liked (right).

In real life, the calyx had plenty of detail and visual interest. But up close in the photo, the details of the calyx lacked contrast and were indistinct.

1. To get started adding contrast to an area in a photo, open the image in Photoshop. (For this example, I'll be using the calla lily calyx.)

2. Duplicate the layer you want to add contrast to by selecting Layer ► Duplicate. In the Duplicate dialog box, name the layer "Contrast."

 In the next step, you'll paint right on the "Contrast" layer. There's no layer mask this time. Don't worry if you aren't great with the Brush Tool, yet. The painting you will do here will be rather thick and look overdone until the Opacity setting for the "Contrast" layer is lowered.

 As you continue to work with the Brush Tool on your photos, you'll find that you do get a feel for it, though some folks prefer using a mouse to paint, while others prefer a tablet and stylus or digital brush.

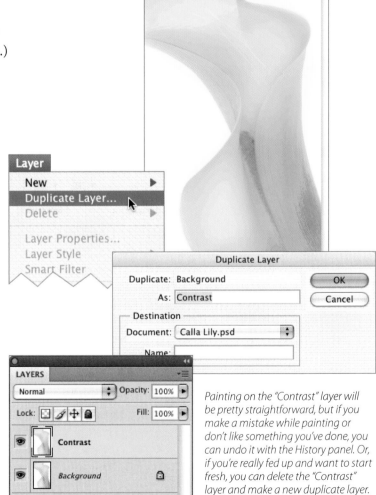

Painting on the "Contrast" layer will be pretty straightforward, but if you make a mistake while painting or don't like something you've done, you can undo it with the History panel. Or, if you're really fed up and want to start fresh, you can delete the "Contrast" layer and make a new duplicate layer.

3. Select the Brush Tool from the Tool panel and set black as the Foreground color by pressing D.

 For this type of painting, you'll want to use a fairly hard, round brush, so open the Brush Tool Picker (page 52) and set the Hardness to 50% and select a small round brush tip. You can use the Master Diameter slider to set the width of the brush tip to be a little wider than the area you want to paint over.

 On the Options bar, set both Opacity and Flow to 70% for starters (page 52). You can adjust these settings as you need to while you paint.

4. Use the Zoom Tool to magnify the area of the image you are painting. Always take the time to zoom in and out while you're working. That way, you can see what effect you are creating.

5. Paint on the layer where it needs more contrast. This can be meticulous work, so take your time and don't feel rushed.

6. Once you have finished painting, use the Layers panel to adjust the Opacity setting of the "Contrast" layer. Experiment until you get it just right. For the calla lily, I first tried 50% Opacity, but it was too strong. Then, I tried 20% Opacity—still, too much. Finally, I settled on 10% Opacity—it looked natural but was significant enough to make the calyx really stand out when compared to the soft buttery white spathe. The final image is shown on page 66.

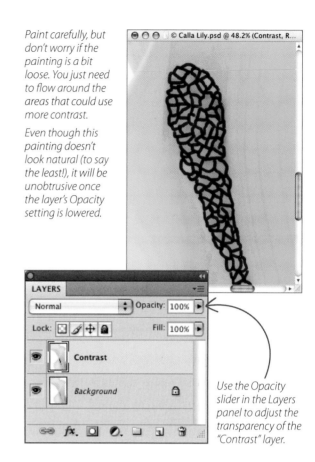

Paint carefully, but don't worry if the painting is a bit loose. You just need to flow around the areas that could use more contrast.

Even though this painting doesn't look natural (to say the least!), it will be unobtrusive once the layer's Opacity setting is lowered.

Use the Opacity slider in the Layers panel to adjust the transparency of the "Contrast" layer.

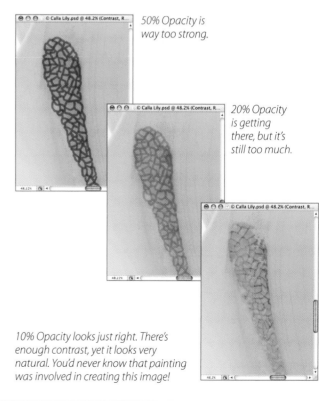

50% Opacity is way too strong.

20% Opacity is getting there, but it's still too much.

10% Opacity looks just right. There's enough contrast, yet it looks very natural. You'd never know that painting was involved in creating this image!

Introducing blending modes

We paint what is not there, not what is. —Robert Leverant

There's one more important Photoshop concept that you need to know about: *blending modes*. Your choice of blending mode determines how a layer interacts with the layers beneath it in the layer stack.

So far in *The Way of the Digital Photographer*, I've primarily shown you how to use *Normal* blending mode. As I've explained, at 100% opacity in Normal blending mode, only the pixels of the topmost layer in the layer stack are visible. With any blending mode other than Normal, this is not the case.

In fact, each blending mode is described by a pixel-based formula. The formula for the Normal blending mode is that the pixels in the topmost layer are the only ones shown. Some

◄ *My thought with this image was to convey some degree of the complexity of my feelings about New York—the place I grew up, and a city that I love and that drives me crazy simultaneously.*

To make the image, I shot a number of bracketed sequences from a high-floor window in midtown. The subject matter of each of these image sequences overlapped but was not identical.

I combined the image sequences using a variety of blending modes and applied textural overlays (as explained on pages 175–183) to finish the image.

Various focal lengths, five bracketed exposure sequences, each exposure sequence consisting of seven exposures ranging from 4 seconds to 1/250 of a second, all exposures at f/8 and ISO 200, tripod mounted; HDR sequences combined using Photoshop and Nik HDR Efex Pro, finished sequences composited using Photoshop.

other easy-to-grasp blending mode examples are *Lighten*—in which each pixel shown is the lighter of the two layers being blended—and *Darken*—in which each pixel shown is the darker of the two layers being blended.

The truth is that understanding the math behind how blends are determined will not help you much in effective and creative use of blending modes. Photoshop is a visual program, and it is by far best to experiment visually with the blending modes so you can get a feeling for what they do.

That said, I won't leave you in the lurch with blending modes without providing some guidance. On the pages that follow, you'll find case studies of two of the most commonly used blending modes (other than Normal):

- Screen, which is used to lighten (pages 72–81)

- Multiply, which darkens (pages 82–85)

I'll also show you how blending modes can be categorized (page 87), and how some of the important blending modes interact with lights, midtones, and darks (pages 88–89).

Finally, most of the examples in these pages talk about blending a layer with a duplicate copy of itself. The rubber starts to meet the road when you blend a layer with another layer that presents entirely different content. I'll show you how to take advantage of this potential synergy for creative artistic effect in the context of some of the less commonly used blending modes (pages 90–95).

Screen blending mode

Finding some beautiful white dahlias blooming in my garden, I brought them into my studio and placed them on a light box. The back lighting heightened the transparent quality of the dahlias' petals and made the flowers almost glow. I shot several sets of dahlia images, working with the exposures to make sure that I got a full dynamic range of lights and darks.

As I worked in Photoshop, in the post-production phase of my workflow, I kept the translucent aspect of the flower petals in mind. To add a sense of lightness to the petals of the dahlias, I used Screen blending mode and painstakingly painted in each petal on a layer mask, lightening the petals one by one. As I painted, I left the edges of the petals untouched. I liked the way the darker contrast looked, and the contrast at the edges also worked to make the petals appear more translucent.

200mm macro lens, two exposures (one at 3/5 of a second and one at 1/8 of a second), both exposures at f/16 and ISO 200, tripod mounted; exposures combined in Photoshop.

How do Lighten and Screen blending modes compare?

Lighten blending mode is really easy to understand: it takes the lightest pixel at every point. This makes it good for certain applications—such as painting in stars against a night sky—but it won't help you lighten areas that are dark in both layers that are being combined. In comparison, Screen will lighten across the range of tones in an image, although it works best in midtone areas.

A group of blending modes can be used to lighten an image, either overall or selectively using a layer mask and painting. My favorite of the blending modes is *Screen*.

Technically speaking, in Screen blending mode Photoshop multiplies the opposite of each pixel of the layer being blended with the pixels beneath it. (Brain twister!) This kind of formula can be hard to comprehend until you see it visually. But all you really need to know is that Screen blending mode lightens everything, most often in a pleasing way.

I often use Screen blending mode in my photos to make large areas lighter and also to bring out selective details. One kind of situation in which this works well is when the foreground is too dark. You'll often find that this occurs in landscapes just before sunset, or even after dark, when there is light in the sky but the landscape itself is quite dark.

While there is still color in the sky but the foreground landscape is very dark, I like to shoot a lighter exposure of the foreground if I can. Then I take my photos back to my studio with the plan of blending this foreground shot into the dark sky background using Screen blending mode, a layer mask, and the Brush and/or Gradient Tools.

If there is motion in the scene then this combination may not be easily possible, and I may have to settle for combining a layer with itself using Screen blending mode to selectively lighten the foreground area (or any other area in the photo that needs lightening).

Shooting in the Patriarch Grove of ancient bristlecone pines in the White Mountains of eastern California, I came upon a tree standing tall in the landscape.

As I pre-visualized the photograph that I wanted to create, I decided to wait until after sunset to capture star trails whirling in the sky behind the pine tree.

Thinking further, I knew that the star trails would make the foreground—and tree—completely black, so I decided to shoot a lighter foreground image before sunset (top right).

My knowledge of post-processing with layers and masks—and the idea that I could combine these photographs later in Photoshop—informed my photography.

After the sun had set, I created the star circle composition (middle right) by shooting thirty-five 4-minute exposures. Back at my studio a few days later, I combined the thirty-five photos in a layer stack in Photoshop. The stacking program that I used to combine the photos essentially used the Lighten blending mode to find the lightest pixel in each point of the thirty-five photographs.

Once I had the star trail image, it was time to combine it with the photo I had shot for the foreground.

I combined the two images in a layer stack by copying the foreground photo into the image window containing the star trails image (bottom right). I named the newly copied, upper layer "Foreground." (For details on copying a layer and making a layer stack, turn to page 44–45, steps 1–7.)

My next step was to select the "Foreground" layer in the Layers panel and add a black Hide All layer mask (page 45, step 2). This hid the "Foreground" layer and made the "Background" layer visible.

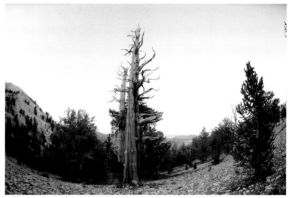

The foreground image showing the landscape and bristlecone pine was shot before sunset (1/250 of a second at f/8, and ISO 200).

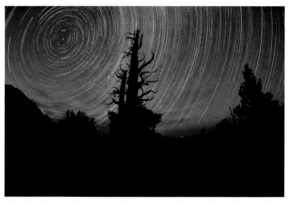

The background image with its star trails was shot after dark (thirty-five images at 4 minutes each, f/2.8, and ISO 400) .

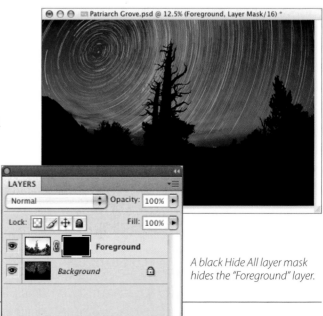

A black Hide All layer mask hides the "Foreground" layer.

With the layer mask selected in the Layers panel, I selected the Gradient Tool, selected the Foreground to Background gradient from the Gradient Picker, and then dragged a white-to-black gradient from the bottom to the top on the layer mask (middle right). (For more about this technique, turn to page 61, steps 6–9).

This seamlessly blended the two images, leaving the star trails from the "Background" layer visible and the trees and landscape from the "Foreground" layer visible.

My next step was to change the "Foreground" layer's blending mode to Screen by selecting it from the Blending Mode drop-down list (middle right).

The final step was to select the Brush Tool from the Tool panel, select a fairly hard brush tip (pages 51–52), and set the Foreground color in the Tool panel to white by pressing D, and then X. Making sure the layer mask on the "Foreground" layer was selected, I carefully painted in the upper part of the tall bristlecone pine in the center of the image (below right).

The final image is shown on pages 76–77.

A gradient quickly blends the best of both layers together.

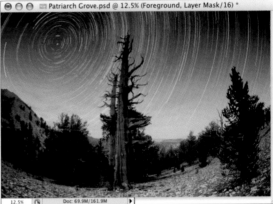

Click here to open the Blending Mode drop-down list and choose a blending mode.

Experiment with the blending modes—try them out and see how they affect the blending of the layers.

After selecting the Screen blending mode, the two layers' pixels blend well, especially across the midtone values in the image.

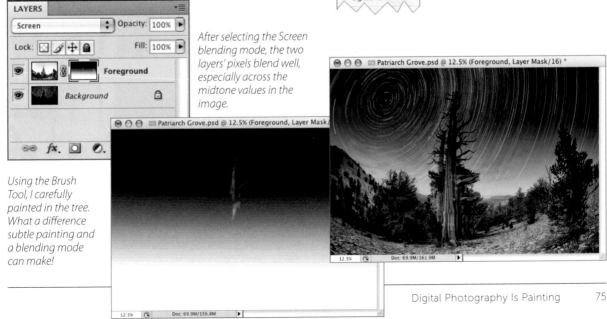

Using the Brush Tool, I carefully painted in the tree. What a difference subtle painting and a blending mode can make!

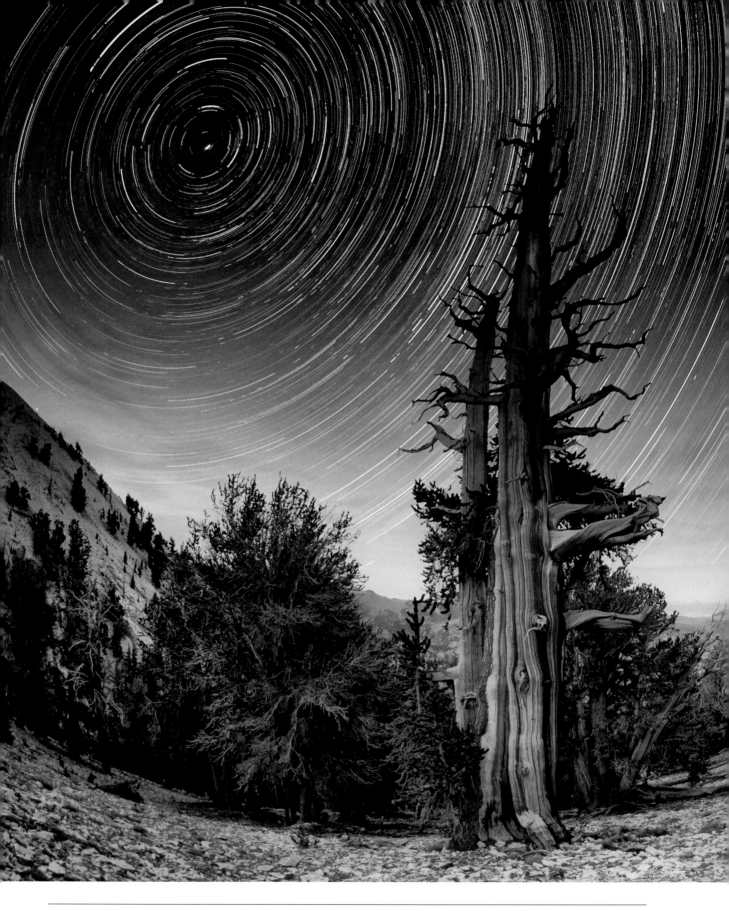

◄ *I used Screen blending mode to make the foreground lighter when I blended a shot made before it was completely dark (for the foreground) with the starry night sky.*

10.5mm digital fisheye lens; Background: thirty-five images at 4 minutes each, f/2.8, and ISO 400 to capture the stars; Foreground (shot before it was fully dark): 1/250 of a second, f/8, and ISO 200, tripod mounted; exposures combined in Photoshop.

▼ PAGES 78–79: *To make this image, I put the camera on a timer and used an external power source. I programmed the time to shoot exposures all night, then blended in the foreground from the first light of dawn.*

10.5mm digital fisheye lens; Background: 139 images at 4 minutes each, f/2.8, and ISO 400 (total exposure time about 10 hours); Foreground (shot after sunrise): 1/250 of a second, f/8, and ISO 200, tripod mounted; exposures combined in Photoshop.

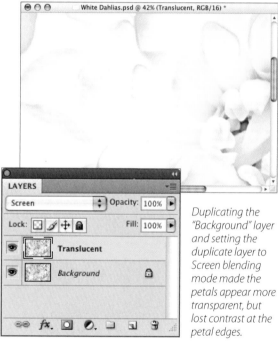

Duplicating the "Background" layer and setting the duplicate layer to Screen blending mode made the petals appear more transparent, but lost contrast at the petal edges.

Using Screen for selective lightening

Sometimes you need to very selectively lighten an image—rather than lightening a large contiguous area of an image (such as the foreground in the bristlecone pine image shown on pages 76–77). For instance, consider the image of white dahlias, shot on a light box, and shown in finished form to the right.

Looking at the petals, my idea was to leave the lines at the edges of the petals hard, but to make the internal parts of the petal soft. This gives a feeling of translucency.

To achieve this result, I opened the dahlia image in Photoshop (upper left), and duplicated the dahlia layer. I named the duplicate layer "Translucent." In the Layers panel, I set the "Translucent" layer's blending mode to Screen. This lightened the duplicate layer considerably, making the petals appear quite translucent. At the same time, however, it lowered the contrast at the edges of the dahlia petals, losing definition (middle left).

The way to fix this was to hide the petal edges on the "Translucent" layer, letting the

Painting with black on a white Reveal All layer mask let me hide the portions of the "Translucent" layer that reduced petal edge contrast, making the petal edges from the "Background" layer visible. The layer mask (right) was complex and took some time to complete.

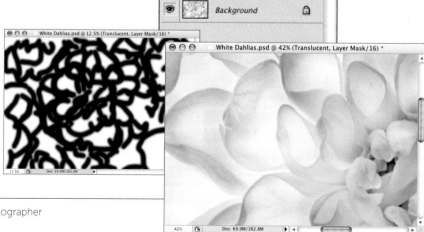

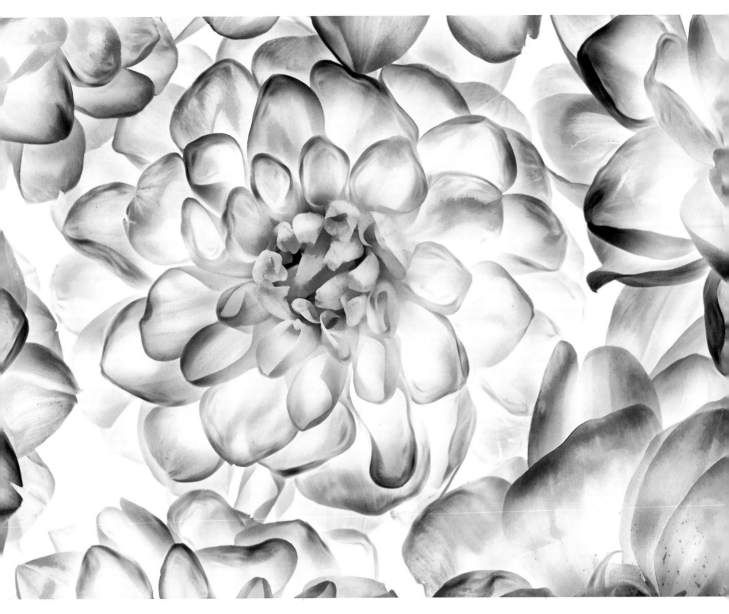

darker petal edges show through from the original layer at the bottom of the layer stack.

To do this, I added a white Reveal All layer mask to the "Transparent" layer (page 47). Using the Brush Tool set with a fairly hard, round tip with black as the Foreground color, I painted freehand, creating a fairly complex layer mask that added the petal edge contrast back in (page 80, bottom). Finally, using the Layers panel and the Opacity slider, I reduced the opacity setting of the duplicate layer until it looked right, at about 34%.

In my studio, I arranged some white dahlias on a light box and I shot several series of photos, grouping the flowers in different ways.

As I worked at my computer on one of the dahlia photos that pleased me most, I realized that I wanted to add a sense of lightness to the petals of the dahlias. To do this, I duplicated the image layer and applied Screen blending mode to make the petals appear more transparent.

200mm macro lens, 2 exposures (one at 3/5 of a second and one at 1/8 of a second), both exposures at f/16 and ISO 200, tripod mounted.

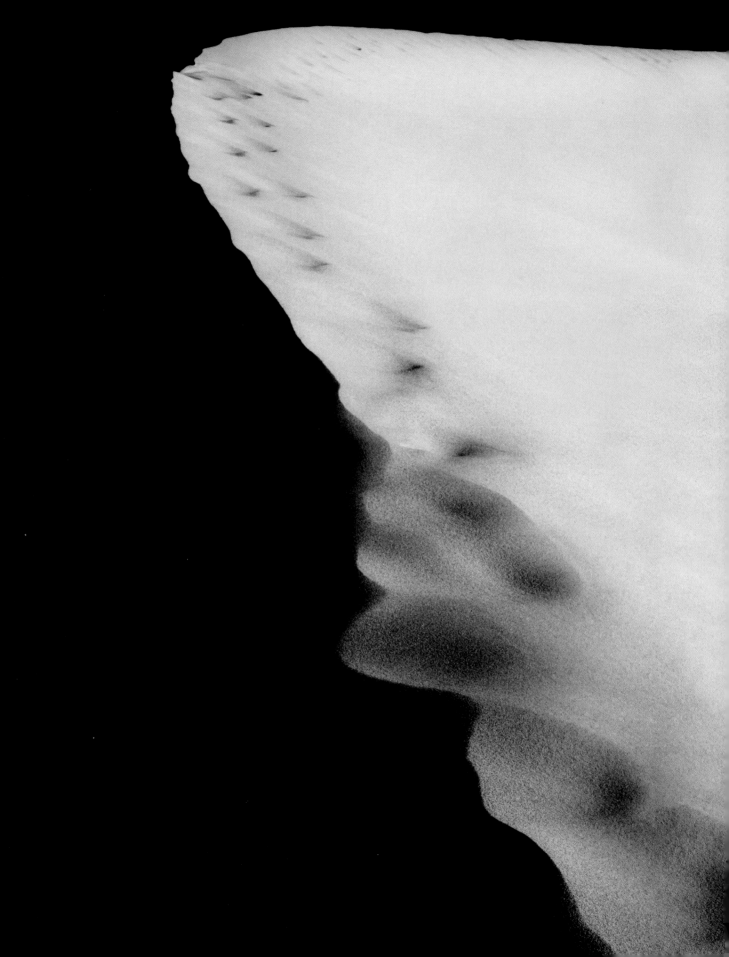

Multiply blending mode

◄ *High in Death Valley's Eureka Dunes I saw this high-contrast composition in the late afternoon sun. It was bitterly cold with a strong, gusting winter wind. Tiny pellets of blowing sand stung my cheeks and hands with every gust. Even though I was wearing cold-weather gear, it was hard to stay warm.*

It's always windy at the Eureka Dunes and as the wind strikes the dunes, it hits harmonics, sounding musical notes. The pitch of the note depends on how much moisture is in the sand. The drier the sand, the higher the pitch of the resulting harmonic. So the sands sang to me as I pre-visualized this photo.

My idea was to exaggerate the demarcation line between the side of the dune in shadow and the side in sunshine.

I knew I could achieve this effect in post-processing by duplicating the "Background" layer, changing the duplicate layer to Multiply blending mode, and then using a layer mask to "protect" the part of the dune in sunshine from the effects of the darkened, Multiply layer (see pages 43–47 for details about layer masks and how to work with them).

With these thoughts in my head, I carefully pulled out my camera and shielded it as best I could from the sand. I didn't want sand to get in my camera, so I had to work fast. No tripod setup here (even though I had lugged it up the dune with the rest of my equipment!). I set my camera to a fast shutter speed and quickly shot a series of images. Then I capped my lens.

After trudging back down the dune, it was a relief to get into the quiet of my van, out of the wind. I immediately set to work, cleaning out the sand from my camera, bag, the rest of my gear, and my hiking boots.

52mm, 1/500 of a second at f/25 and ISO 320, handheld.

Just about as common as wanting to lighten an image is the need to darken it. When I want to selectively darken an image, most often I reach for the Multiply blending mode.

This blending mode compares the two layers being blended and multiplies each pixel on the bottom layer with its corresponding pixel on the upper (blending) layer, creating a darker color.

The only color in an image that the Multiply blending mode does not work on, meaning darken, is white. You can multiply white with white all you like, and it will still just be white!

By using a layer mask and controlling the opacity of the Multiply blended layer, I can add drama and tonal range to any photo.

For example, high in Death Valley's Eureka Dunes, I looked across the top edge of a large dune and pre-visualized this high-contrast composition in the late afternoon sun (left). My idea was to exaggerate the demarcation line between the side of the dune in shadow and the side in sunshine. I knew I could achieve this effect in post-processing using the Multiply blending mode, so I planned my shots with this in mind and took them accordingly.

Back at my studio, I started by duplicating the "Background" layer and naming the duplicate "Contrast." For information about how to duplicate a Background layer, see page 55, step 3.

Then I changed the "Contrast" layer's blending mode to Multiply. Changing blending modes is explained on page 75.

Next, I added a white Reveal All layer mask (for information on working with Reveal All layers masks, see page 47) and used the Brush Tool with the Foreground color set to black (to carefully paint the line of the dune and the sun side of the dune on the right. (I show you how to use the Brush Tool on pages 51–52).

These steps allowed the brighter, sun side of the dune on the Background layer to be visible, and the darker, shadowed side of the dune to become really dark where the layer mask allowed the Multiply blending mode version of the layer to come through.

Since this kind of high-contrast image works well in black and white, I converted the image to monochrome using Nik Silver Efex Pro. You'll find information about converting an image to black and white in post-production on pages 167–173.

The final image of the crest of the Eureka Dunes is shown to the right and on page 82.

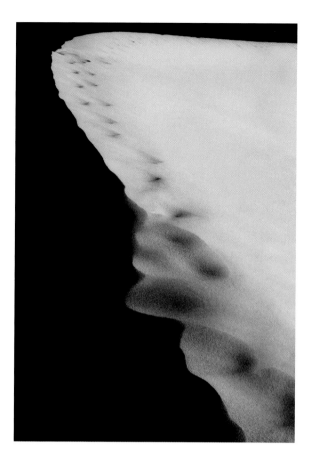

▲ *Using the Multiply blending mode let me make the shadowed side of the dune very dark, adding to the contrast and shape of the dune line.*

52mm, 1/500 of a second at f/25 and ISO 320, handheld.

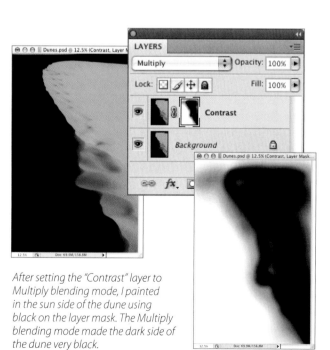

After setting the "Contrast" layer to Multiply blending mode, I painted in the sun side of the dune using black on the layer mask. The Multiply blending mode made the dark side of the dune very black.

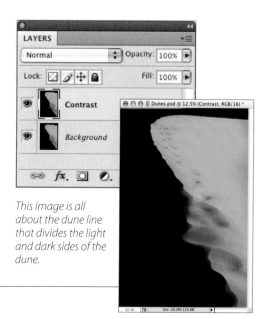

This image is all about the dune line that divides the light and dark sides of the dune.

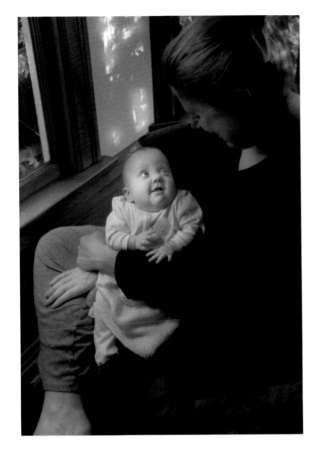

For another example, in this image of my wife and daughter (left), I wanted to emphasize the glowing expression on the face of my little girl. To achieve this result, I needed to darken the surrounding image so that extraneous details wouldn't visually clutter the image (original photo below left).

As a first step, I duplicated the background layer that I wanted to darken and named it "Baby Face." Next, I changed the "Baby Face" layer to Multiply blending mode. This created an effect of overall darkness.

I added a white Reveal All layer mask, and used the Brush Tool to paint out the areas that I wanted to stay bright, primarily the baby's face (below right).

Finally, I took down the opacity of the "Baby Face" layer to the point where it looked attractive rather than too dark—about 50% opacity.

▲ *This image has emotional impact because of the glowing light on my daughter's face, emphasizing her wonderful expression. To achieve this lighting effect in post-processing, I used the Multiply blending mode on a duplicate of the Background layer and selectively lightened my daughter's face using a layer mask and the Brush Tool.*

32mm, 1/80 of a second at f/5.6 and ISO 800, handheld.

While this photo was pleasing, I really wanted the viewer to focus on my little girl's expression. The best way to do this would be to darken the entire image, leaving my daughter's face light.

Using a white Reveal All layer mask, I used the Brush Tool to gently paint in my daughter's face with black, making the brighter "Background" layer visible in those few areas.

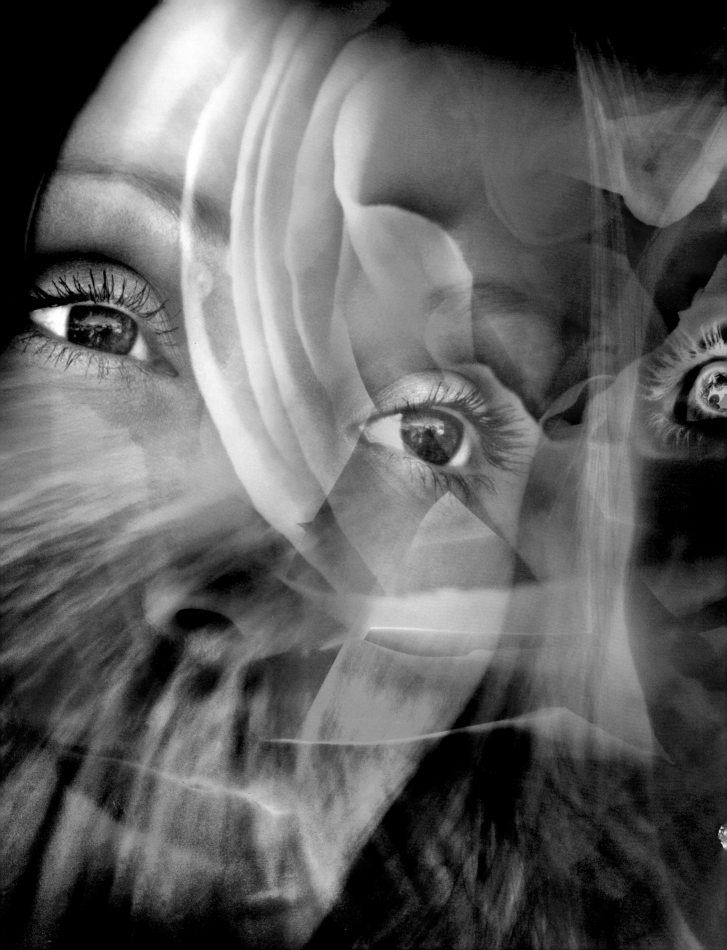

Blending mode categories

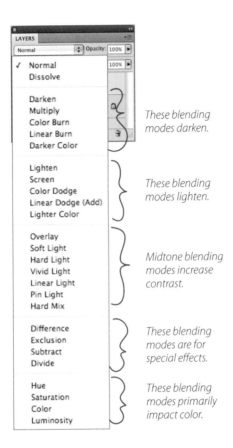

These blending modes darken.

These blending modes lighten.

Midtone blending modes increase contrast.

These blending modes are for special effects.

These blending modes primarily impact color.

Blending modes are a key feature that you can use to impact how your images look. If you've never taken a blending mode off Normal, you've got a great surprise in store.

In the Layers panel on the Blending Mode drop-down list (left), the blending modes are divided into categories for darkening, lightening, and increasing contrast. In addition, there are comparative blending modes, and blending modes that modify color.

In a previous book, I called the comparative blending modes—Difference and Exclusion—"weird," and the author of another Photoshop book calls them "psychedelic." The comparative blending modes are the Rodney Dangerfield of blending modes—they don't get no respect!—but they can pack a real punch in creative image making, as you'll see starting on page 91.

I'm all for finding out what different blending modes do by trying them out. After all, there's nothing like seeing something for yourself.

▲ *The blending mode drop-down list divides the blending modes by category.*

◀ *To make this image of a model that I titled "Becoming a Dream," I combined four exposures in post-production. This combination used a variety of blending modes, and more than 100 different layers.*

Four exposures, 100mm, exposures at shutter speeds ranging from 1/6 of a second to 1/200 of a second, apertures from f/2 to f/8, ISO 200, tripod mounted; exposures combined in Photoshop.

Meditation

If you want to live your life in a creative way, as an artist, you have to not look back too much. You have to be willing to take whatever you've done and whoever you were and throw them away. —Steve Jobs

Testing the blending mode categories

Here is a quick blending mode test to see how a few blending modes affect lights, midtones, and darks.

The image used here is an iPhone photo of a lunch I had at an Ecuadorian restaurant one day (right). This image is the "Background" layer for the test (below). On the layer above, called "Test Strips," I've put three rectangles, one that is black, one that is 50% gray, and one that is white.

Try creating your own blending mode test to see how they affect your photos.

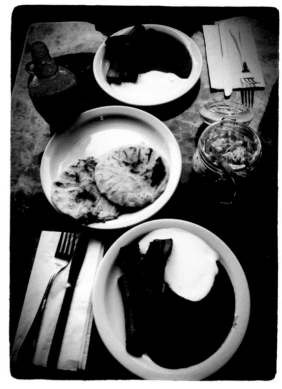

▲ *This lunch of fried plantains and gorditas looked so good, I had to photograph it!*

iPhone camera app using HDR, post-processed with Lo-Mob app.

Above: This is the "Test Strips" layer. The black rectangle will react to a blending mode just the way the darkest pixels in the layer would react. The 50% gray rectangle will react like midtones, and the white rectangle will react like the lightest pixels.

Right: Here's lunch! This is the "Background" layer for the test.

Using the Blending Mode drop-down list, you can test to see how a blending mode affects your image. Don't be afraid to experiment—give it a try!

Normal is the default blending mode. It does not blend the two layers' pixels together, leaving the pixels' appearance exactly as they are on their individual layers.

Screen is a blending mode that lightens pixels. It does not affect black pixels. Here the black rectangle disappears, and the area under the gray strip becomes lighter.

Multiply is a blending mode that darkens pixels. It does not affect white pixels. Here the white strip disappears and the area under the gray strip becomes darker.

Overlay is a midtone blending mode that increases contrast. Here the gray strip disappears, the white strip lightens the area it is over, and the black strip darkens the area it is over.

Comparative blending

◀ *Across the Bay from San Francisco, Oakland, California—like the comparative blending modes— doesn't get no respect. But Oakland is a significant city in its own right. It is one of the most important urban areas on the west coast of the United States.*

One cold winter day, I was wandering the streets of downtown Oakland when I saw a series of reflections in the plate glass windows of an office high-rise.

These reflections showed architectural details, including clocks and pillars, and cornices and arched windows with divided lights, all from a bygone era.

Moving out to a small traffic island in the middle of a busy boulevard, I realized that my tripod was going to stay in my bag. There wasn't enough room and the cars and trucks whizzing by would create enough tripod shake to ruin shorter exposures.

Setting a fast shutter speed and bracing my back against a streetlamp, I shot a number of exposures.

Back at my studio I used a series of comparative blending modes to combine the different exposures. My idea was to create a composition that showed a partially fractured society through the shapes in the reflections: architecture literal and present, but also at the same time not coherently possible.

170mm, circular polarizer, two exposures, each exposure at 1/250 of a second at f/7.1 and ISO 100, handheld; exposures combined in Photoshop.

If you look at how the comparative blending modes—Difference, Exclusion, Subtract, and Divide—work from a technical perspective, you'll be hard put to intuitively know what they do. For example, the Difference blending mode compares the brightness of the pixels of the source and target layers and subtracts the brightest pixels. A white layer in Difference blending mode inverts the layer beneath it, and a black layer leaves the underlying layer unchanged.

Weird, huh? I should fully disclose right off the bat that comparative blending modes are not much beloved of Photoshop book authors. ("Psychedelic," "freaky," and "useful only on Hallowe'en" are the way one author puts it!)

I think that if you'll bear with me, you'll find quite a few artistic and creative uses for these comparative blending modes when it comes to your photography. Of course, like any tool they need to be used with discretion and taste—and possibly not at full opacity, with a layer mask to direct specific rather than overall application. (To find out more about applying blending modes to layers, turn to pages 71–89.)

Many of the blending mode examples I've shown you so far involved blending a layer with a duplicate of itself. However, when it comes to comparative blending modes, the rubber really meets the road when you blend a layer representing one photo with a layer representing a second photo.

By the way, when you do experiment with blending layers consisting of wildly different subjects,

don't limit yourself to the comparative blending modes. It's true that the comparative blending modes have the most striking impact when you use them on imagery that is intentionally divergent—but it is also worth playing with blending modes across the board to see what the blending process comes up with.

Looking through my files for divergent photos to use as source material for a comparative blending mode collage, I was struck by an image of an old oak tree (upper right), and distant mountain ranges near Death Valley (middle right). The two images seemed very different, but I had an idea that they might work together.

I started by duplicating the mountain image (page 44) and creating a layer stack with the tree image. Appropriately, I named the layers "mountains" and "trees" (below).

Then I started playing with the comparative blending modes. You can see the results below and on page 93.

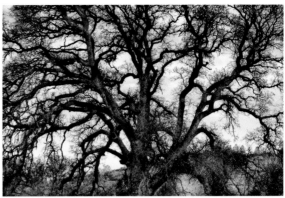

I shot the bare branches of this old oak tree in the western foothills of the Sierra Nevada Mountains in autumn, and then worked in Photoshop to increase the color values in the image.

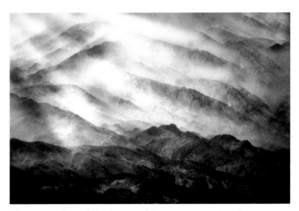

This is a version of the image of distant mountains shown on pages 10–11.

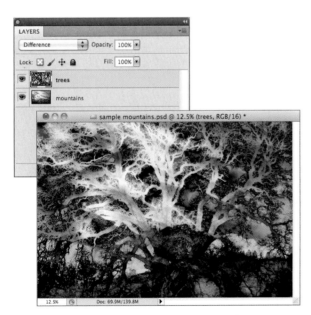

I started with Difference blending mode with the "trees" layer on top. Clearly something graphically interesting was happening. In the Difference blending mode, the dark trees on top have gone mostly white.

Meditation

Visualize two of your images. Now, imagine how they would look as layers blended together with one of the blending modes other than Normal. With this in mind, how could you expose new photos specifically for the purpose of using with the blending mode you visualized?

Next, I tried putting the "mountains" layer on top of the stack and applying the Difference blending mode. This looked very different from the same blending mode with the order of the layers switched. With the mountains on top, in Difference blending mode the dark foreground goes mostly white.

I swapped the layer stack around again, putting the "trees" layer on top, and then tried the Exclusion blending mode. With this blending mode, an interesting pattern began to emerge.

▼ *Using the comparative blends that I had been playing with, I worked to create the digital collage below. I started with two photos, and combined them using a number of comparative blending modes (see text for a full explanation).*

Two photos: Tree, 95mm, 1/800 of a second at f/14 and ISO 200, handheld; Mountains, 300mm, 1/160 of a second at f/6.3 and ISO 320, handheld; images combined in Photoshop.

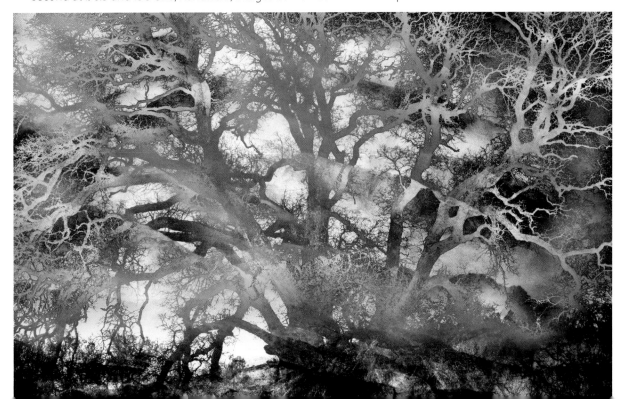

In point of fact, comparative blending modes have usefulness going beyond the abstract. Whenever I want to introduce an element in one of my compositions that seems like it might have a little to do with the supernatural, I start to think of comparative blending modes.

The image of the interior of Grand Central Station shown to the right was somewhat complex to make. The first hurdle was that I couldn't use a tripod on the floor of Grand Central Station when it was busy with people bustling by. To solve this, I found a balcony with a railing where I could rest my camera.

I needed each exposure to be fairly long so that I could create the partially visible "ghostly" people in motion. Since there was a good deal of light in Grand Central Station, I added a neutral density filter and a polarizing filter to my camera and then shot four exposures, each at 4 seconds, with my lens stopped all the way down.

I processed the sequential images by placing them in two stacks. One stack used the Lighten blending mode, and the other stack used the Darken blending mode. I merged down each of the two stacks, and blended them with a layer mask and a gradient.

Finally, I amplified the ghostly pedestrian effect by merging LAB colored layers (see pages 155–163 for more on LAB color) back into the image using comparative blending modes. With each of these operations, I used a layer mask so I could be very selective. In other words, I used a specific layer and blending mode only on individuals and small groups of people, and not overall.

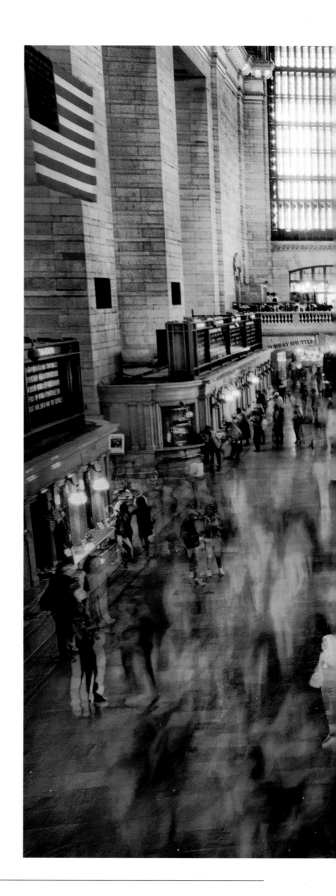

▶ *My idea in making this photo was to combine a number of long exposures with the hope of creating an image that showed both solid people and others that seemed more ghostly (see text for further details).*

Four combined photos (see explanation in the text), each photo 18mm, 4 seconds at f/22 and ISO 100, circular polarizer and +4 ND filter, camera placed on an overlook balcony rail.

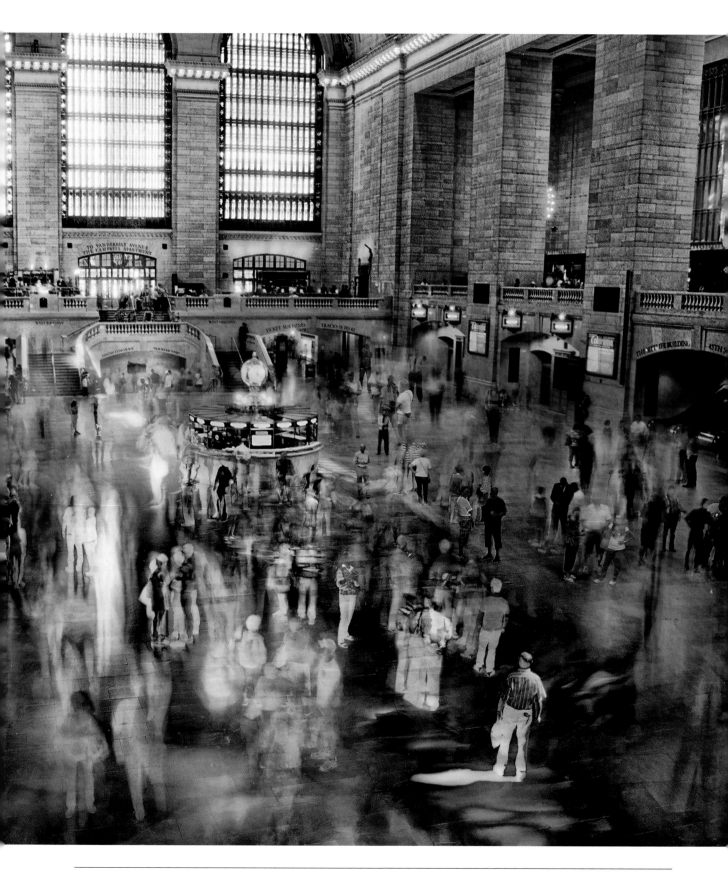

Workflow

Art, being bartender, is never drunk. —Randall Jarrell

◀ *Wandering around my neighborhood one sunny day, I found a large clump of variegated bamboo fluttering in the breeze. I liked the way the sun lit up the thin leaves, making the white and green striping more apparent.*

Never one to be out and about without my garden clippers, I snipped several stalks and took them back to my studio.

Several days before I had gotten a call from a décor client looking for a botanical image with a "simple look." I thought the bamboo would fit the request.

The image may appear simple; however, the workflow to create this image was anything but simple. I started by arranging the bamboo on a light box and then taking seven different exposures. I processed the exposures in Photoshop and using automated HDR software. By the time I was finished, a total of more than 50 layers were involved.

The final image was on a white background and I knew the client wanted something textured but neutral. So as a last step, I scanned a piece of washi rice paper and used Photoshop to position the bamboo on the rice paper background. This final step required another six layers and three different work-in-progress files.

There's no doubt that an important part of creating this apparently straightforward image was to use an organized workflow that allowed me to keep track of everything and to create order in what might have been a very chaotic process.

50mm macro lens, seven exposures at shutter speeds ranging from 1/40 of a second to 2.5 seconds, all exposures at f/11 and ISO 100, tripod mounted; exposures combined in Photoshop and Nik HDR Efex Pro; scanned washi rice paper added as a background in Photoshop (see page 175).

I've always had a problem with the term "workflow" because enhancing and creating images in post-production is so much fun that it really should be called playflow! That said, if you are working through an image with many processing steps, not to mention different layers—along the lines of what I've shown you so far in *The Way of the Digital* Photographer—organization becomes a significant issue.

From a thousand-mile viewpoint, workflow has come to mean the process of getting an image from camera to computer to output device—and all the steps in between. If you are dealing at professional level with color reproduction, you will need to consider color management as part of workflow. In addition, storing, retrieving, and archiving image files is a necessary part of workflow.

It's a truism that everyone's workflow needs are different. The most important point is to be organized. That said, based on my years as a digital artist and photographer, and the questions I get when I give workshops, here are some recommendations:

■ Use a calibrated monitor (for information about getting what you need to keep your monitor calibrated, see the Resources section on page 188). This may not ensure that you see the same color as everyone else (especially if their monitors aren't calibrated), but it will keep you consistent. Also, when printing, the resulting image will appear much closer to the image you see on the screen.

- Use a card reader and copy the files from your memory card to your computer using Explorer (Windows) or Finder (Mac). Avoid the programs that will automate this process for you because they will try to force you into some type of storage scheme with file names created by the software program. This name may not be intelligible to the mere mortal—and if you need to find an image later, the file name will be inscrutable.

- Store files in folders that use a chronological scheme along with a content slug to make for easier searching (below). For instance: 2013.07.10 - Poppy macros.

- Separate unprocessed files from post-production work in progress and final files. I usually start three subfolders: Source (for original JPEG and RAW files), WIP (for post-production work-in-progress), and Final (for the final master file, and output-specific final files).

- Keep unflattened versions of all layered files.

- Always keep the original version of a file at the bottom of the layer stack; that way, you can refer back to it as you work.

- Group work-in-progress files by the functionality of the layers. For example, one file might include comparative blending layers, and a subsequent file the monochromatic conversion layers. I tend to name my work-in-progress files containing layers in alphabetical order; for example, DSC1214.a.psd, DSC1214.b.psd, DSC1214.c.psd, and so on. For more about work-in-progress workflow, please turn to pages 139–140.

- Make sure to add your copyright notice to the EXIF data of your master file.

- Leave the master file untouched when you make images at specific sizes for prints or other kinds of reproduction.

▶ *This is a screen shot of some of the folders that I use to store my photo source files. Note that each folder starts chronologically with the year first and includes a content description to make searching easier.*

▲ *These are the 12 files that make up the post-production workflow for* Lonely Islet *shown on pages 100–101 and on the cover. If you look at the file names, you'll see that I named them using alphabetical order. Each of these files was created at what I call a "checkpoint," where a major bit of work had been done and I wanted to save the image at that point with all layers intact. I always save these files as I work, so I have the option of reverting to an earlier stage if I decide that the way an image appears is not the direction I would like it to go. Post-production workflow is explained further on pages 139–140.*

▶ *These are the layers that I used to get the* Lonely Islet *image to this particular stage in the post-processing. As you can see from the file name, I wasn't very far along in the process, yet, because the file name doesn't have an alphabetical letter attached to it. In fact, these ten layers were just the start of an image that would eventually use more than 117 layers.*

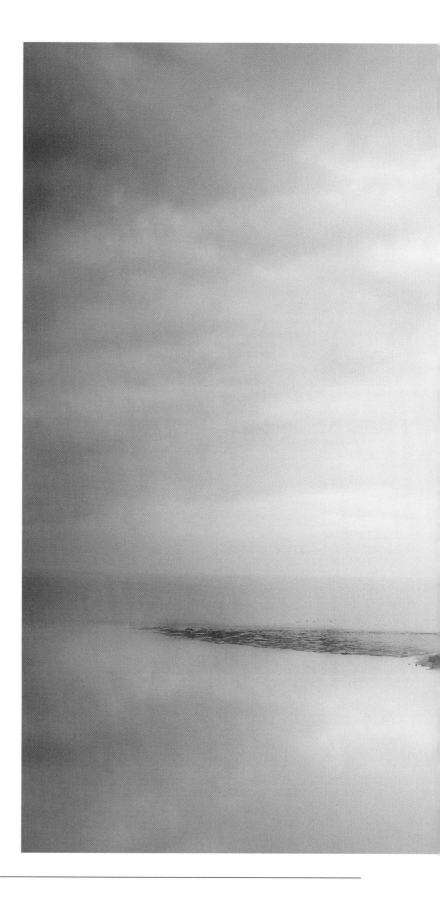

▶ *I shot this image early in the evening on a bitterly cold New Year's Eve from a bluff near China Beach overlooking San Francisco Bay. As I set up my camera and tripod, I studied the scene while the twilight sky turned to night. Even though I was wrapped up in numerous layers of wool and down, the cold was creeping in past the layers, making me shiver.*

By the time I shot this photo, there was very little detail visible. But I knew that my camera was pointed in the right direction, out toward the small islet.

Digital cameras always "see" more at night than eyes can—all you need is a long exposure, patience, and the faith that your camera is recording something.

I needed a fairly long exposure (2 seconds) to record the detail. Processing the image took far longer than shooting it (at least I was warmer in my studio). The final image required 12 post-production files with an aggregate of 117 different layers, using a variety of blending modes and layer masks.

18mm, 2 seconds at f/8 and ISO 100, tripod mounted.

Do it on your iPHONE: Slow Shutter Cam

If you go into any restaurant these days and look at the diners who are eating alone, many of them are likely to be playing with their smartphones. Some of these folks are checking email and some are surfing the web. Others, like me, are often using the camera in their phone to take and process photos.

It's well known that the iPhone camera is now the most used camera in the world. If not the world's best digital camera, it is the camera that is always with one. But—like more professional digital cameras—if you treat it as just another camera that renders static and realistic images via a sensor (instead of film), you are missing most of the creative potential.

Digital photography is a completely new art form and a whole new ballgame. This is true if you make digital images with a DSLR, and also true if you create with an iPhone. New media require new thinking, new tools, and new ways of seeing.

A good example of using iPhone camera apps to think in a new way about post-production—leading to a new way of working with photos themselves—is the Slow Shutter Cam app. This app is designed to let you make long exposures with your iPhone camera, and to specify the length of the exposure (which you can't do with the iPhone's native camera app).

But the fact is that the app allows more artistic freedom than is apparent at first, because you can adjust shutter speed, blur, and exposure *after* the fact—using sliders to choose a single image from a vast array of potential images.

▲ *The Freeze and Exposure sliders in Slow Shutter Cam let you change motion blur and exposure after an image has been shot!*

▶ *While waiting for breakfast in a restaurant, I created this sugar packet image using the Slow Shutter Cam iPhone app. Somewhat astoundingly, Show Shutter Cam lets you adjust effective shutter speed, blur, and exposure after the fact—you tweak these things following composition and image creation, and then save the image to the Camera Roll.*

In other words, I was able to completely control the blur in the impressionistic image of sugar packets I had made by adjusting a slider after the photo had been made.

iPhone 4, using Slow Shutter Cam app.

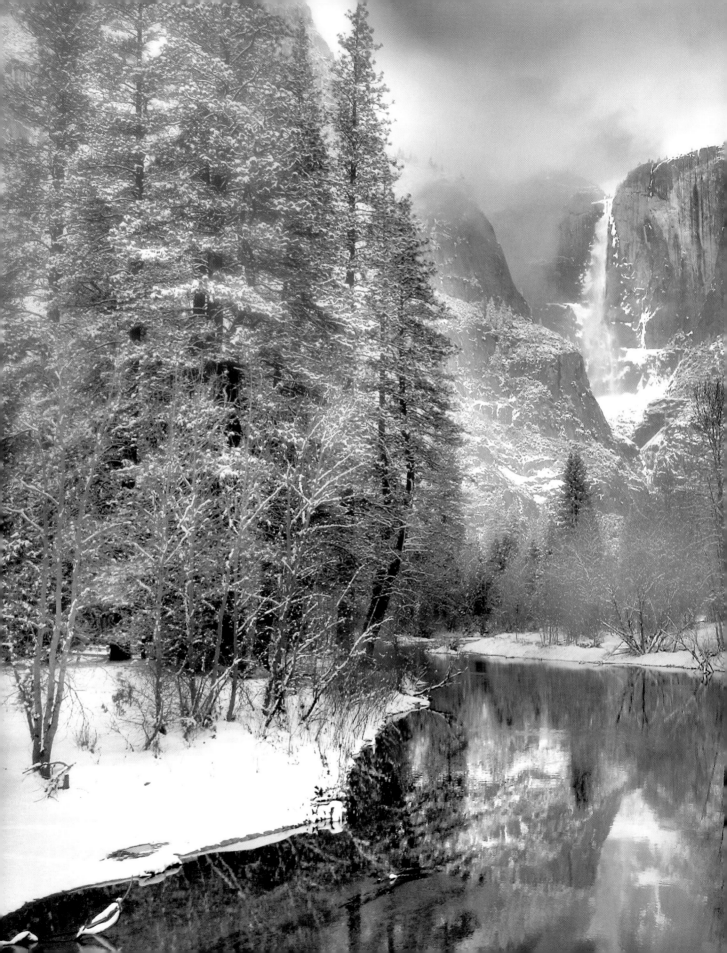

Multi-RAW and
Hand-HDR Processing

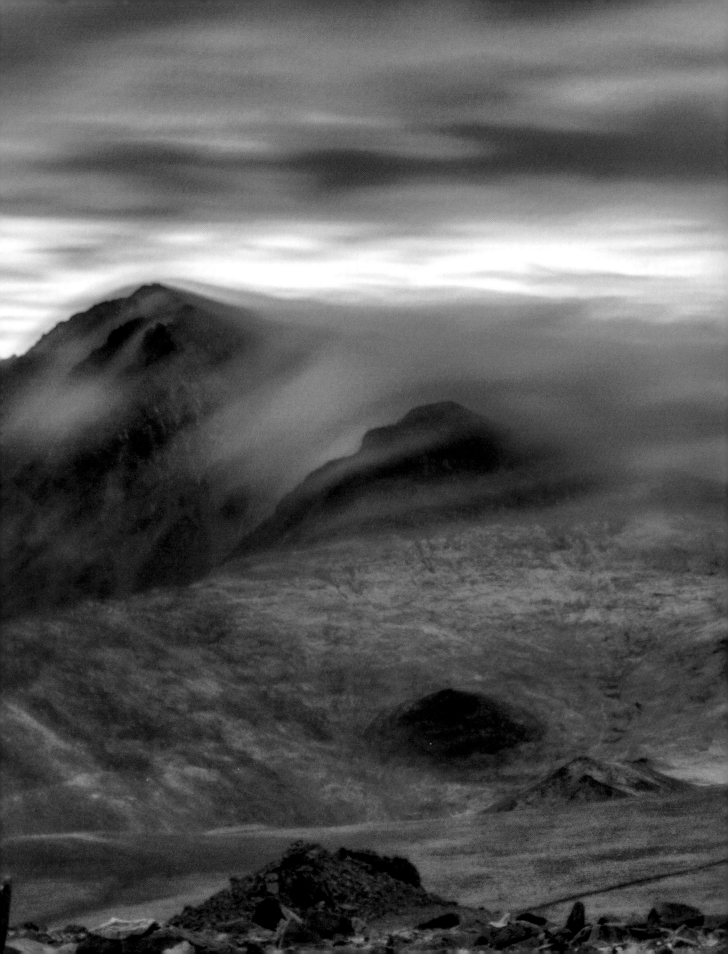

Multi-RAW processing

"This is the purpose of all Zen teaching—to make you wonder and to answer that wondering with the deepest expression of your own nature." —Richard Baker

Expanding tonal range

From almost the very beginning of photography, practitioners have had a problem with the tonal range in their photos. Tonal range, often called dynamic range, refers to the difference that can be captured in an image between the darkest darks and the lightest lights. The problem was that chemical developing and printing processes did not extend the tonal range nearly far enough. With possibilities limited due to the inherent nature of photographic materials, photographers tinkered, tried alternative processes, and burned and dodged ferociously in the chemical darkroom.

Digital photography has not solved all the problems with tonal range—but has made great strides compared to film photography. Everyone can unlock the secrets of extending the tonal range of a digital photo in RAW file format. In this section I'll show you how.

◄ *In the gathering twilight, I could see the clouds swirling as a storm swept across White Mountain Peak in eastern California. The foreground and mountain were quite dark in contrast to the bright sky. I knew that there was no way I could get the image properly exposed with just one shot. But I did know that I could use multi-RAW processing to perfectly expose for both the sky and the foreground in post-processing. So I took my 2-minute exposure with confidence.*

70mm, 2 minutes at f/5.6 and ISO 200, tripod mounted.

The way of the digital photographer as artist is to use concepts such as layers, layer stacks, and layer masks, and techniques such as painting on a layer mask to modify digital imagery. The first part of this book showed you how to understand and work with these concepts and tools. My hope is that you internalized this information, to the point that you can now draw upon it to inform the way you compose and expose digital photos at the time of their making.

All this, however, begs an important question: where does the source material—the photos—come from?

Early on, I explained the difference between JPEG and RAW files (see page 22). If you shoot photos as JPEGs, then you are done—meaning, you have your source material. But if you shoot RAW files, then it is time to derive your images by taking advantage of this hugely flexible format, using the tools I've explained to you earlier in this book.

Processing a RAW file once is good. Most likely you will do a better job of this conversion than your camera. Processing the RAW file two—three, four, or more—times is even better!

The first, and arguably most important, application of multi-RAW processing is to expand tonal range in an image. This means that from a *single* RAW file, you can create an image that is perfectly processed for each significant area in the image. For instance, you can make an image that has a perfectly exposed sky and a perfectly exposed landscape. It's not magic—it's multi-RAW processing.

Expanding tonal range with multi-RAW processing

The easiest way to expand the tonal range via multi-RAW processing is to process the *same* photo twice. This creates *two* images. For example, one image can be processed for a bright sky, and the other image can be processed for a dark landscape.

The two images created from the same RAW file can then be easily combined in Photoshop using the layer and layer-masking techniques you've already learned about in *The Way of the Digital Photographer*. Here's how.

1. In Adobe Bridge, double-click on the image you want to open and process in Adobe Camera RAW (ACR).

Looking through my shots of White Mountain Peak in my studio, I found the one I wanted to process.

2. Move the Exposure slider to the right to "expose" this version of the image for the foreground (about +2EV). The sky will become overexposed, but don't worry!

Move the Exposure slider to the right to "expose" for the foreground.

3. Click the underlined color space and resolution information at the bottom of the ACR screen. This will open a Workflow Options dialog box.

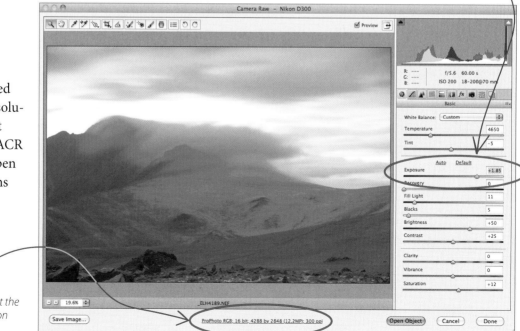

Be sure to click here to set the color space and resolution that your image will use.

4. Using the Workflow Options dialog box, set the Space to ProPhoto RGB, and then click OK.

 By the way, I like to set the Depth to 16 Bits/Channel and the Resolution to 300 pixels/inch.

Use the Workflow Options dialog box to set color space.

5. When you are satisfied with the exposure for the foreground, hold down the Alt key and click Open Copy to open the image file as a copy in Photoshop.

6. Return to Adobe Bridge and double-click on the *same original RAW image a second time.*

7. In ACR, use the Exposure slider to "expose" for the sky. The foreground will become underexposed, but don't worry about it!

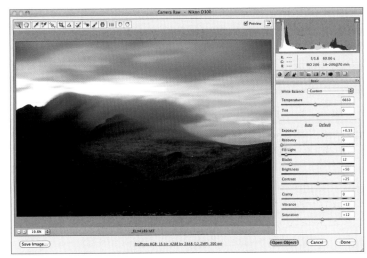

Process the same original RAW image a second time—this time for the sky.

Getting the widest gamut with ProPhoto RGB

It's important to open your RAW files using the ProPhoto RGB color space (for more about color spaces and gamut turn to page 155). It turns out that if you lose gamut (the extent of color that can be described) at this point in the post-production process, it cannot easily be regained. ProPhoto is the widest gamut RGB color space available in Photoshop (it has more color values than Adobe RGB, for example).

In ACR it is easy to set the default to ProPhoto RGB, but not entirely intuitive. If the link shown above is not already set to ProPhoto, click it, and set the color space to ProPhoto RGB. You've now set the default color space that ACR opens to ProPhoto, and preserved the widest possible range of color values for your future use in the post-production process, and in printing. (Perhaps counterintuitively, it is important to preserve color gamut even if you are interested in only making black and white prints.)

In my studio, I have found that it is really important to work in the widest possible gamut (e.g., ProPhoto RGB) right from the beginning. This pays dividends down the road when I print my images for galleries and collectors. It turns out that if you lose the gamut early in post-production, you can never get it back. Keeping as much gamut as possible is important if you want to make high-quality digital prints, whether in black and white or color.

8. When you are satisfied with the exposure for the sky, hold down the Alt key and click Open Copy to open the image file as a copy in Photoshop.

 You will now have two images open in Photoshop, one processed for the sky and one processed for the foreground.

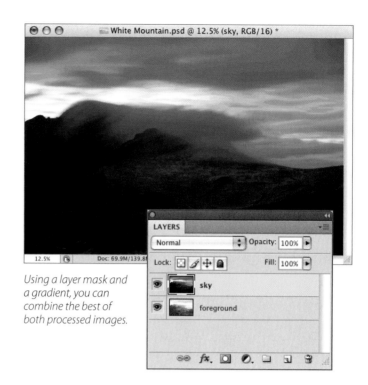

Using a layer mask and a gradient, you can combine the best of both processed images.

9. Copy the image processed for the sky into the image window containing the image processed for the foreground (top right). (See pages 44–45 for copying an image into another image window.)

 For this example, I named the layers "sky" and "foreground.

10. Make sure the "sky" layer is selected in the Layers panel, and add a black Hide All layer mask to the layer. (Turn to page 45, step 2 for directions on how to do this.)

After drawing a gradient on the layer mask, the upper portion of the "sky" layer is visible and the lower portion of the "foreground" layer is visible, making for a perfectly exposed image.

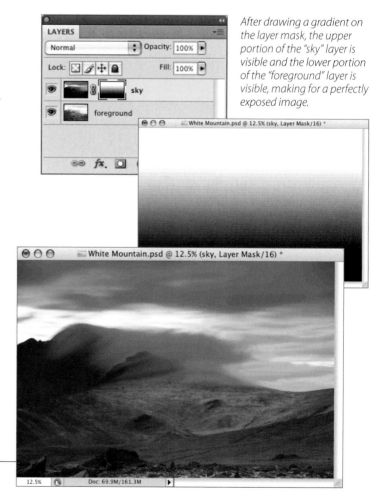

11. With the black Hide All layer mask selected, use the Gradient Tool to drag a white to black gradient from the top of the image window down to the bottom (right). (Take a look at page 61 for directions on how to do this.)

 The two layers will now be seamlessly blended, and the image will show only the best of each layer—a perfectly exposed sky and a perfectly exposed foreground. The finished image is shown on page 106.

All roads lead to Photoshop

The saying is that "All roads lead to Rome." Well and good—but the implication is that there are many of these roads leading to Rome. In this case, "Rome" for those needing to work with layers is Photoshop. Following the metaphor, it is true that there are a number of alternative ways to open and process RAW files (in addition to the technique I just showed you on pages 108–110) before you load them as layers in Photoshop. (But all roads do lead eventually to Photoshop!)

Using Smart Objects

An alternative workflow that uses ACR to open multiple versions processed from a RAW file in Photoshop uses so-called Smart Objects. Smart Objects "remember" their own history, and provided the layer stack isn't merged down, you can alter the properties (such as the ACR exposure settings) used to create the object after it has been opened.

Here's how you can use Smart Objects in a multi-RAW processing workflow:

1. Open the image you want to process in ACR normally, but when it comes time to save it, hold down the Shift key to open it as a Smart Object (or in the Workflow Options dialog box, shown on page 109, select the Open in Photoshop as Smart Objects setting).

2. Copy the Smart Object in Photoshop by choosing Layer ► Smart Objects ► New Smart Object via Copy.

3. With the copied Smart Object active in the Layers panel, choose Layer ► Smart Objects ► Edit Contents (or double-click on the Smart Object's thumbnail in the Layers panel).

4. Change the exposure settings using the ACR controls on the copied layer.

5. Align the copied Smart Object in a stack on top of the original Smart Object as if they both were normal layers, and proceed with masking in a normal fashion.

Using Lightroom

You can use Lightroom instead of ACR to do the initial multiple processing of RAW files, even though the files will ultimately need to be worked on in Photoshop for blending. Here's how:

1. Open the image in Lightroom.

2. Use the Develop module to process a version for the "foreground" layer.

3. Next, make a virtual copy of the image.

4. Send the virtual copy through the Develop module, processing it for the "sky" layer.

5. Open both virtual copies in Photoshop, and proceed as if they had been created in ACR by combining layers, masking, and so on, starting with step 9 on page 110.

Meditation

The foolish reject what they see, not what they think; the wise reject what they think, not what they see. —Huangbo Xiyun

Zen is simply a voice crying, "Wake up! Wake up!" —Maha Sthavira Sangharakshita

Adjusting exposure selectively

You don't have to make fantastic landscape images worthy of an Ansel Adams or Edward Weston to get benefits from using multi-RAW processing. Multi-RAW processing can salvage grab shots with just as much *élan* as it makes great photos greater.

As an example, consider the snapshot of tourists on an observation deck shown at the bottom of page 113. The image seemed funny to me at the time I snapped it, but I didn't have much time to compose this image or worry about exposure.

When I looked at the RAW image, it still seemed humorous to me, but the sky was washed out and the I-Was-Here sign wasn't really readable on the phone screen in the tourist's hands (above right). These problems were easily fixed using multi-RAW processing.

I started with the RAW capture in ACR and processed three versions from the same original RAW file: the first version was processed for the buildings, the second for the sky, and the third for the LCD screen on the mobile phone. (Find out more about processing multiple versions of an image from one RAW file on pages 107–110.)

In Photoshop, I copied the images and combined them as layers into a layer stack (below).

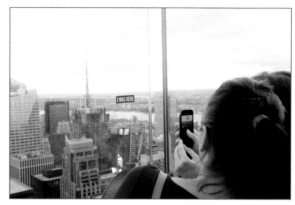

In the as-shot version of the photo the sky was washed out, and the mobile phone screen was too dark.

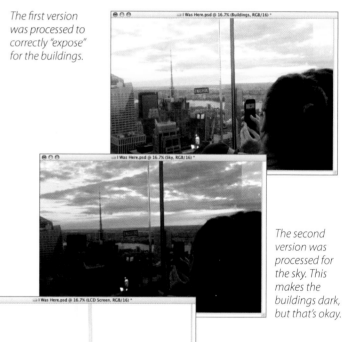

The first version was processed to correctly "expose" for the buildings.

The second version was processed for the sky. This makes the buildings dark, but that's okay.

The third version was processed to correctly "expose" the LCD screen on the mobile phone. The rest of the image is overexposed, but that won't matter once a layer mask is in place.

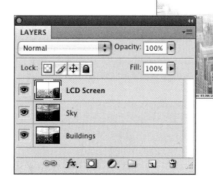

I combined the three versions into a layer stack in Photoshop.

The next step will be to add black Hide All layer masks to the "Sky" and "LCD Screen" layers and then use the Gradient Tool, and the Brush Tool to selectively paint in the areas that I want to see in the finished photo.

Next, I added two black Hide All layer masks, one to the "Sky" layer and one to the "LCD Screen" layer.

With the layer mask selected on the "Sky" layer, I used the Gradient Tool to drag a white-to-black gradient from the top to the bottom of the image window. This seamlessly blended the best parts of the "Sky" and "Buildings" layers. (Turn to pages 59–61 to find out more about the Gradient Tool.)

Finally, I selected the layer mask on the "LCD Screen" layer and used the Brush Tool set with white as the Foreground color to just paint in the area on the phone's LCD screen. (Turn to page 56 for details about painting on a layer mask.)

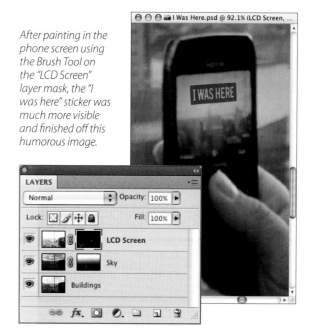

After painting in the phone screen using the Brush Tool on the "LCD Screen" layer mask, the "I was here" sticker was much more visible and finished off this humorous image.

▼ *At sunset on the Rockefeller Center observation deck in New York City, I was looking for photo opportunities. I thought that this scene showing tourists capturing an "I Was Here" sticker was really rather humorous, so I snapped a quick picture. To make the photo work, I used multi-RAW processing to bring out the fact that you can see the sticker in the LCD screen.*

29mm, 1/50 of a second at f/7.1 and ISO 200, handheld.

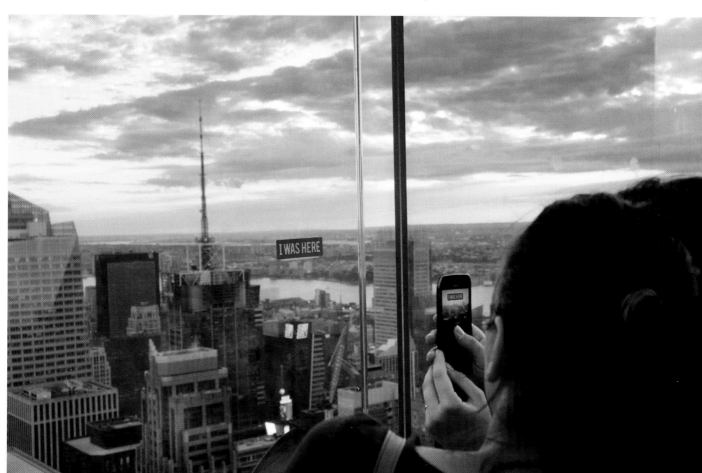

Meditation

The Zen ways and arts draw a
bridge from real artistic creation
(in painting, architecture, poetry)
to artistic skills like flower
arrangement and gardening,
and ultimately to all of everyday
life. —Heinrich Dumoulin

▶ *This ornate, multi-story bridge runs
across a street in midtown Manhattan
between two older office buildings.*

*The challenge with taking this
photograph was that the bridge was
essentially in a darkened "canyon"
between the two tall office buildings.
Bright sunlight was touching a part
of the bridge roof, but the rest of the
structure was in shadow.*

*I knew that if I exposed the photo
correctly for the bridge, the sky would
get completely blown out—and you
can never get any kind of detail out of a
blown-out area in a RAW file no matter
how you process it.*

*Instead, I decided to expose the photo
correctly for the sky, leaving the bridge
quite underexposed. I knew this wouldn't
be a problem in post-processing, though,
because I could easily process a version
of the RAW file that would correctly
render the details and colors in the
bridge.*

*Back in my studio, I processed two
versions of the image from the one RAW
file: one version that correctly "exposed"
for the sky and one that "exposed" for
the bridge. Then, I combined these two
versions in Photoshop using a layer
mask and the Brush Tool.*

170mm, 1/250 of a second at f/8 and
ISO 200, handheld.

Hand-HDR

The things that hurt, instruct. —Benjamin Franklin

If one RAW exposure is good, then many exposures are indeed better. Look at it this way: within a single RAW file there is a potential exposure range of 8 f-stops.

Each f-stop lets in half the light of the previous f-stop. Just so you are clear on the notation, from the viewpoint of letting in light, a full f-stop is the equivalent of one EV (Exposure Value).

However, the range within a RAW file is not entirely usable because image quality deteriorates as you press the limits of what it is possible to recover from the RAW file. So the effective usable range within a single RAW file is more like 4 EVs than 8 EVs.

Whatever the specific limitation of exposure range within a single file, it just stands to reason that you can get a greater range from light to dark by combining layers from multiple files that were created from *bracketing*—the process of progressively varying exposures—rather than from a single exposure.

It's possible to put the files created using a bracketing sequence through an automated HDR (High Dynamic Range) program as explained starting on page 125. However, results that consistently match your aesthetic are more easily obtainable using the very same layering techniques—using layers, layer masks, the Brush Tool, and gradients—that I've already shown you. I call this process "hand-HDR."

I've been told in my workshops that my hand-HDR process is a "pain in the keister" and "too much work." On that note, a prominent reviewer once called my workflow "HDR the hard way." All this may or may not be true—actually I think you'll find the process pretty intuitive and straightforward once you get the hang of it—but it is the only way to get exactly the blend you can see in your mind's eye from a sequence of bracketed files. No automated process is going to do it for you. Creating the blend you want depends on your eye, your imagination, and your Photoshop skills.

◀ *To render this image of a strongly backlit window and the dark interior of a reconstructed historic apothecary at Laws Train Museum near Bishop, California, I shot an extensive bracketed sequence (the bracketed files are shown on page 119 in Adobe Bridge). I processed the sequence by hand, using elements from each of the exposures.*

22mm, eight exposures at shutter speeds ranging from 1.6 seconds to 1/640 of a second, each exposure shot at f/8 and ISO 200, tripod mounted; exposures combined in Photoshop.

More about hand-HDR

If you want to learn in more detail about creating and processing hand-HDR images, and find out about the best workflow to use, please check out my book *Creating HDR Photos: The Complete Guide to High Dynamic Range Photography* (Amphoto), pages 49–88 and 142–152.

Shooting a bracketed sequence for hand-HDR

There are a number of issues to consider in shooting a bracketed sequence for hand-HDR blending in post-production workflow. These include:

- The tonal range you want to capture

- Spacing the exposure sequence

- The mechanism that is best to use to make an exposure sequence

Before I show you how to approach these issues, let me mention that multi-shot HDR blending (whether by hand or automated) tends to be most successful when the original sequence is shot using a tripod. Also, subjects that move usually don't work so well—with some exceptions, because these techniques can be used to create attractive images of moving water and clouds.

Tonal range

The idea is to capture the entire range from light to dark. You can determine this range by metering the lightest lights and the darkest darks in your subject. The light meter in many DSLR cameras in spot-metering mode works well for this purpose. You need to go a bit darker than the darkest dark obtained this way, and a bit lighter than the lightest light.

Generally, the exposure range in most situations with variegated lighting will be in the 10–20 EV range. Note that this is far greater than the usable range within a single RAW file. Since EVs are logarithmic, this translates to at least one hundred times from lightest to darkest.

A caveat is that in some situations one doesn't care about the entire dynamic range, rather only portions of it—for example, just the light half of the exposure histogram (see page 120).

Spacing the exposure sequence

Ideally, you want to capture every exposure in the range in such a way that the exposure value is rendered somewhere in the middle of the histogram. At the same time, overlap doesn't cause problems—you can never have too much information because you can always discard redundant data. So the strategy should be to overshoot. As I like to say in my digital photography workshops, "Film is so expensive!"

I find that a 1 EV exposure differential works well to fit this requirement. It is better to bracket shutter speed than aperture or ISO. For example, if the aperture and ISO are fixed, a sequence I might use would be 1/250 of a second, 1/125 of a second, 1/60 of a second, and so on.

The mechanics of capture

To actually create a sequence there are two approaches. You can use the auto-bracketing function in your camera—which is in some respects easier because it means you don't have to do the math, or touch the camera controls while exposures are sequencing. On the other hand, auto-bracketing may not extend the sequence as far as you'd like, and may not provide pinpoint control over exposure settings.

The second approach is to put your camera in manual exposure mode, and manually adjust the shutter speed between shots. This can work very well if you use a delicate touch, but you need to be sure that the camera is firmly in place on its tripod so you don't create any shake when adjusting the shutter speed.

Understanding the apothecary sequence

If you look carefully at the fine print in the exposure data below each of the frames that I shot of the apothecary shop (right), you'll see

that most of the exposure data doesn't vary. Each exposure was shot at 22mm, f/8, and ISO 200. What varies between the exposures is the shutter speed.

For this sequence, I used a shutter speed of 1/640 of a second at the darkest end and 1.6 seconds at the lightest end. If you do the math, you'll see that this is a variation of 1,024 times from the darkest exposure to the lightest exposure.

Actually, the tonal range is even broader than the 1,024 multiplier makes it seem because each RAW exposure has a considerable potential tonal range.

This kind of exposure sequence is much more feasible if both the subject and the camera are completely stationary. It can be trickier than meets the eye. For example, in the case of the apothecary sequence, I had a hard time getting the tripod physically in position.

Successfully creating an exposure sequence requires mastering manual exposure because the exposure range cannot be accomplished using auto bracketing.

Finally, it's important to understand that shooting a bracketed sequence such as the one to the right has potential benefits beyond extending dynamic range. This kind of sequence, if correctly processed, can be used to add resolution to the final image, and also to greatly improve the lighting conditions present in any single one of the exposures.

_DSC2310.NEF
6/18/12, 12:52 PM
1/25 s at f/13.0, ISO 200
40.0 mm

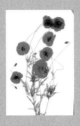

_DSC2311.NEF
6/18/12, 12:52 PM
1/13 s at f/13.0, ISO 200
40.0 mm

_DSC2312.NEF
6/18/12, 12:52 PM
1/6 s at f/13.0, ISO 200
40.0 mm

_DSC2313.NEF
6/18/12, 12:52 PM
0.3 s at f/13.0, ISO 200
40.0 mm

_DSC2314.NEF
6/18/12, 12:52 PM
0.5 s at f/13.0, ISO 200
40.0 mm

May the force be with your florals

The idea behind using multiple exposures to extend your dynamic range is to end up with a final image that shows more variations between lights and darks than a single image could.

But it is a fact of life that sometimes you don't want to use the entire dynamic range of a subject. Images that are intentionally skewed toward darkness are called *low-key*, and images that embrace the light side are referred to as *high-key*.

It is not often recognized that using multiple exposures, hand-HDR, layers, layer masks, and painting in the layers starting from the lightest exposure first is a great way to create extended tonal range high-key images.

This is a technique that works particularly well with floral images that have a partial translucence such as the image of red poppies shown here.

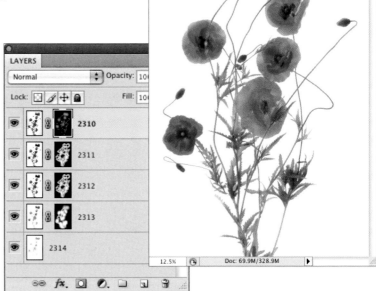

Starting with the lightest capture _DSC2314 at the bottom, I built a layer stack from lightest to darkest, naming each layer using the numbers from the RAW file name.

Then, using layer masks and the Brush Tool, I selectively painted in elements from each layer. This is meticulous work that took me many hours.

▶ *In creating this image of red poppies, I knew I was only interested in lighter exposures. So, while I shot eight exposures (at shutter speeds ranging from 1/100 of a second to 1 second), I only used the five exposures shown in the Layers panel above to blend the image.*

Once the images had been blended using layer masks and painting, I added a background created from a flatbed scan of a sheet of Japanese rice paper to ease the harshness of the stark white background.

40mm macro lens, five exposures at shutter speeds ranging from 1/25 of a second to 1/2 of a second, each exposure at f/13 and ISO 200, tripod mounted; exposures combined in Photoshop.

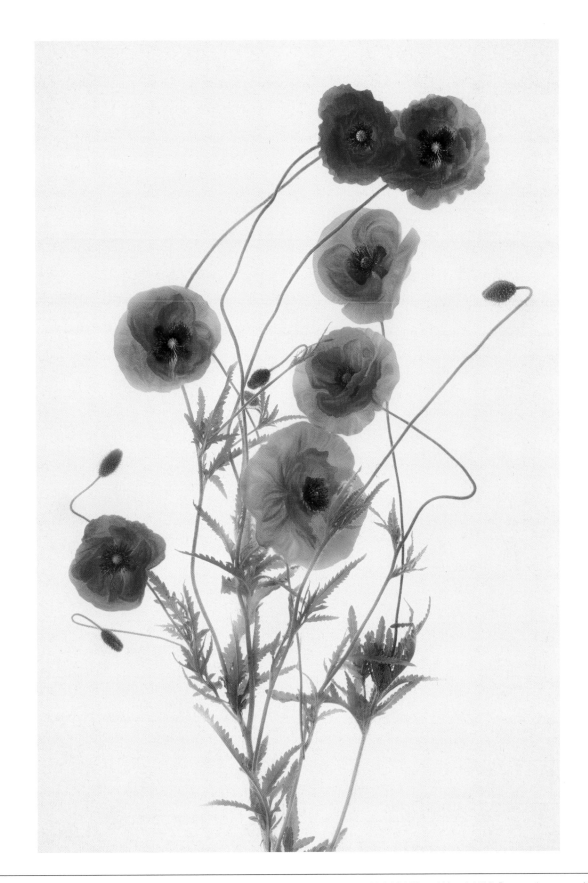

◀ On a sunny summer day, I shot a bracketed sequence of this beautiful, hand-crafted one-of-a-kind Falcon motorcycle in open shade light.

You would think that the shooting conditions would have been pretty easy, but many people were interested in this beautiful machine and were circling it, looking at the amazing details. In fact, one onlooker tripped over my tripod legs, nearly dumping my camera.

When shooting the HDR sequence, I decided not to use the camera's auto-bracketing feature because I knew it would not capture the entire tonal range. Even though I shot a total of ten captures, I knew I probably wouldn't use them all. But it's better to take the time to shoot as many captures as possible, because once the shooting is over, there are no redos. I'd rather have too much material to work with than not enough.

Back at my studio, I combined seven of the ten captures using hand-HDR techniques to bring out the full tonal range of the burnished metal and reflections.

80mm, seven exposures at shutter speeds ranging from 2.5 seconds to 1/200 of a second, each exposure at f/16 and ISO 200, tripod mounted; exposures combined in Photoshop.

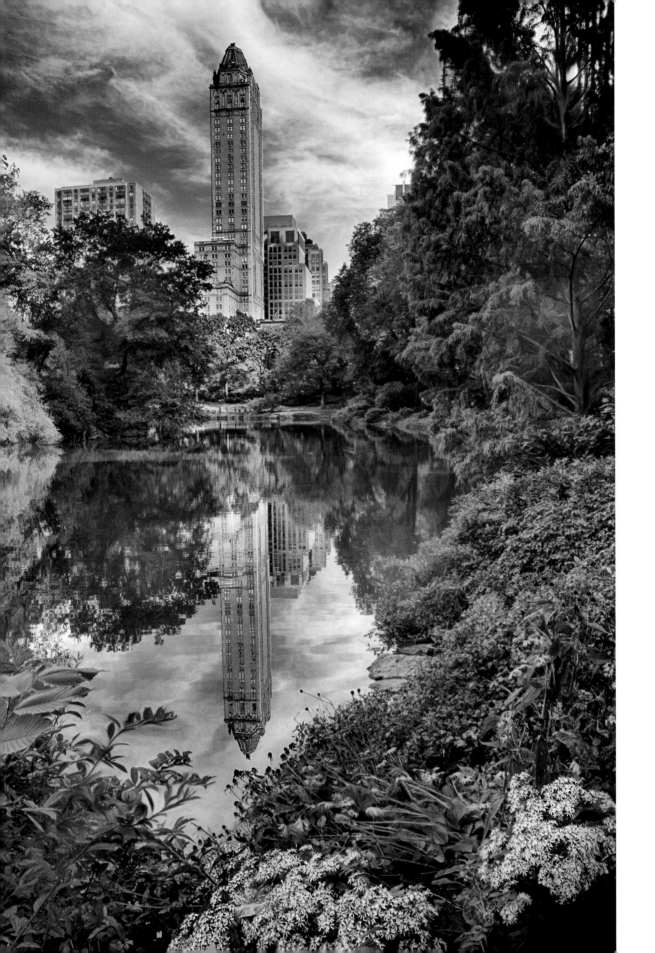

Automated HDR

Sometimes a multi-shot sequence shot for HDR involves more compositional complexity than can easily be blended using hand layering. In other cases, a hand-HDR blended image needs a "kick in the pants" to add more structure in specific areas. These are examples of some of the times that it makes sense to call in the heavy guns of automated HDR programs such as Photomatix, Nik HDR Efex Pro and Photoshop's HDR Pro.

Each of these automated HDR programs works in two steps. First, the bracketed sequence of

◀ *I was visiting New York City with my camera and I had a meeting in the morning with a client who has asked to see what I was shooting. Since I didn't have enough time to create hand layers and masks, I simply ran a bracketed sequence shot in New York's Central Park through Photomatix before processing the image further in Photoshop.*

18mm, six images shot at shutter speeds ranging from 1/2 of a second to 1/320 of a second, each image shot at f/13 and ISO 200, tripod mounted; images combined using Photomatix and Photoshop.

More about automated HDR

If you want to learn in more detail about processing automated HDR using Nik HDR Efex Pro, Photoshop, and Photomatix, please check out my book *Creating HDR Photos: The Complete Guide to High Dynamic Range Photography* (Amphoto), pages 116–135.

images is combined into a high bit-depth file. This file cannot be accurately rendered or viewed on a monitor, or printed.

The second step is to choose from a number of settings and downscale the high bit-depth HDR image into a normal file that can be viewed on a monitor, modified in a program such as Photoshop, and reproduced.

As a practical matter, once you've specified the files to be blended, the first part of this process is essentially automatic.

The second step—sometimes called "applying a tone curve"—usually works by choosing a preset, and then modifying the settings, much as you would with a conventional filter. In fact, it is worth noting that you can use the tone-curve portion of automated HDR software as a filter on a single image to generate pseudo-HDR effects, even if you didn't shoot a series of bracketing images.

While I seldom use automated HDR as the only arrow in my post-production quiver, there are many situations in which a touch of automated HDR adds greatly to the impact of an image that has been primarily processed by hand.

Meditation

"Never trust anything that can think for itself if you can't see where it keeps its brain."
—Arthur Weasley in J. K. Rowling's *Harry Potter and the Chamber of Secrets*.

Automated HDR programs

Probably the most widely used HDR programs are Photomatix from HDR Soft and HDR Efex Pro 2 from Nik Software. There are many similarities between how these two programs work, and also some differences.

Photomatix is the "grand-daddy" of automated HDR programs. It's been around for a while. This program runs as standalone software. Once you've combined your image sequence in Photomatix and applied a tone curve, you can save the resulting file in the TIFF format and bring it into Photoshop.

In contrast, Nik's HDR Efex Pro runs as a plug-in with Adobe Lightroom, Adobe Bridge, and Adobe Photoshop. You can't use it as a standalone program.

Both HDR Efex Pro and Photomatix can be used as a filter within Photoshop—essentially this is applying the "tone curve" portion of the software to an image that already exists. This capability can be used to run an HDR image through the software for a *second* pass.

With both programs, the best approach until you really get to know them is to merge your image sequence and then browse the preset thumbnails that the software provides (some of these preset thumbnails are shown in both programs to the right). Once you've selected the preset that is closest to your artistic vision, you can then use the slider controls to fine-tune what you are going to get.

▲ As a quick and effective way to combine a bracketed sequence of images shot in New York's Central Park, I used Photomatix to preprocess the images. Next, I applied tone curve settings as shown here.

The tone curve I selected was arrived at by first choosing the Compressor–Deep preset, shown as a thumbnail on the right panel above. With this thumbnail selected, I adjusted Tonal Range Compression and Color Temperature to create an image that was in line with my vision. The finished image is shown on page 124.

▲ Nik HDR Efex Pro provides the starting point for an HDR image blend that otherwise would involve quite a complex bit of blending. In fact, if you look at the finished image to the right, the complexity of the curves and shapes of the trees make hand masking a daunting proposition.

▶ On my way to give a workshop at Carmel-by-the-Sea, California, I was fortunate to be able to spend some time photographing at Point Lobos State Preserve near Big Sur, California.

Point Lobos was one of the favorite subjects of classic photographers, including Ansel Adams and Edward Weston, and it is truly one of the most beautiful locations that I know.

The day had been raining, but as I got to Point Lobos the weather cleared. Conditions were bright but overcast, so that colors were saturated but muted.

My idea in capturing this image of one of the trails around Point Lobos was to render the colors and saturation as vividly as I saw them when I was photographing.

The level of detail in the trees, moss, and lichen seemed potentially tedious to process by hand, so I used Nik HDR Efex Pro as a Photoshop plug-in to help me on the way.

34mm, nine exposures shot at shutter speeds ranging from 1.3 seconds to 1/250 of a second, each exposure at f/18 and ISO 200, tripod mounted; exposures combined using Photoshop and Nik HDR Efex Pro 2.

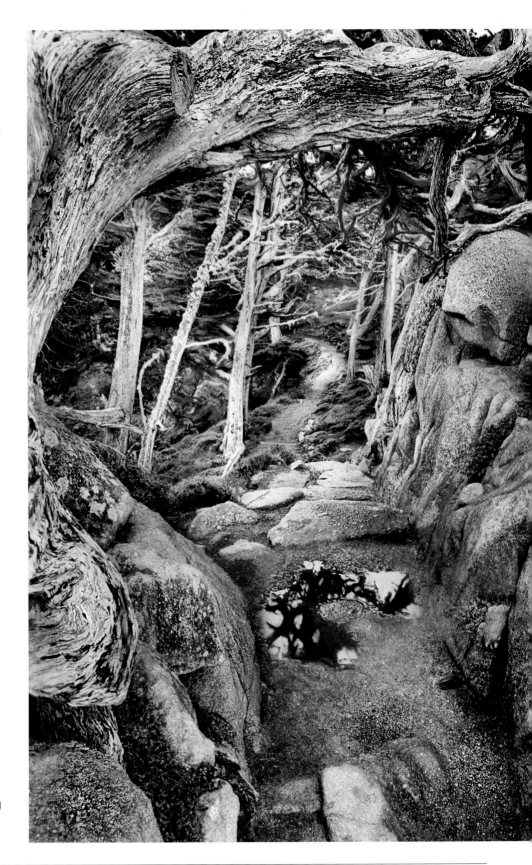

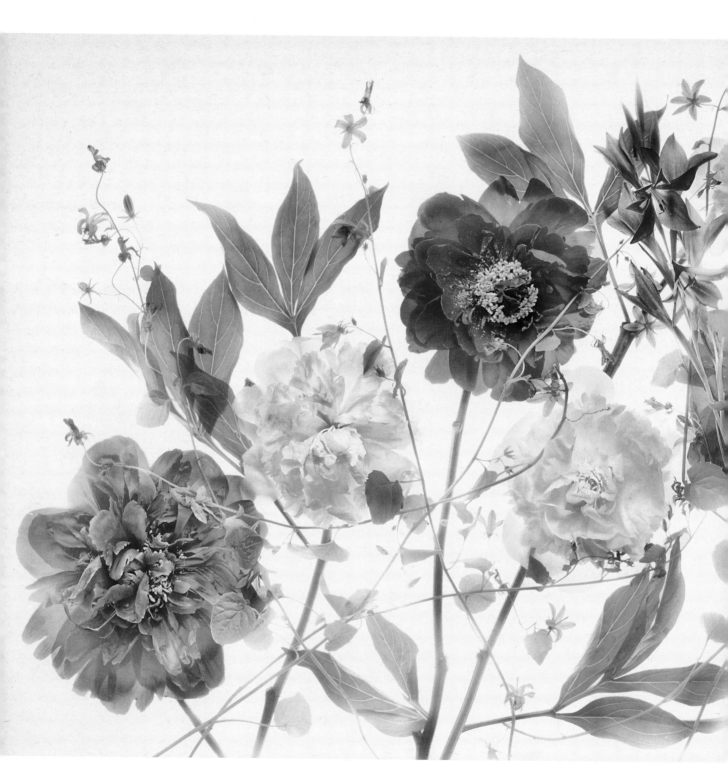

▲ *This image of peonies and campanulas is a panoramic HDR composite. The image was so wide that I had to shoot it in three sections. I shot a bracketed sequence for each section and hand-blended each section individually. Once each section was finished, I masked in a version created using Nik HDR Efex Pro to add definition to the flower centers. With each of the three sections complete, I stitched them together, finally adding a scanned background in Photoshop.*

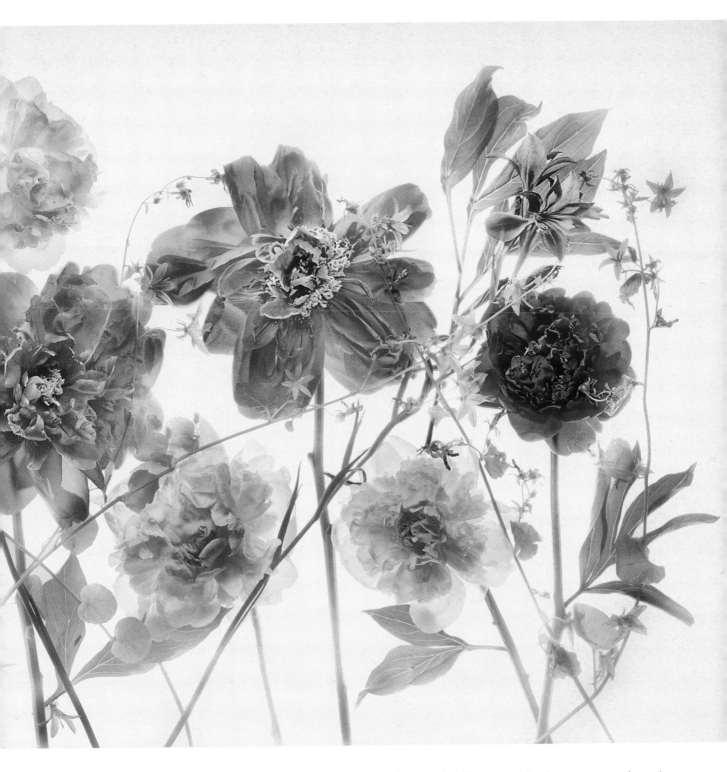

40mm macro lens, three sections of five exposures each for a total of fifteen combined exposures, each section at shutter speeds ranging from 1/4 of a second to 4 seconds, all exposures shot at f/11 and ISO 100, tripod mounted; images combined primarily using hand layering in Photoshop with a version created using Nik HDR Efex Pro to add definition to the flower centers.

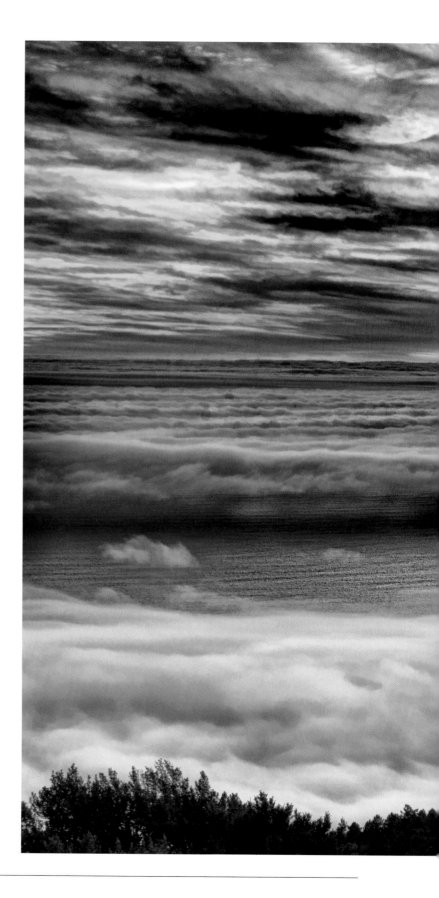

▶ *Wandering the slopes of Mount Tamalpais, north of San Francisco, California, my companion and I stopped to admire the view from an overlook often used as a launch spot by hang gliders.*

While notionally we were peering straight down at the Pacific Ocean, in fact there was a solid wall of white clouds all the way to the horizon.

As I stood watching, I noticed that the clouds were beginning to break up slightly, perhaps parted by the same thermal winds that makes this place such a successful one for hang gliders.

Since the ocean and beach were beginning to come into partial view, I decided to set up my tripod and wait for sunset.

As the sun dipped lower, I realized that the dynamic range from the bright fiery ball of the sun to the dark mountainside in deep shadow would be untenable in a single shot—so I bracketed an exposure sequence that (on the dark side) was able to capture the sun without blowing out (at 1/400 of a second) and was also able to render the very dark parts of the scene (at 1/6 of a second).

28mm, ten exposures at shutter speeds ranging from 1/400 of a second to 1/6 of a second, each exposure at f/8 and ISO 200, tripod mounted; exposures combined using hand-HDR in Photoshop and Nik HDR Efex Pro.

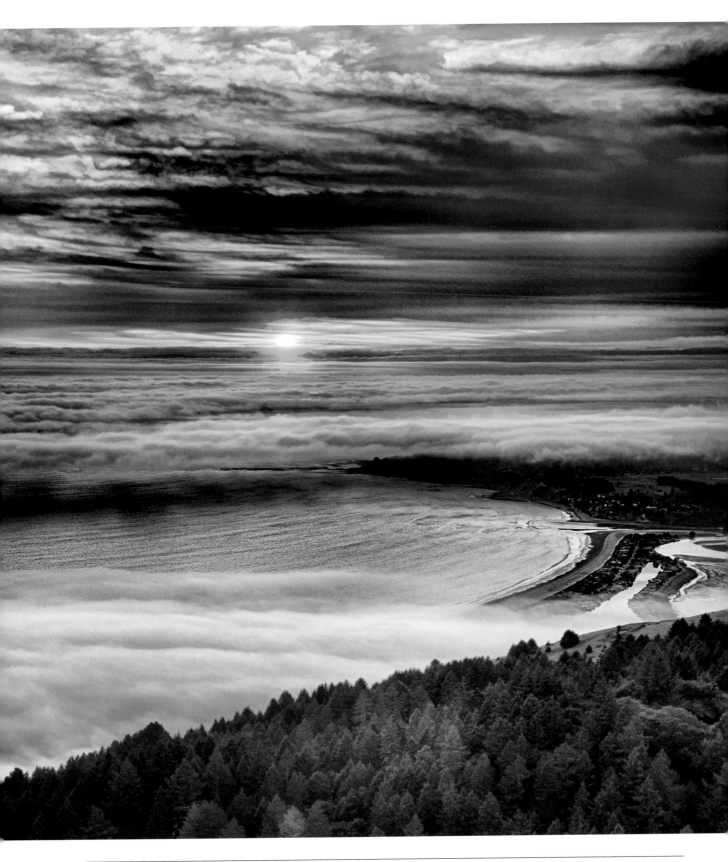

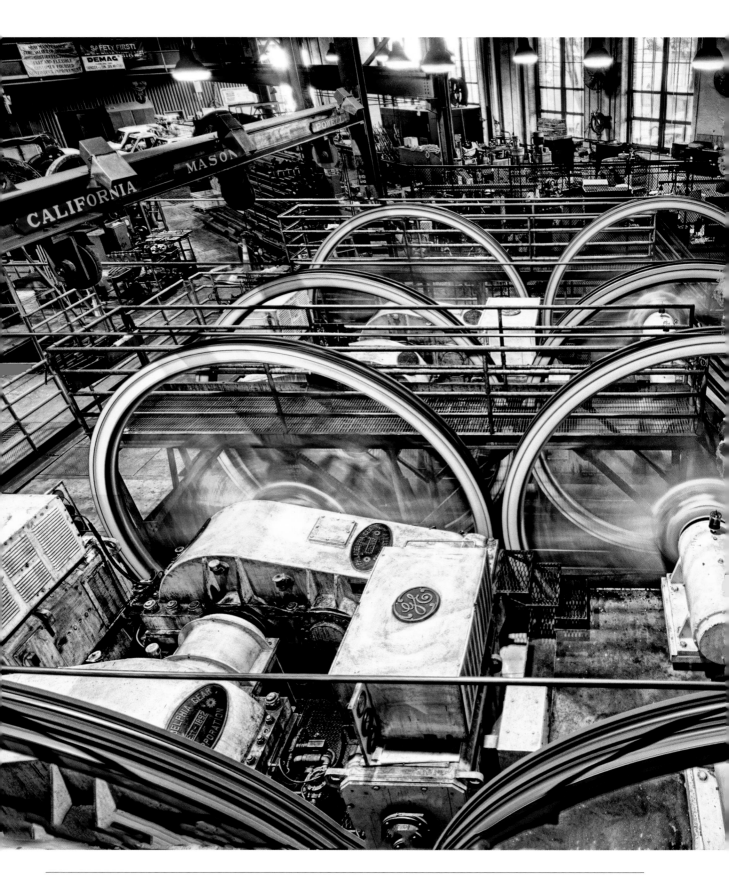

The highlight of the San Francisco Cable Car Museum is the wheels that power the cable cars. These have a somewhat Victorian steam punk look, despite the fact that they are actually powered by General Electric diesel engines. The constantly turning wheels and cables pass through underground tunnels to power San Francisco's famous cable cars.

This kind of Victorian steam punk industrial environment is a great subject for HDR because big wheels, gears, and bizarre-looking machine parts seem to be the kind of subject that even conventional HDR makes look good.

It's important to recognize the possibility of making this kind of image even in low-light conditions, as was the case in the Cable Car Museum.

I combined these manually bracketed images in post-production to create a single HDR image using tools provided by Nik Software, as well as hand-HDR layering in Photoshop.

There were several challenges in post-production. One was to retouch out a man in a red shirt, who appeared as a "ghost"—he was partially rendered—in two of the frames. Another issue involved the motion of the big wheels themselves. Normally, motion is anathema to automated HDR programs because the software just doesn't know what pixels to combine. In this case, however, the blur of the flywheels in motion was actually rendered fairly attractively—particularly as I pasted in a single frame in a couple of places where it needed it.

12mm, seven exposures at shutter speeds ranging from 1/13 of a second to 10 seconds, each exposure at f/9 and ISO 200, tripod mounted; exposures combined using Nik HDR Efex Pro and Photoshop.

Do it on your iPhone: PhotoForge

This works just like Photoshop: There are layers!

With PhotoForge, you can duplicate a layer to work on—or to partially mask the duplicate layer.

S o, I'll bet you didn't know you could do layers on your iPhone. Yes, it's true! PhotoForge is a leading app that has a full implementation of layering on your iPhone. This app allows you to create a layer stack, manipulate opacity and blending modes, create layer masks, and paint on both layers and layer masks—in short, everything you need to use post-production creatively, starting with photos from your iPhone camera as the source material and using your iPhone to do the actual post-production work.

Here's one thing that is really surprising: You can import an image, layers and all from your iPhone into Photoshop—and the layers will be preserved!

As usual in life, just because you can do something doesn't mean you want to do it. PhotoForge's capabilities are nothing short of astounding—and a good reminder of the basic importance of layers to all kinds of photography. But painting on a layer mask with your fingers (or a stylus) on a screen the size of the iPhone gets pretty old pretty fast. Still, if you are stuck somewhere and the iPhone is the only camera you have with you, there's no reason in principle you can't implement a layer stack, blending modes, and layer masks. And I don't know about you, but that is a great comfort to me—it's amazing how many times I find myself on location, waiting for the weather to change, and playing with layers on my iPhone!

Below the layer mask is shown as a small, inset thumbnail in the PhotoForge app.

It can also be displayed as a mask (right) or an alpha channel so you can modify it.

▲ *iPhone Camera+ app, background darkened and partially desaturated in PhotoForge using a duplicate layer and layer mask.*

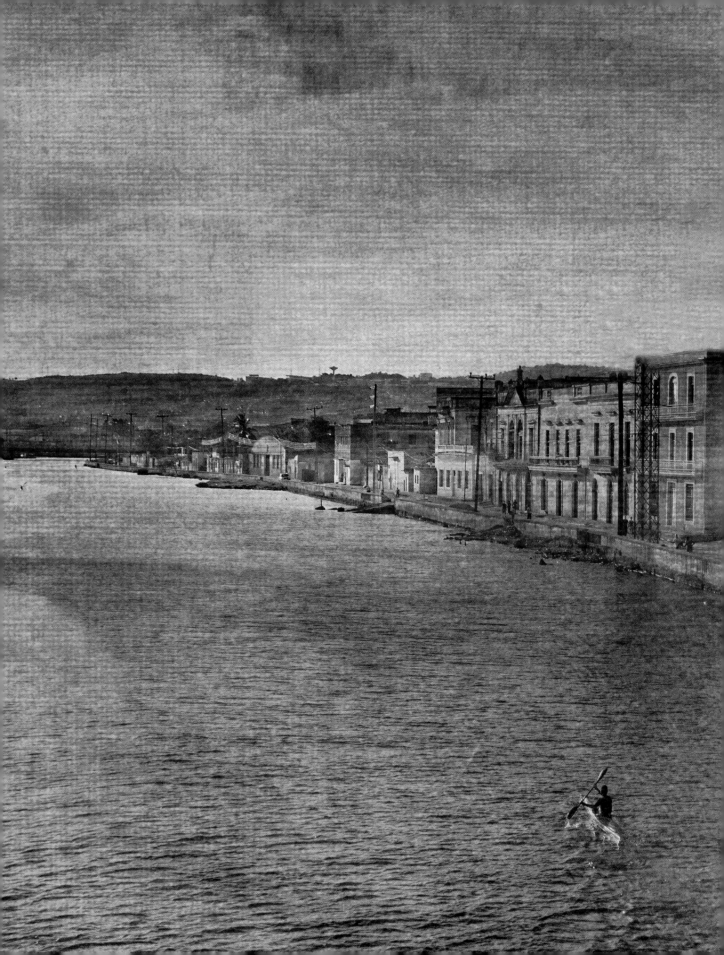

Enhancement to Glory

Workflow redux

Everything in moderation, even moderation. —*Oscar Wilde*

◀ *I shot a model, Kirsten, using a large, strobe-powered softbox as the single source of illumination. The softbox was on a low setting and positioned above and to the right of the model. You can see the reflection of the light in Kirsten's beautiful eyes. The low level of very diffuse lighting, and the position of the single light, account for both the overall attractiveness of the light and the radical light fall-off on the left side of the image.*

To process the image in Photoshop, I used a number of textured overlays on top of the background image of Kirsten. (See page 175.) The trick with this kind of post-processing is not to overdo it. I wanted Kirsten to look as gorgeous as she is naturally, and slightly abstract—but I didn't want the post-production work to make her look artificial.

200mm, 1/160 of a second at f/5.6 and ISO 100, tripod mounted.

▲ PAGES 136–137: *The gritty industrial town of Matanzas, Cuba, is sometimes called the "Venice of Cuba" for the seven rivers that bisect the place. In my mind's eye, as I made this image, I thought of this composition as a Canaletto painting because Canaletto's famous paintings of Venice, Italy, show a long perspective line of a city interacting with the water.*

To fully realize this idea, after processing the RAW file a number of times, I retouched out some antennas and wires because I didn't want traces of modernity to show. As a final, finishing step I overlaid the image with a texture to make it look more like canvas that had been painted on.

27mm, 1/320 of a second at f/9 and ISO 200, handheld; texture overlay used during post-processing.

In the first part of *The Way of the Digital Photographer*, "Digital Photography Is Painting" (pages 18–103), I started by explaining how to work with layers, layer masks, and related tools. There is method in this unusual methodology: The concepts that I showed you how to use are integral to every important post-production step involving creative visualization. To complement this approach, on page 97 I suggested that you keep in mind the importance of organization as you work.

The second part of this book, "Multi-RAW and Hand-HDR Processing" (pages 104–135), showed you how to use the tools from the first part, to begin to creatively post-process imagery using multi-RAW and hand-HDR processing. This creative post-processing is something you should keep in mind as you compose and shoot your photographs.

This final part, "Enhancement to Glory," takes you on to image glory by showing you various approaches to add pizzazz and finish your images once the basic elements are in place.

From a workflow perspective, there are many possible approaches that can be taken when you are working to finish an image. I will show you some of these ideas in this section. The key things to bear in mind are that there is no one right way to proceed, that some steps may need to be repeated, and that your adjustments should work to implement *your* visual idea for your image.

The diagram on page 140 shows this flow of photographic and post-processing techniques and ideas.

Checkpoints

A good reason—but not the only reason—for working with layers and layer masks is to be able to reverse a "move" if you have gone too far or if you do something you don't like. For example, if you are painting with white on a black Hide All layer mask to reveal selected portions of an underlying layer and you reveal too much, it is easy to partially reduce the effect using a brush loaded with gray.

In Photoshop, flattening a layer stack is pixel destructive: You can't go back once the flattened file is saved and closed. So taking advantage of the reversible and archival properties of layering is really important. You need to create a system

of *checkpoints* to preserve these layers as you work. That way, you'll never have to go back too far if you go too far!

Every time I hit a major step in the editing process, I save a version of the file. This is what I call a checkpoint. Usually the version is multi-layered. As a next step, I flatten the layers so I'm back to a single-layer image, and then I save a copy under another name, using the sequential naming system explained on page 98.

The internal layers of each saved file allow me to track my progress—particularly if I've named the layers carefully—and let me go back to an earlier checkpoint if I need to.

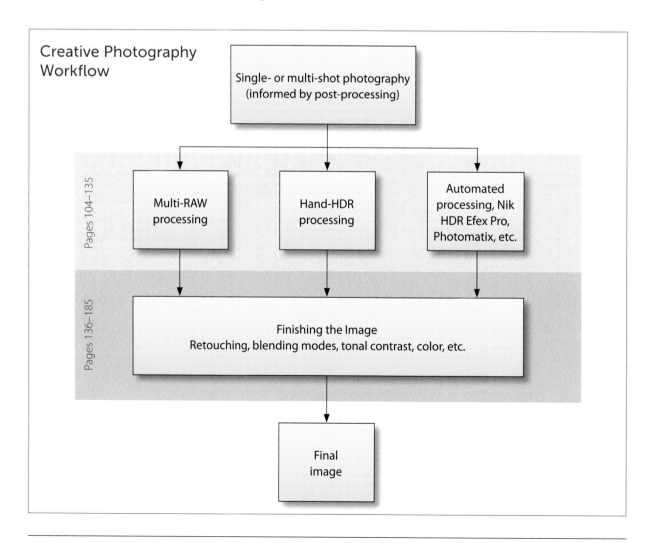

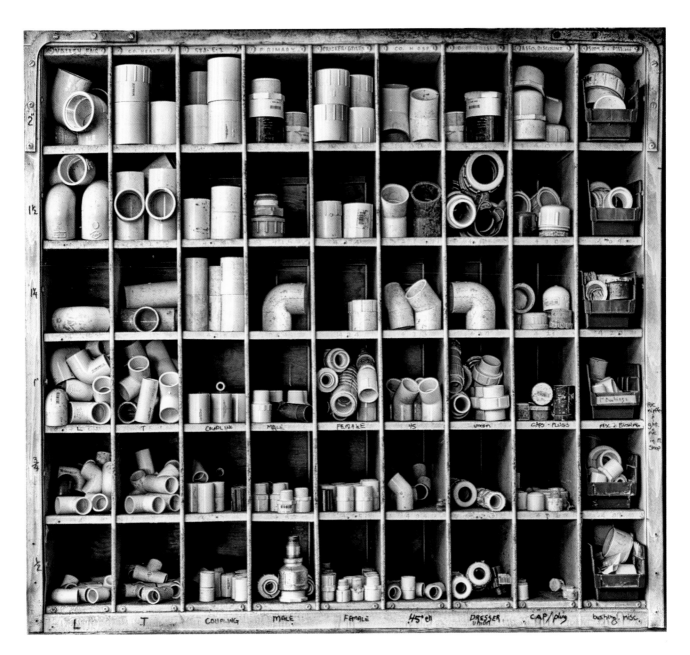

▲ *To make this image of spare plumbing parts neatly stored in rectangular bins within an overall square, I first bracketed exposures as described on pages 118–119. I combined the images using hand-HDR layering (pages 117 and 143–151) and an automated HDR blend created using Nik HDR Efex Pro. Next, I cropped the image so it would be square, and used Photoshop's transformational tools to modify the interior contents so that they seemed to be all squared away.*

38mm, five exposures at shutter speeds ranging from 1/25 of a second to 2 seconds, each exposure at f/10 and ISO 200, tripod mounted; exposures combined using Nik HDR Efex Pro and Photoshop.

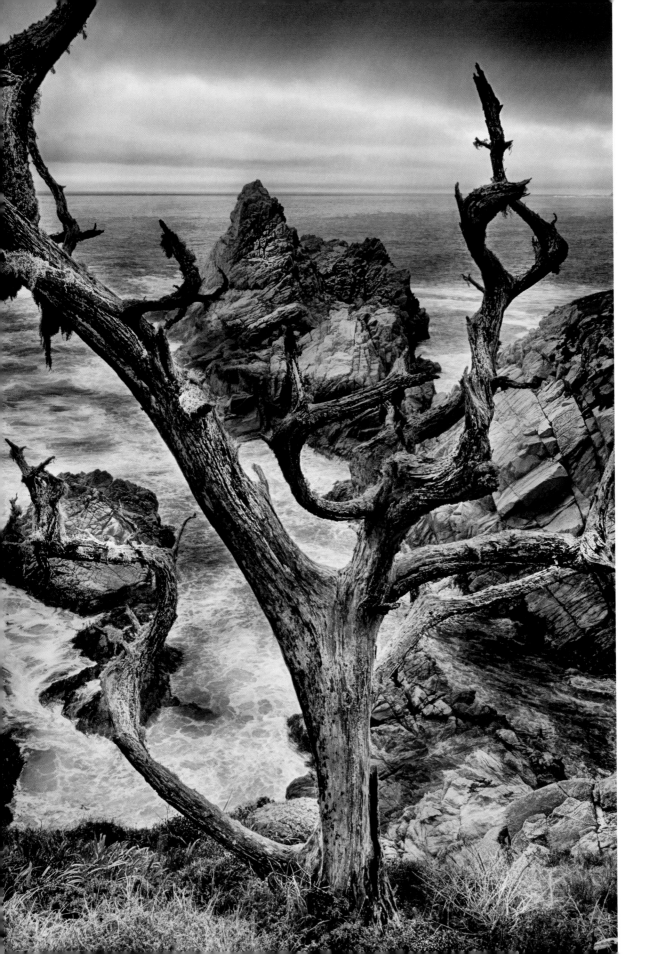

Tripping the light fantastic

Truth is found neither in the thesis nor the antithesis, but in an emergent synthesis which reconciles the two. — *Georg Wilhelm Friedrich Hegel*

It all starts with a single layer. But as you start to think about what you are going to do with that layer once it has been duplicated—the creative possibilities are limitless.

The good news is that if you've been following *The Way of the Digital Photographer*, you've already done most of the heavy lifting. You know how to work with layers, layer masks, and blending modes (pages 18–101), and you know how to bring RAW exposures (pages 104–133)—and bracketed sequences of RAW exposures—into Photoshop.

What's left is playtime! I'd like to start you with some thoughts about some of the ways I like to play in the digital darkroom.

◄ *I was lucky to be able to spend a little time photographing at Point Lobos on the coast of California between Carmel and Big Sur. The weather was perfect: raining when I got there but quickly turning to clouds with chiaroscuro lighting effects.*

The contrast between clouds with shafts of light and rain-swept vistas led me to play with a variety of effects in post-production to increase tonal and contrast ranges in the image, and to create painterly effects, without deviating too greatly from the scene as it appeared when I shot the image.

26mm, seven exposures at shutter speeds ranging from 1/4 of a second to 1/250 of a second, each exposure at f/18 and ISO 200, tripod mounted; exposures combined using Nik HDR Efex Pro and Photoshop.

As I've said, between filters, adjustments, and blending modes, the possibilities are literally infinite. So it is important to not get overwhelmed.

You should experiment, but as you experiment keep track of what you are doing—and from time to time sit back and rethink it.

I like to work in paired sequences, where the paired adjustments oppose one other. For example, if you duplicate a background layer twice, and put one of the duplicate layers into Screen blending mode and the other into Multiply blending mode, then the Screen and Multiply blending modes are moving in opposing directions.

There's almost no filter or adjustment that should be used overall at 100% opacity. Making any radical move at 100% is probably going to be a bad idea. You should think incrementally, and use selective painting and low-layer opacities.

The idea is that an adjustment should be meaningful, but just below conscious visual perception. My strategy often is to do my work, save a layer stack, then take the opacity just a tick below where what I just did is noticeable. This maintains control of the process, and does not overwhelm the viewer with apparently dissonant visual elements—because the dissonance has been cloaked by the lack of full opacity.

Once you know how to work with layers and layer masks, and how to get your photos into Photoshop, it is time to fully express yourself and have fun. Enjoy!

Why be average?

Here's an example of the way I like to play with images using paired adjustment sequences.

On my way to teach a workshop in Carmel, California, I had a few extra hours, so I explored the beautiful landscape of Point Lobos, on an overcast afternoon.

Walking about, I found an old tree that looked almost like a Henry Moore sculpture. I knew I couldn't get the entire tonal range of the scene by taking only one photograph. There was a bright strip of sky, looming black clouds, white surf, bushes, and the bark of the tree itself. Lights, darks, and everything in between. One "average" exposure (upper right) just wasn't going to cut it.

If I had just seen this average exposure image and known what I do about multiple image processing and post-production, I wouldn't have been impressed. This image would have ended up in my trash pile as uninteresting and with insufficient tonal range. My photos can be average, but I don't let them!

Following the way of the digital photographer, and using the techniques I've explained here, I knew I could get interesting results despite the dynamic range problem if I shot a bracketed sequence of seven exposures. These bracketed exposures are shown in Adobe Bridge (below), starting with a very light exposure at 1/4 of a second and moving my way through the scene's tonal range by doubling the exposure time with each successive photo, until I finished the sequence at 1/250 of a second.

To start processing the sequence of images, I brought them into Photoshop using automated HDR processing and some individual processing of RAW exposures (middle below). Now that I had a base to work from, I was ready to start playing with paired adjustment sequences.

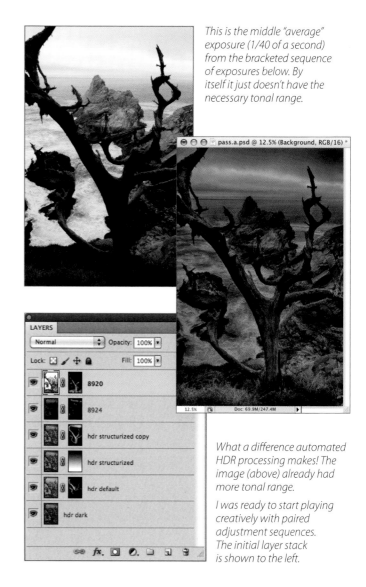

This is the middle "average" exposure (1/40 of a second) from the bracketed sequence of exposures below. By itself it just doesn't have the necessary tonal range.

What a difference automated HDR processing makes! The image (above) already had more tonal range.

I was ready to start playing creatively with paired adjustment sequences. The initial layer stack is shown to the left.

I used this bracketed sequence to construct the image shown in its final version on page 142.

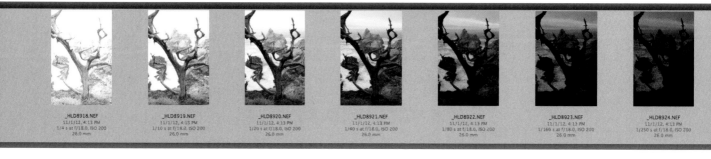

First pair: Multiply and Screen blending modes

The idea behind using Multiply blending mode and Screen blending mode in a matched pair is to very carefully and selectively darken and lighten the overall image. This is a technique that I will sometimes perform many times over the course of finishing an image.

To use this technique, start with a Background layer. Duplicate the Background layer twice. Change one duplicate layer to Multiply blending mode (turn to page 83 for more about Multiply blending mode), and the other to Screen blend-ing mode (see page 73 for details about what Screen blending mode does). Add a black Hide All layer mask to each duplicate layer (see page 45, step 2 for directions on how to do this), and selectively paint in the areas you want to change using a white brush and the layer masks (turn to page 46 for info about painting on a layer mask).

After you've completed this process, it is a good idea to experiment with the overall layer opacity sliders on the Layers panel (explained on page 35) to make sure that the effect is subtle and not overwhelming. I often find that I lower the overall Opacity of both the Screen and Multiply blending modes to about 30%.

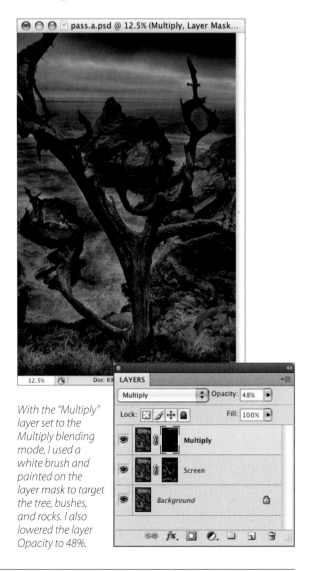

On the "Screen" layer, I used a white brush on the layer mask to paint in the dark clouds at the top of the image and the surf. This added more depth to the image. I left this layer at 100% Opacity.

With the "Multiply" layer set to the Multiply blending mode, I used a white brush and painted on the layer mask to target the tree, bushes, and rocks. I also lowered the layer Opacity to 48%.

Second pair: Sharpening and blurring

Another matched—and opposite—pair is to sharpen and blur. The idea here is to selectively sharpen the subject matter that is most important, for example the tree in the foreground of the Point Lobos image. If you blur the rest of the image, then the difference between the sharpened tree and the rest of the image makes the sharp subject stand out.

There are many possible tools you can use to both sharpen and blur, but for this double adjustment you can use the tools that come with Photoshop: the Smart Sharpen filter and Lens Blur filter will work well.

Once again the process is to duplicate the background layer twice, apply sharpening to one of the duplicate layers and blurring to the other, and then use layer masks and painting to control the areas where the effects should be applied.

The impact of applying this pair of adjustments is to visually make the sharpened part of the subject stand out from the blurred background—a potentially very effective way to enhance an image.

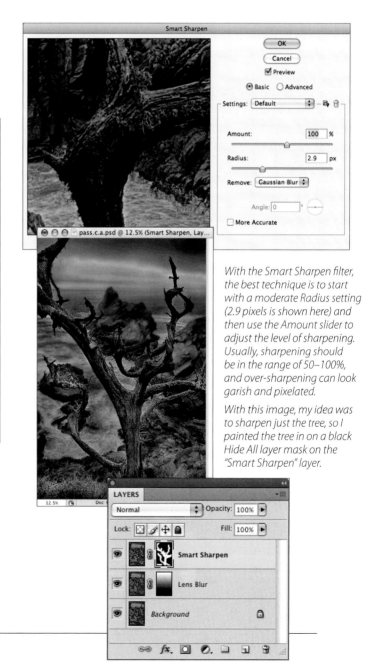

The Lens Blur filter can be used to simulate optically created blur. With this image, I used a gradient on the "Lens Blur" layer's layer mask to apply the blur effect to the top of the image, but not to the bottom.

With the Smart Sharpen filter, the best technique is to start with a moderate Radius setting (2.9 pixels is shown here) and then use the Amount slider to adjust the level of sharpening. Usually, sharpening should be in the range of 50–100%, and over-sharpening can look garish and pixelated.

With this image, my idea was to sharpen just the tree, so I painted the tree in on a black Hide All layer mask on the "Smart Sharpen" layer.

Third pair: Glamour Glow and Tonal Contrast

Nik Color Efex Pro is a Photoshop add-on that provides a massive number of filters, some of which are superb. Rather than blurring and sharpening, I often like to use two of the Nik Color Efex filters as matched and opposite pairs. One good example of this kind of filter opposition are the Nik Glamour Glow and Tonal Contrast filters.

The conventional use of Glamour Glow is in beauty shots, primarily of the human female. I find this filter also works well with landscapes and flowers. (Don't forget that nature is beautiful!) This filter tends to create attractive edges, hide defects, and promote an overall slight blurring.

The tendencies of the Tonal Contrast filter are equal and opposite: Edges are sharpened, and tonal range is increased.

As with the sharpening-blurring dyad, I use this pair of filters to increase interest in specific subject matter against an overall background that is slightly softened.

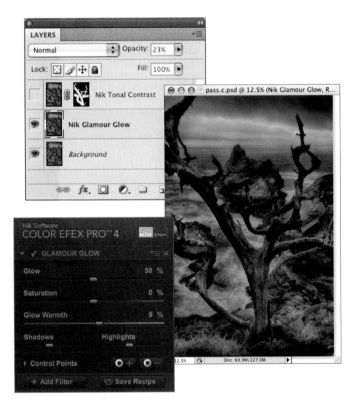

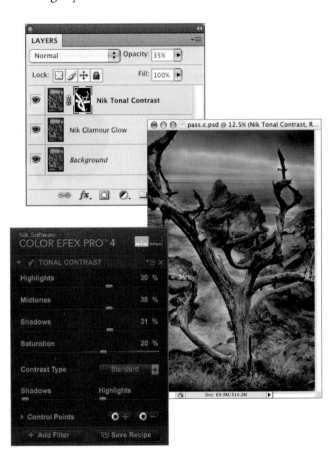

Most of the time, I use the Glamour Glow filter to add "Glow," leaving the Saturation and Glow Warmth sliders alone. The reason for this is that adding Saturation and Glow Warmth can easily produce an over-the-top effect.

One great feature of Nik's Color Efex filters is that you can save filter settings as a "recipe." My formula of 50% Glow and 0% Saturation and Glow Warmth is saved so I can easily access it with one click.

Even with these settings, I usually take the entire layer Opacity down to about 30%.

Nik's Tonal Contrast filter is a powerful tool with a number of different contrast types that you can select using the Contrast Type drop-down list. Be careful of overdoing this filter with anything other than Standard Contrast Type!

My standard recipe for Tonal Contrast is to increase Saturation by about 20%, and to increase Highlights, Midtones, and Shadows to about 30%.

Even with these relatively low settings, I usually mask the application of Tonal Contrast and lower the Opacity of the overall layer.

A second helping of HDR

I've noted that you can run a single image through the tone curve portion of software like Photomatix and Nik HDR Efex Pro. What happens when the image you are running through this software was derived from this software in the first place?

There's actually no way to know until you try, but I've found that effects generated in this way can be surprisingly painterly. As always, you need to be selective as to where you apply an adjustment created in this way, and don't overdo the opacity!

To run HDR Efex Pro 2 a second time as a filter on an image, first duplicate the Background layer of the image. Then with a duplicated layer selected in the Layers panel, choose Filter ▸ Nik Software ▸ HDR Efex Pro 2.

With Photomatix, first duplicate the image you want to adjust. Next, open the duplicate image in Photomatix and select Tone Mapping from the menu bar.

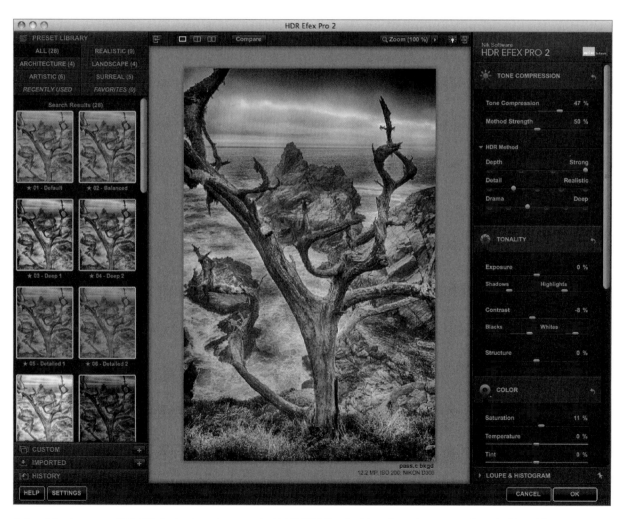

As I explained on pages 126–127, the best way to proceed with Nik HDR Efex Pro 2 is to first select a preset from the Preset Library thumbnails shown on the left. The preset 04 – Deep 2 is selected above. Once you've chosen a preset, you can adjust many aspects of the effect, including Tone Compression, Exposure, and Saturation using the sliders on the right side. When you are finished making adjustments, click OK to return to Photoshop. Note that if you have a combination of settings that you particularly like, you can save the settings as a Custom preset.

Pushing the boundaries: Pixel Bender

Pixel Bender is a group of filter effects available for free download from Adobe Labs. The most useful Pixel Bender filter is Oil Paint, which creates images that appear to have been created using oil paint and a brush (see page 53 for an example).

Generally, I will leave most of the Oil Paint settings set to the default, and play with the Cleanliness slider (the second from the top). It's important to position this slider so that the shapes with the Pixel Bender transformation look nearly natural.

This is a really neat filter, but if overdone it can look horrible and detract from your image. Be particularly careful of Pixel Bender's tendency to put a dark line in light areas of an image. This can look very unnatural.

I then selectively apply the Pixel Bender Oil Paint filter to areas of the image that look like they could use some interpretative painting—of course at low opacity so it is not necessarily obvious to the viewer that I have applied this filter.

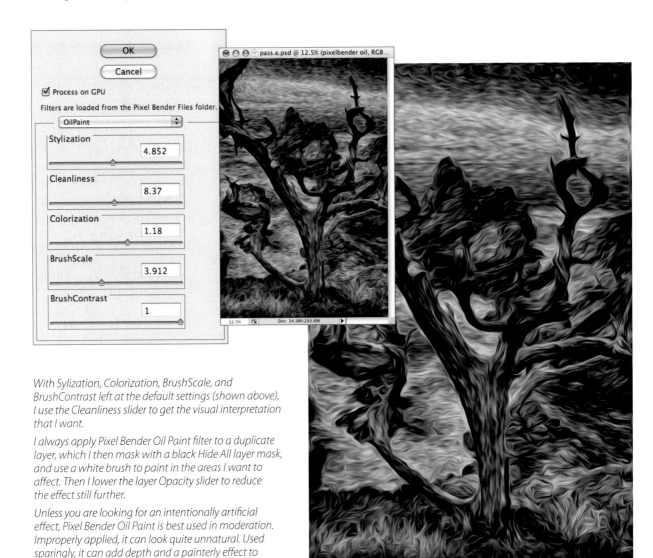

With Sylization, Colorization, BrushScale, and BrushContrast left at the default settings (shown above), I use the Cleanliness slider to get the visual interpretation that I want.

I always apply Pixel Bender Oil Paint filter to a duplicate layer, which I then mask with a black Hide All layer mask, and use a white brush to paint in the areas I want to affect. Then I lower the layer Opacity slider to reduce the effect still further.

Unless you are looking for an intentionally artificial effect, Pixel Bender Oil Paint is best used in moderation. Improperly applied, it can look quite unnatural. Used sparingly, it can add depth and a painterly effect to subjects such as human hair, tree branches, and textiles.

Some other painterly filters

I can't emphasize enough that there are many filters you can experiment with. For painterly effects, besides the Pixel Bender Oil Paint filter, I'd particularly suggest the Artistic filters that ship with Photoshop and the Topaz Simplify filter pack. The filters are shown applied in a "painterly" part of my workflow in the Bolinas, California, image.

A
B
C
D
E
F

I use many filters to add a more painterly effect to my images. However, if you look closely at the black Hide All layer masks attached to each layer shown above, you'll see that just a small portion of the filtered layer is painted into the image.

The letters in the blue circles next to each layer above correspond to the sample windows and settings shown to the right.

Applying filters to your images

Try playing with the filters that come with Photoshop and other great filters such as the ones from Nik Software and Topaz Labs.

You can add any kind of painterly effect to your images using a duplicate layer, layer mask, and the Brush Tool to selectively paint the effect in. Don't forget to lower the layer Opacity setting so the effect is almost subliminal. That way, the effects you use enhance your images in a subtle way.

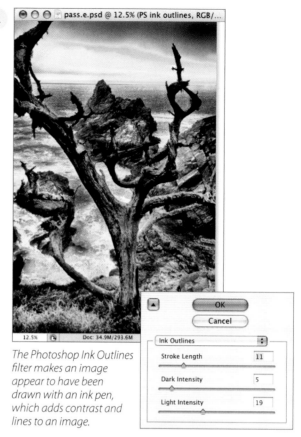

The Photoshop Ink Outlines filter makes an image appear to have been drawn with an ink pen, which adds contrast and lines to an image.

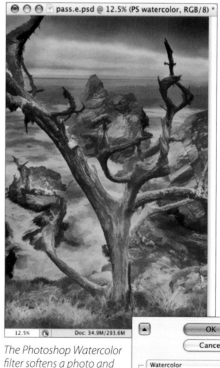

The Photoshop Watercolor filter softens a photo and makes it appear mottled, as though it had been painted on absorbent watercolor paper.

C

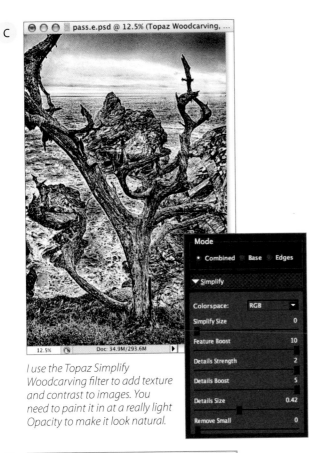

I use the Topaz Simplify Woodcarving filter to add texture and contrast to images. You need to paint it in at a really light Opacity to make it look natural.

E

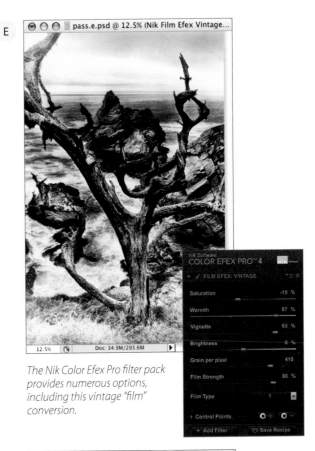

The Nik Color Efex Pro filter pack provides numerous options, including this vintage "film" conversion.

D

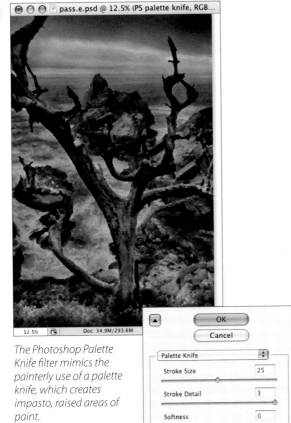

The Photoshop Palette Knife filter mimics the painterly use of a palette knife, which creates impasto, raised areas of paint.

F

The Topaz Simplify BuzSim filter is a popular way to soften and increase saturation in an image.

▶ *Wandering though one of the slot canyons near Page, Arizona, I looked up to see a tunnel of light coming through gaps in the rock formation.*

To reproduce the scene that I saw with my eye, I knew that I would need more than a single photo to capture the wide tonal range. The tiny bit of sky peeking through the rock was extremely bright and the rock formations farther down on the cave's ceiling were shadowed and quite dark. Looking at the lights and darks, my understanding of post-processing informed my ability to conceptualize an exposure sequence that could be combined and processed to create this image digitally.

This was a very difficult photographic environment because sand was blowing everywhere. I couldn't put anything down and I had to keep all my equipment, except for what I was using, in my kit bag on my back while taking the exposures. So, I carefully set my camera controls to get ready for manual bracketing (as explained on page 118), and then quickly removed the lens cap for the minute needed to take a sequence of four exposures.

Back in my studio, I processed the images and then used a number of paired adjustments as described on pages 142–151. I used Multiply blending mode to take down brightness in some areas in combination with Screen blending mode to open up shadows. I applied Glamour Glow at 30% Opacity to enhance the quality of the light and Tonal Contrast at 25% Opacity to emphasize the beautiful striations in the rocks. Finally, I selectively sharpened the edges of the rock formations to create a sense of space, depth, and separation.

18mm, four exposures with shutter speeds ranging from 1 second to 10 seconds, each exposure at f/22 and ISO 200, tripod mounted; images combined in Photoshop.

Using LAB inversions

Work in as wide a gamut as you can, for as long as you can. —Harold Davis

The colors you see in a photo, or on display in a program like Photoshop, are created using a *color model* (sometimes called a color space)—by whatever name a domain of color value described using a mathematical formula, most significantly a color's channels.

You are probably familiar with RGB color, in which the Red, Green, and Blue channels are added together to create colors that are displayed on computer monitors, or on the Web.

Another familiar color model is CMYK. In CMYK, Cyan, Magenta, Yellow, and Black channels are used subtractively to render color imagery in books like this one.

LAB is yet another color model, with some very interesting characteristics from the viewpoint of photography that I'll get to in a moment. The underlying color calculations in Photoshop are performed in LAB, but it is largely a theoretical color space in the sense that you can't print a

LAB image or display it on the web without first converting it back to CMYK or RGB.

It's worth noting that LAB has the widest *gamut*—or range of colors—of any color space (see the color gamut drawing below). In fact, there are colors that can be specified in LAB that cannot be perceived, rendered, or reproduced.

Color Space Diagram

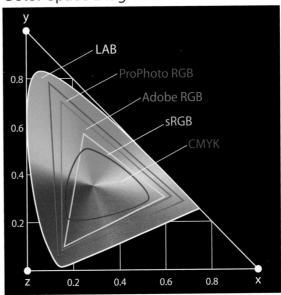

This diagram shows the approximate relative extent of color spaces. The LAB color space includes colors that cannot be rendered or reproduced.

◄ *To make this image I used a macro lens, and shot twenty-one exposures of a wet spider web in the early morning sun. Most were underexposed to bring out the color saturation and to let the background go dark. I combined the exposures as layers in Photoshop using a variety of blending modes, and was pleased to see that the result was essentially an abstraction.*

105mm macro lens, twenty-one exposures, each exposure at 1/3200 of a second, f/3.5 and ISO 200, tripod mounted; exposures combined in Photoshop.

Meditation

If a color can't be seen or reproduced, what does it look like?

Understanding the LAB color model

In LAB, there are three channels: L or Lightness, which contains the grayscale information; A, which contains magenta and green information; and B, which contains yellow and blue information as shown in the diagram below. There are two notable points about this setup:

- Lightness, also called luminance or gray-scale, information is separated from the color information in the image. This means it can be operated on independently of the color information.

- Each channel is *color-opponent*. This means that small adjustments on a channel can have big effects on the color values of an entire image.

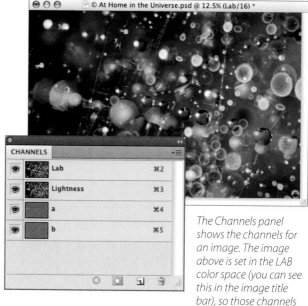

The Channels panel shows the channels for an image. The image above is set in the LAB color space (you can see this in the image title bar), so those channels appear in the Channels panel. If you don't see the Channels panel in the Photoshop window, choose Windows ► Channels to open it.

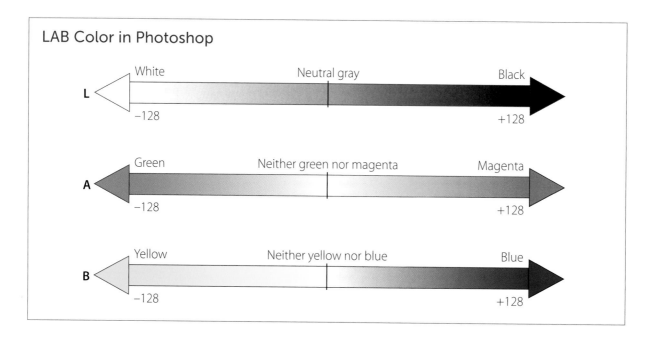

LAB adjustments

The easiest and most spectacular adjustment that can be made on an image in the LAB space is the inversion. You can invert an entire image, or just one channel (usually the L channel).

To apply a LAB inversion, first make sure that your image is in the LAB color space by choosing Image ► Mode ► LAB Color.

To invert the entire image, choose Image ► Adjustments ► Invert.

If you want to invert a single LAB channel, select the channel in the Channels panel. Make sure that all channels are visible (see page 54 to find out how to work with selection and visibility in the Channels panel). Once again, choose Image ► Adjustments ► Invert.

If this sounds easy, it is—and, at the same time, an image modification technique with tremendous power if used judiciously in support of one's vision!

For example, the image of a spider web and water drops shown on page 154 seemed so abstract to me that I thought it would be fun to try further abstractions—and apply both an overall inversion (below) and an L-channel LAB inversion Page 158).

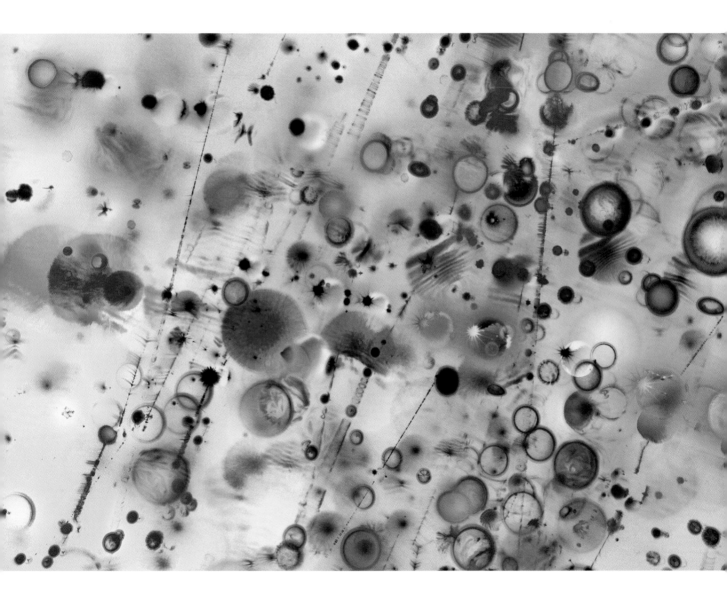

▲ *This image was created by converting the image shown on page 154 to LAB color. Then, after making sure all the channels were selected in the Channels panel, I chose Image ► Adjustments ► Invert to create this image that shares the content of the original image, but not the color.*

▲ *This image was created by inverting the L or Lightness channel of the waterdrops image shown on page 154. By inverting the L channel, the grayscale information was reversed; meaning that black became white, white became black, and all the grays inverted to their darker or light counterpart. The form of the abstract image is the same, but the colors are different, creating a new look.*

▲ *Using a light box, it is possible to shoot images of great delicacy and translucency.*

▼ *This is an L-channel inversion of the Lilies panorama, which creates a unique composition with striking lighting and effects.*

40mm macro lens, panorama shot in three panels, each panel consisting of five exposures with shutter speeds ranging from 1 second to 1/60 of a second, each exposure shot at f/8 and ISO 100, tripod mounted; exposures and panels combined in Photoshop.

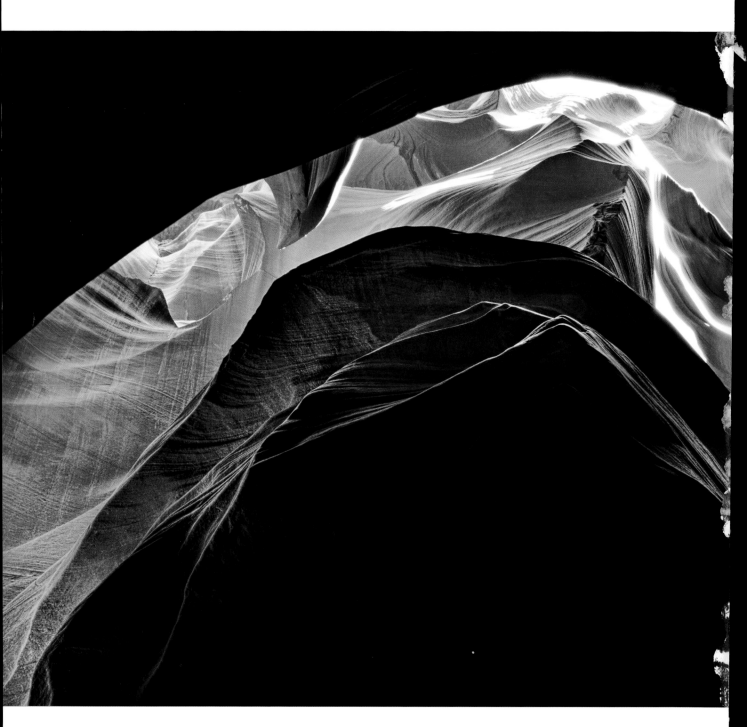

▲ *Looking up toward the sky from the floor of a slot canyon near Page, Arizona, I saw the*
canyon structure above me as a sculptural ribbon of light. To render the dynamic range
of this light ribbon, I shot five exposures and later combined them in Photoshop.

26mm, five exposures at shutter speeds at shutter speeds from 4 seconds to
1/4 of a second, each exposure at f/25 and IDO 200, tripod mounted; exposures
combined in Photoshop.

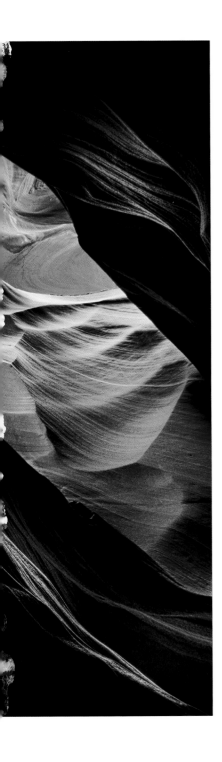

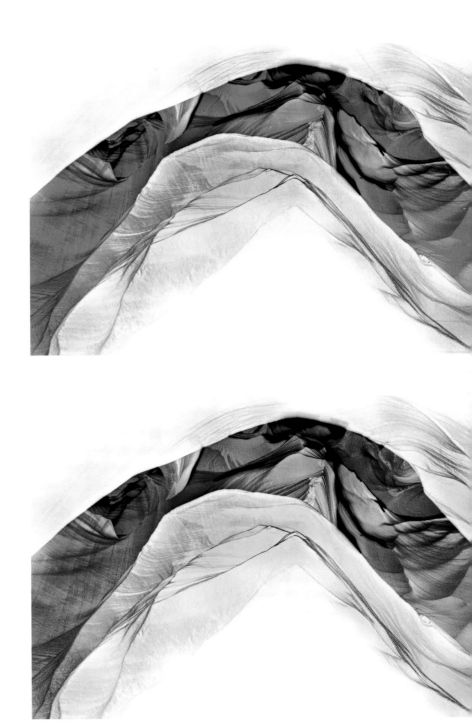

▲ *One day I started playing with inversions of the Antelope Canyon image shown to the left. These inversions led to a fantasy image shown on pages 162–163.*

TOP: *I created this version by selecting all the channels in the Channels panel and then inverting them.*

BOTTOM: *Then I created this version by selecting only the L (Lightness) channel and inverting it.*

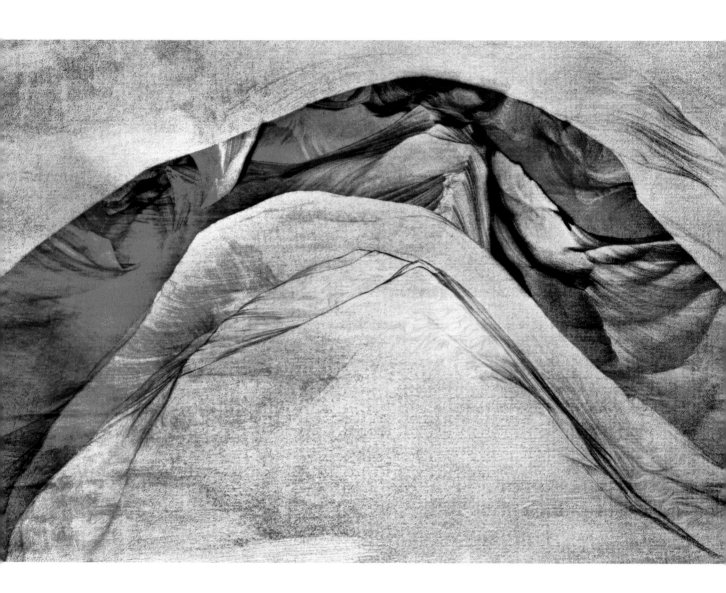

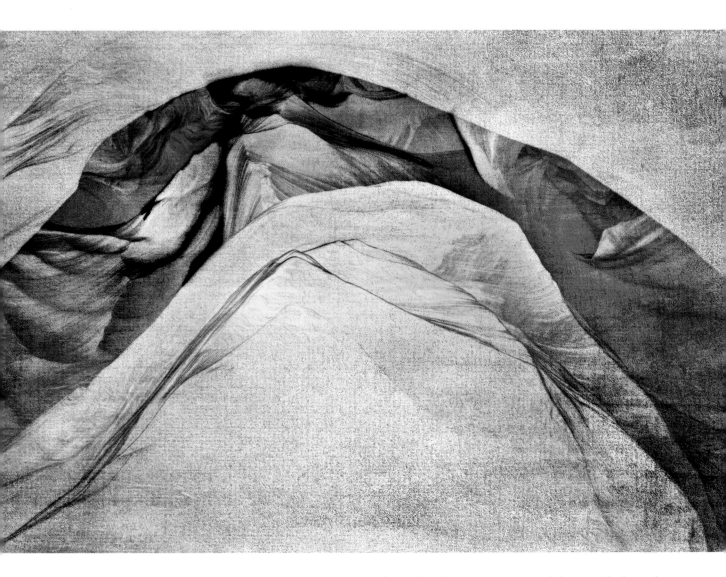

▲ I started with the canyon image shown on page 160, and after duplicating the image, I started playing with channel inversions (page 161). Using these inversions as a color palette for a new image, I combined the L-channel version (on the left) with the horizontally flipped LAB inversion on the right. This created a very wide horizontal image with patterns that I had not necessarily anticipated (some people have told me that they see a face in the center of the image).

After combining the two inversions, I used blending modes, layer masks, and painting to add the kaleidoscope of colors. (Turn to pages 33–53 to find out more about these techniques.) Finally, I used a layer mask to brush in a texture to add more depth and contrast. (For more about textures and adding them to your images, turn to pages 175–183.)

Black and white

◄ *As many people know, I like to photograph tiny waterdrops (in fact, I have written an entire book about waterdrop photography!). One thing that always amazes me when I shoot this diminutive subject is the way an entire world is contained within a single drop of water.*

The blades of grass shown in this image were coated with waterdrops following a late spring rainstorm. I knew I had to photograph them, particularly because the composition could play with size and scale. At first glance, one could be looking at large leaves, but these blades of grass were no more than 1/16" across.

200mm macro lens, 36mm extension tube, 1/15 of a sec at f/13 and ISO 100, tripod mounted; converted to monochrome using Photoshop and Nik Silver Efex Pro.

▲ PAGES 164–165: *In the dead of winter there's not much color, even in California's usually highly saturated gardens. The Tilden Park Botanic Garden in the Berkeley Hills emphasizes California native plants. It's always a wonderful place to wander, but at the turning of the year I looked for texture and form rather than color with monochromatic imagery on my mind.*

The succulent gardens, and particularly the agaves shown in this image, seemed to answer my needs for graphic subject matter. My idea in processing the image was to create an effect that looks almost like an etching rather than a photo.

40mm macro lens, four exposures at shutter speeds ranging from 2.5 seconds to 1/6 of a second, each exposure at f/22 and ISO 100, tripod mounted; exposures combined using Nik HDR Efex Pro and hand-HDR in Photoshop; converted to monochrome using Photoshop and Nik Silver Efex Pro.

As Paul Simon wrote in his supposed paean to Kodachrome, "Everything looks better in black and white." Well, not quite everything. If you are considering a monochromatic image, here are some characteristics that you should look for in your subject matter:

■ The image is *not about* color—hey, color may not even matter!

■ The composition is crucial—perhaps the image *is* mostly about shapes and form.

■ High-contrast images are best for monochrome.

■ Simple images that are inherently graphic work well in black and white.

■ Strong lines work well in black and white, but are often lost if there is a riot of color.

■ The absence of color should help tell the story that the image is intended to reveal.

The following two ideas apply to any quality digital monochromatic image:

■ A RAW file captures the world in color, and you need the information that this color provides, so don't simply drop the color information by desaturating the image.

■ When you convert an image to monochrome, you can use layers and layer masks to do so very selectively. In other words, there is no reason why a monochromatic conversion has to be— or should be—applied uniformly across an entire image all at once. Different areas

in an image can be converted using alternative techniques that are appropriate to the subject matter in those areas.

These ideas about digital monochromatic image making imply a multi-step workflow, in which a color RAW file (or sequence of RAW files) is first processed more or less normally to create a color image. The only difference from a normally processed color image in this progression is that you don't have to pay as much attention to color as you normally would, and that you want a bit more contrast than you might in a conventional color image.

The second part of creating a black and white image means using layers to apply various monochromatic conversion techniques selectively. For example, with the Park Bench image shown to the right, on several layers I used Nik's Silver Efex Pro and Photoshop's Black & White Adjustment layers. But other conversion tools work well, so long as they allow you to use the color information as part of the conversion process. Using the color information will give you more detail, and tonal range from light to dark in your black and white image.

This is the finished color version of the image before I started converting it to black and white.

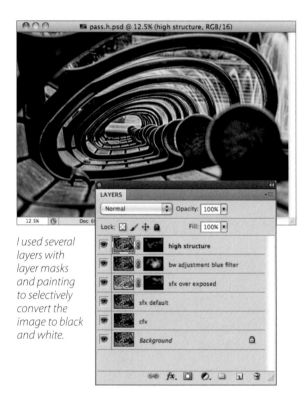

I used several layers with layer masks and painting to selectively convert the image to black and white.

Below, shown in Adobe Bridge, is the bracketed sequence of seven RAW images that I shot to capture the entire tonal range of the park bench. Notice that the image is rather monochromatic to begin with, even though it was shot in color.

_HLD8019.NEF
10/3/12, 5:39 PM
1/8 s at f/22.0, ISO 100
200.0 mm

_HLD8020.NEF
10/3/12, 5:39 PM
1/4 s at f/22.0, ISO 100
200.0 mm

_HLD8021.NEF
10/3/12, 5:39 PM
0.5 s at f/22.0, ISO 100
200.0 mm

_H
10/
0.8 s

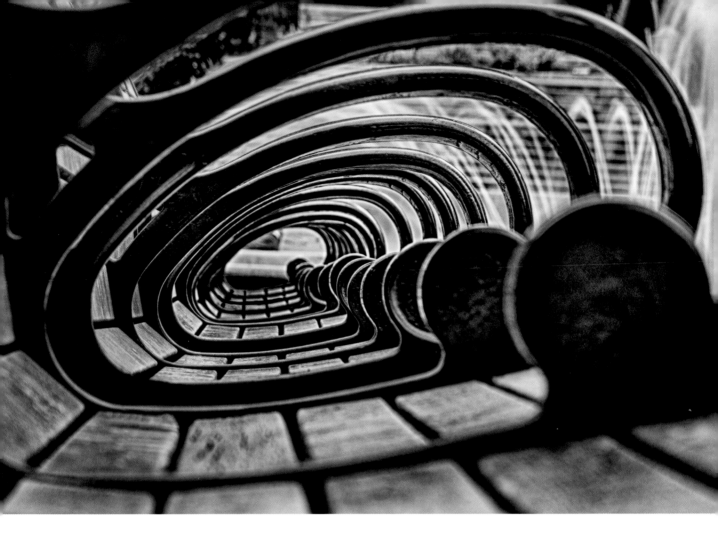

▲ *The minute I noticed this unusual view down the length of a series of park benches, I decided that the image needed to be rendered in black and white. Regardless, I shot a sequence of color RAW files, and created a high-contrast color version of the image (top, page 168). I converted the color image to monochromatic using six layers (shown on page 168 in the Layers panel) at varying degrees of opacity, using blending modes and layer masks.*

200mm, seven exposures at shutter speeds from 1/8 of a second to 10 seconds, each exposure at f/22 and ISO 200, tripod mounted; exposures combined in Photoshop and Nik HDR Efex Pro and converted to monochrome using Photoshop Black & White Adjustment layers and Nik Silver Efex Pro.

NEF
9 PM
ISO 100
n

_HLD8023.NEF
10/3/12, 5:39 PM
1.6 s at f/22.0, ISO 100
200.0 mm

_HLD8024.NEF
10/3/12, 5:39 PM
5.0 s at f/22.0, ISO 100
200.0 mm

_HLD8025.NEF
10/3/12, 5:40 PM
10.0 s at f/22.0, ISO 100
200.0 mm

▶ *This is a variation of the motorcycle image shown in the photo on pages 122–123.*

I've always liked to photograph beautiful machines, and of course this motorcycle is exquisite. However, one conundrum presented itself to me along the entire process from image conception to post-production: should the presentation be in color or black and white?

There are good visual arguments in both directions. On the one hand, the color image (see pages 122–123) presents sensuous color that is unusual in the context of a normally hard-edged motorcycle.

On the other hand, the monochromatic version lets the beauty of the machinery shine in the starkest sense.

As it turns out, my collectors like prints of both color and monochrome versions. So I guess you'll just have to decide for yourself.

40mm, nine exposures with shutter speeds ranging from 1/320 of a second to 1.3 seconds, f/13 and ISO 200, tripod mounted; exposures combined in Photoshop; converted to monochrome using Nik Silver Efex Pro and Photoshop.

▼ PAGES 172–173: *As I left a Zen Buddhist monastery, I looked back and saw what I thought might be an interesting composition of a fork in the road. One road was well used, and the other less traveled.*

Since I had an appointment, I almost drove on. But I made myself pull over and park the car, and shot the image. It would have been easy to drive on without stopping, but I find that taking the time to stop and to really look around me is what leads to my best images.

60mm, 1/160 of a second at f/6.3 and ISO 200, handheld; converted to monochrome using Nik Silver Efex Pro and Photoshop.

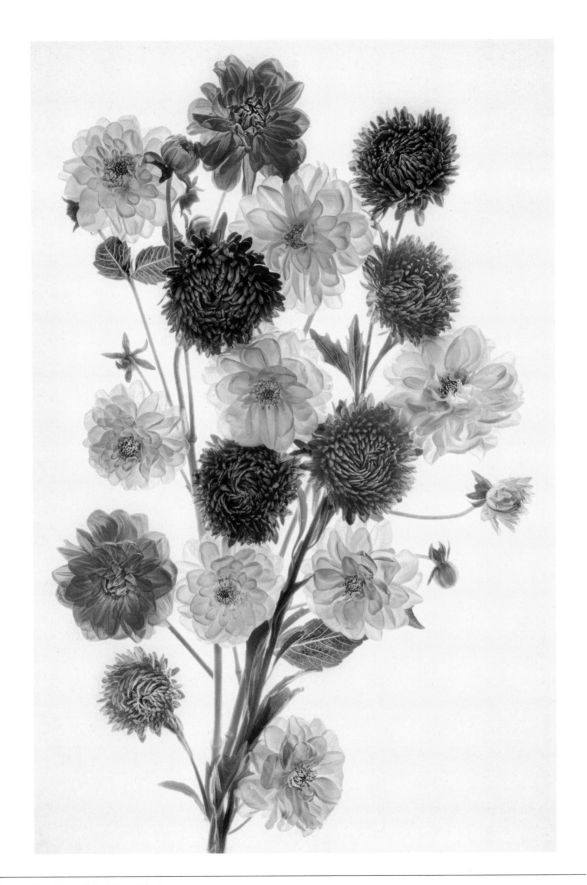

Backgrounds and textures

◄ *I have several raised flower beds that I use to grow flowers specifically for photography. Starting in January each year, I visit several local horticultural nurseries in my area, looking for interesting seedlings that will (hopefully) grow into beautiful flower-bearing plants that I might like to photograph a few months later. Even though I put markers in when I plant, some become lost over time and I forget what each plant is exactly. Walking outside with my pruning shears one day in early autumn, I discovered some beautiful white dahlias in full bloom.*

Looking at these flowers, it seemed to me that they would be more appealing by adding some color. So besides the white dahlias, I cut some nearby purple and pink asters, and a few pink dahlias.

Back inside in my studio, I arranged the flowers on a light box for transparency, taking care to make a coherent internal structure so it looked like all the flowers were part of one bouquet.

I shot a series of bracketed exposures going from the "average" exposure to way overexposed (see pages 120–121 for more information about this technique).

I combined the resulting exposures, starting with the lightest on the bottom of the layer stack. Each successively darker layer was painted in at moderate opacity using layer masks and the Brush Tool.

After combining the layers, I had the result on white (shown on page 176). This image, while quite beautiful, was also a bit more stark than I wanted in order to create a botanical print. So to finish the image, I layered it over a scanned paper background.

40mm macro lens, seven exposures at shutter speeds from 4 seconds to 1/30 of a second, each exposure at f/16 and ISO 200, tripod mounted; exposures combined in Photoshop, and added to a scanned paper background.

One of the easiest ways to add a bit of pizzazz to an otherwise finished image is to add a background or texture. Images appear placed on a background, whereas a texture is intended to add patterns, marks, or color swatches across an image rather than function as a backdrop.

In either case, the most effective technique is often to overlay the background or texture and use a blending mode other than Normal to create the desired effect. Alternatively, you can place your image on a background that is textured.

Examples of images that use textured backgrounds and overlays can be found on pages 18–19, 128–129, 136–137, 162–163—throughout *The Way of the Digital Photographer*.

One way to create image files that can be used as a background or texture is to scan them. Anything you can place on a flatbed scanner can, most likely, be scanned—specialty papers such as Japanese washi or fabrics such as canvas, linen, or silk. You can also create textures by shooting an image, most often—but not always—of something textural. If you want to shoot an image for use as a texture or background, the best practice is to use a fast shutter speed and a wide-open aperture for minimal depth-of-field. You can also license images to use as textures, such as the Florabella Textures collections.

Meditation

The perfect is the enemy of the good … but that shouldn't stop us from seeking perfection.

Blending a background with an image

With the image of dahlias and asters shown to the right, I assembled a composition and shot a series of bracketed photos straight down on a light box.

After processing the flower image, I wanted to enhance it a bit more and give it the look of a botanical print. So I found a piece of Japanese washi rice paper and scanned it on a standard flatbed scanner.

As you can see from the layer stack shown below in the Layers panel, I put the scanned washi on the bottom of the stack, and then added the aster composition first using Normal blending mode with the layer set to 15% Opacity. Finally, I duplicated the aster layer, set the blending mode to Multiply and lowered the duplicate layer's Opacity to 85%. This gently blended the flowers into the washi background.

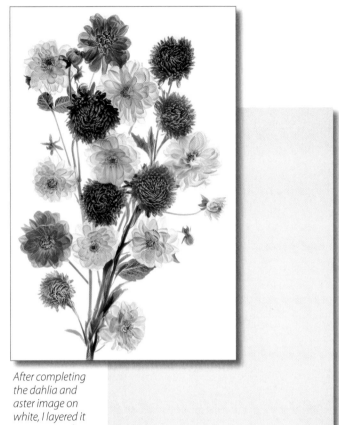

After completing the dahlia and aster image on white, I layered it over a scan of a piece of Japanese rice paper.

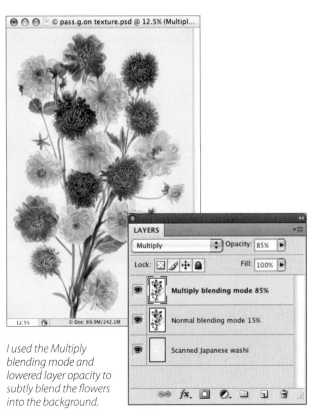

I used the Multiply blending mode and lowered layer opacity to subtly blend the flowers into the background.

▶ *Often an inversion of an image on a light background can create a very attractive and distinctive image that stands in its own right. For instance, after converting the dahlias and asters image shown on page 174 to the LAB color space, I inverted the L channel creating the luscious and painterly effect shown in this composition.*

To enhance the painterly qualities of the image, I added a canvas-textured overlay that incorporated large brush strokes.

An L-channel inversion of the image is shown on page 174. For more information about LAB inversions, turn to pages 155–163. Additional texture overlay was added in Photoshop using a layer mask and the Brush Tool (see pages 43–56 for details about this layering technique).

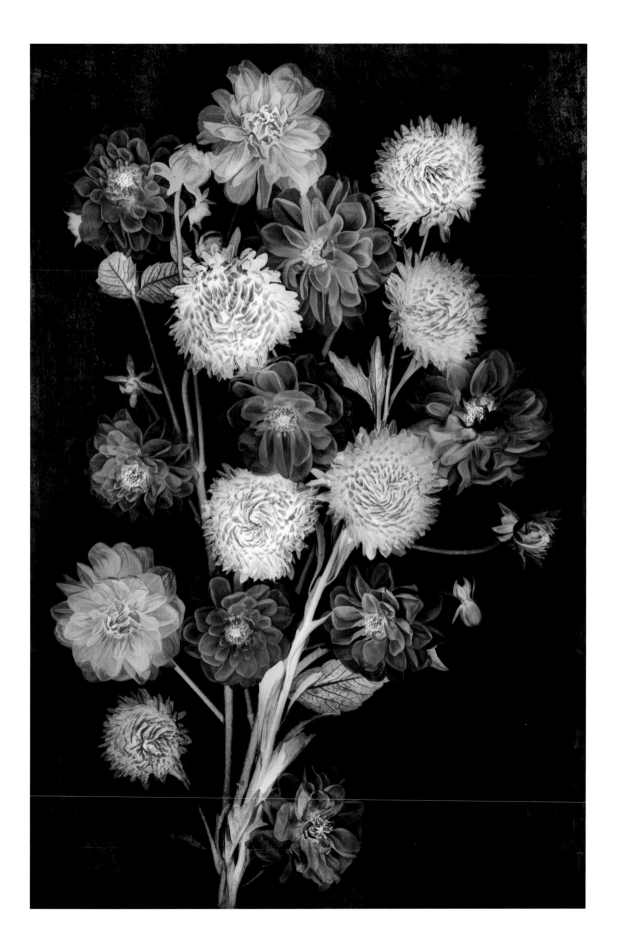

Using textures to change the scene

This photo of glamour model Jade Vixen was certainly intriguing, but the beige paper background with footprints on it left something to be desired (top right).

I decided that adding some texture to the background would move the model away from the studio shot to an image that would be reminiscent of an old-fashioned 19th-century photograph.

This studio photograph shows a very beautiful woman in not so beautiful surroundings. Besides the footprints on the paper background, there is a dark sofa at the bottom.

Time to get to work with Photoshop! Adding textures and removing the dark couch would certainly move the viewer's attention where it belongs—on the model.

1. To get started, I looked through my files of textures and found an Artiste texture from one of the Florabella Texture packs (see the Resources section for info about these textures) that appeared to have broad brush strokes and a similar golden-brown tonality to the model (below right).

 I opened the Artiste texture in Photoshop and created a layer stack by copying the texture into the image window containing the model. I named the layer "Artiste." (For directions on how to copy an image and create a layer stack, turn to pages 44–45.)

I layered this Artiste texture on top of the model. It got rid of the boring background but left texture on her skin.

2. Then I added a white Reveal All layer mask (page 47) to the "Artiste" layer and changed the blending mode to Soft Light (turn to pages 71–95 for info about working with blending modes). I used a black brush set to a low opacity to blend the texture into the model "Background" layer. (Turn to pages 43–56 to learn about the Brush Tool and painting on a layer mask.)

 The texture was still too strong on the model's skin, so the next step would be to correct it.

Using a white Reveal All layer mask and the Soft Light blending mode, I was able to cover the boring paper background.

3. To correct the skin texture problem, I duplicated the "Background" layer and put it at the top of the layer stack (right). I then added a black Hide All layer mask.

4. Next, using a white brush, I carefully painted on the layer mask to reveal the smooth skin of the duplicated layer, leaving the texture of the "Artiste" layer visible.

 At this point, I saved a copy of the image as a checkpoint (in case I made a mistake and needed to go back later). (To find out about checkpoints and file management, turn to pages 139–140.)

5. To add a more antique feel to the image, I duplicated the "Background" layer and applied Nik's Film Efex Vintage #2 filter to the duplicate (middle right). To blend the vintage layer in with the "Background" layer, I used a white Reveal All Layer mask, and used black to paint out the effect on the model. I then changed the layer Opacity to 51%.

6. Finally, I added another Florabella texture, Patina Warm, to the top of the layer stack (below), blended the texture in using a layer mask and painting, and lowered the layer Opacity to 14%. The final image is shown on page 180.

I removed the texture from the model's skin by duplicating the "Background" layer and putting it on top of the layer stack. Then I added a black Hide All layer mask, and used a white brush to gently paint in the smooth skin from the duplicate layer.

To add a more vintage feel to the image, I applied the Nik Film Efex Vintage #2 filter at 51% Opacity.

I added a subtle graininess around the edges of the image, by layering the Patina Warm texture on top of the layer stack. Using a white Reveal All layer mask, I painted with black to remove the texture from the model's body.

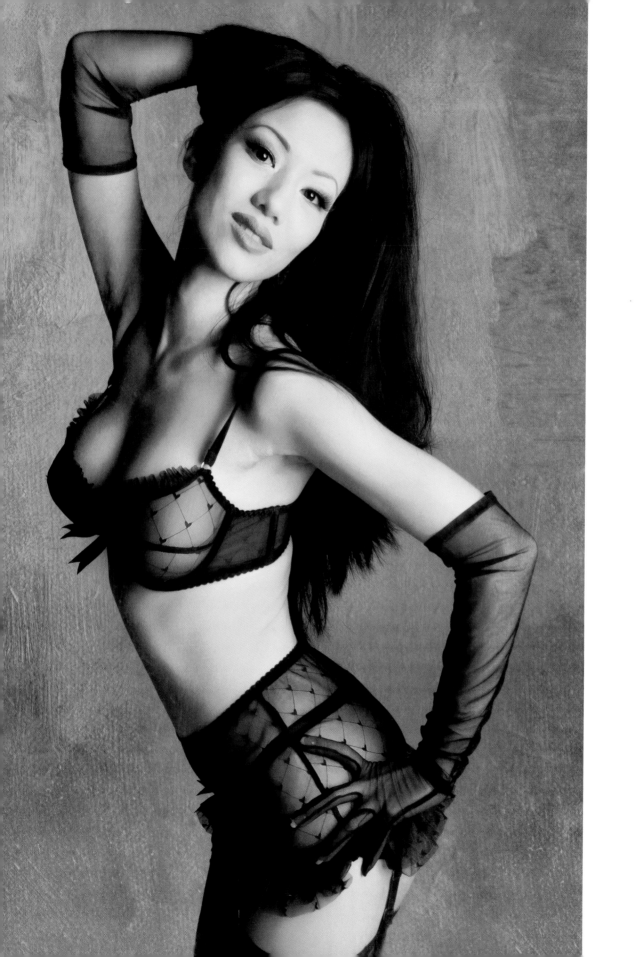

◀ *I shot this glamour model in a studio on a beige background (original photo page 178, top). Looking at the image on my computer in my studio, it seemed to me that the contrast between the model and the background was simply too stark. So I used the techniques shown in this section to add a texture overlay to the image that somewhat resembles a painted wall.*

To make sure that the texture overlay did not interfere with the fine quality of the model's skin, I masked out the model when I added the texture overlay.

It's often been my experience that adding a texture can increase the attractiveness of many kinds of photos.

36mm, 1/160 of a second at f/6.3 and ISO 200, handheld; texture overlay added in Photoshop.

▶ *In my life, I have traveled and photographed in quite a few exotic locations. So it's no wonder when folks see this image that they think I shot it somewhere off the beaten path. In fact, this is the Ferry Building in San Francisco at sunset, just a few miles from where I live.*

Adding a texture overlay helped make what would otherwise be a rather normal-looking photo into something that resembles an attractive oil painting.

150mm, 1/2000 of a second at f/16 and ISO 200, tripod mounted, texture overlay added in Photoshop.

▲ *To shoot this wet maple leaf, I positioned the camera on a tripod inside looking out—so the image is looking through a wet window to the leaf on the exterior of the glass. I used a macro lens, and shot two exposure sequences, one at moderate depth-of-field (f/10) for the window glass, and one stopped down (to f/22) to get the leaf itself maximally in focus. After processing the image, I duplicated the layers and used the Topaz Simplify Woodcarving filter (see page 151) to increase the sense of texture in the leaf and window.*

40mm macro lens, six exposures, four exposures shot using shutter speeds between 1/15 of a second and 2.5 seconds at f/10, and two exposures shot at shutter speeds of 2 seconds and 5 seconds with an aperture of f/25, all exposures at ISO 200, tripod mounted; exposures combined using Nik HDR Efex Pro and Photoshop.

◄ *The idea behind this photo is to show the model emerging from a background. To make it, I shot the model on a white background. She was wrapped in sheer, white gauze. In post-production, I placed the model image as a layer on a canvas background, and then added a series of textures on top of the Photoshop composite.*

42mm, 1/160 of a second at f/9 and ISO 100, handheld; scanned canvas background and texture overlays added in Photoshop.

DO IT ON YOUR iPHONE: LO-MOB AND PLASTIC BULLET

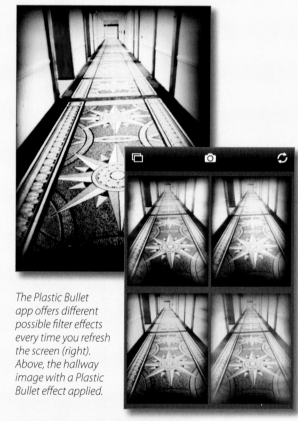

Some surprisingly sophisticated post-processing is possible on the iPhone—for example, you can work with layers using PhotoForge (see pages 134–135). Snapseed is another sophisticated iPhone image-editing tool. But this begs the question of why one wants to use a sophisticated editing tool on a tiny screen, and the answer is that most people don't.

The iPhone may be the camera that you always have with you, and the post-production computer that fits in your pocket, but if you are like me you probably just want to apply an effect or two and be done with it—which is the point of apps like Instagram, and the two shown here: Lo-Mob and Plastic Bullet.

With both Lo-Mob and Plastic Bullet you can load an image by shooting it, or from the iPhone's Camera Roll. In either case, with both apps you are presented with a menu of effects, displayed visually, and all you have to do is choose the effect you want to apply. With Lo-Mob, the possible effects are in a long, scrollable listing—and in Plastic Bullet you refresh the screen to see new possible effects.

These apps let you email your image with the filter effect applied, or save it directly to your favorite social media. Of course, you can also save the updated image back to your Camera Roll—without overwriting the original.

This stuff is truly fun and doesn't consume too many brain cells, which is why I find myself doing it in hotel corridors and while waiting in restaurants for food. One tap, and voilà, you're done!

The Plastic Bullet app offers different possible filter effects every time you refresh the screen (right). Above, the hallway image with a Plastic Bullet effect applied.

The Lo-Mob app offers a menu of possible filter effects that you can apply on the fly.

▲ *The spoon has been treated with Lo-Mob's "Vintage Postcard" filter.*
iPhone 4 camera app, using HDR.

Resources

Notes

Digging deeper

Here are some suggestions about where you can go to get more information about the techniques covered in *The Way of the Digital Photographer*:

- Multi-RAW processing, HDR (High Dynamic Range) and hand-HDR are covered in detail in my *Creating HDR Photos: The Complete Guide to High Dynamic Range Photography* (Amphoto, 2012).

- If you want to find out more about Photoshop, or to brush up on Photoshop concepts and techniques, you might find my other books that are specifically about Photoshop helpful. Please check out *The Photoshop Darkroom: Creative Digital Post-Processing* (Focal Press, 2009) and *The Photoshop Darkroom 2: Creative Digital Transformations* (Focal Press, 2011).

- Digital black and white photography is explained in depth in my book *Creative Black & White: Digital Photography Tips & Techniques* (Wiley Publishing, 2010).

Come visit my blog

Please visit my website and photography blog at www.photoblog2.com. There you will find literally thousands of images and the stories behind them. My goal in writing my blog is to share my journey as a digital photographer with you. In this regard, you'll find information about many of the techniques that I use as well as backstory information about the visual and philosophic decisions I have made.

Software

There are a number of software products covered in *The Way of the Digital Photographer*. More information about these products, and free trial versions for you to download, are available at the Web addresses listed below.

- Adobe, Adobe Bridge, Adobe Camera RAW (ACR), Adobe Lightroom, and Adobe Photoshop: www.adobe.com

- Pixel Bender can be downloaded for free from Adobe Labs, http://labs.adobe.com/downloads

- HDRSoft, Photomatix: www.hdrsoft.com

- Nik Software, HDR Efex Pro, Color Efex Pro and Silver Efex Pro: www.niksoftware.com

- Topaz Labs, Adjust and Simplify plug-ins: www.topazlabs.com

Recommended texture packs are available from:

- Florabella: www.florabellacollection.com

- Flypaper Textures: www.flypapertextures.com

Monitor calibration

For monitor calibration I recommend the products from X-rite in particular the ColorMunki: www.xrite.com.

Following the path

In the Meditations in my book I have also shared some of my thoughts about the philosophy behind being a digital photographer. If my Meditations interest you, you might also want to take a look at:

The War of Art by Steven Pressfield

Wabi-Sabi for Artists, Designers, Poets & Philosophers by Leonard Koren

Zen in the Art of Photography by Robert Leverant

Zen Mind, Beginner's Mind by Shunryu Suzuki

Glossary

Adobe Camera Raw (ACR): Used to convert RAW files into files that Photoshop can open.

Aperture: The size of the opening in a camera lens, usually designated as an f-stop.

Blending mode: Determines how two layers in Photoshop will combine.

Bracketing: Shooting many exposures at a range of settings. It often works better to bracket shutter speed rather than aperture.

Brush Tool: Used to paint on a layer or layer mask in Photoshop.

Channel: In Photoshop, a channel is a grayscale representation of color (or black) information. In RGB color there are three channels: red, green, and blue.

CMYK: Cyan, Magenta, Yellow, and Black; the four-color color model used for most offset printing.

Color opponent: A color channel that includes information about both a color and its opposite color.

Color space: A color space—sometimes called a color model—is the mechanism used to display the colors we see in the world, in print, or on a monitor. CMYK, LAB, and RGB are examples of color spaces.

Curve: An adjustment used to make precise color and exposure corrections.

Depth-of-field: The distance in front of and behind a subject that is in focus.

DSLR: Digital single lens reflex camera.

Dynamic range: The difference between the lightest tonal values and the darkest tonal values in a photo.

Equalization: A Photoshop adjustment that maximizes the color in a channel or channels.

EV (Exposure Value): Denotes any combination of aperture, shutter speed, and ISO that yields the same exposure. –1 EV means halving the exposure, and +1 EV means doubling the exposure.

f-number, f-stop: The size of the aperture, written f/n, where n is the f-number. The smaller the f-number, the larger the opening in the lens; the larger the f-number, the smaller the opening in the lens.

Focal length: Roughly, the distance from the end of the lens to the sensor. (The relationship of focal length to sensor size is explained on page 15.)

Gradient: A gradual blend, often used when working with layer masks in Photoshop.

Grayscale: Used to render images in a single color from white to black; in Photoshop a grayscale image has only one channel.

Hand-HDR: The process of creating an HDR image from multiple photos at different exposures without using automatic software to combine the photos.

HDR: Extending the dynamic range in an image using techniques including multi-RAW processing, hand-HDR, and automated HDR software.

High key: Brightly lit photos that are predominantly white, often with an intentionally "overexposed" look.

Histogram: A bar graph that represents a distribution of values; an exposure histogram is used to display the distribution of lights and darks in an image.

Inversion: A Photoshop adjustment that inverts the color in a channel or channels.

ISO: Scale used to set a camera's sensitivity to light.

JPEG: A compressed file format for images that have been processed from the original RAW file.

LAB color: A color model consisting of three channels. The Lightness (L) channel contains the luminance (black and white) information, the A channel contains magenta and green, and the B channel holds blue and yellow.

Layer: Photoshop documents are composed of layers stacked on top of each other.

Layer mask: Masks are used to selectively reveal or hide layers in Photoshop.

Low key: Dimly lit photos that are predominantly dark, often with an intentionally "underexposed" look.

Multi-RAW processing: Combining two or more different versions of the same RAW file to extend the dynamic range and create a more pleasing final image.

RAW: A digital RAW file is a complete record of the data captured by the sensor. The details of RAW file formats vary between camera manufacturers.

RGB: Red, Green, and Blue; the three-color color model used for displaying photos on the Web and on computer monitors.

Shutter speed: The interval of time in which the camera shutter is open.

Stacking: Combining images shot over time to create a single image with the effective exposure time of all the shots combined.

Stop down: To stop down a lens means to set the aperture to a small opening; denoted with a large f-number.

Tonal range: The range of color and light and dark values in an image.

Index